MAURICE SENDAK

A CELEBRATION OF THE ARTIST AND HIS WORK

CURATED BY JUSTIN G. SCHILLER AND DENNIS M. V. DAVID

EDITED BY LEONARD S. MARCUS

ABRAMS, NEW YORK

This Catalogue is published in conjunction with an Exhibition taking place at the Society of Illustrators in New York City and opening on June 11, 2013. Neither the Exhibition nor this Catalogue have been approved of by the Estate of Maurice Sendak.

For generations past, present, and future who appreciate the fine artistry of Maurice Sendak, this tribute is respectfully dedicated.

–JGS and DMVD

Published in conjunction with the exhibition *Maurice Sendak: A Celebration of the Artist and His Work* at the Society of Illustrators, New York, June 11–August 17, 2013, curated by Justin G. Schiller and Dennis M. V. David.

Editor: Susan Homer
Project Manager: Charles Kochman
Designer: Danielle Young
Production Manager: Anet Sirna-Bruder

Cataloging-in-Publication Data has been applied for and may be obtained from the Library of Congress.

ISBN: 978-1-4197-0826-8

Compilation copyright © 2013 Justin G. Schiller and Dennis M. V. David.

Copyrights in original artwork created by Maurice Sendak are owned and controlled by the Estate of Maurice Sendak.

Text copyright © 2013 by the individual contributors.

Photography by Lei Han except for: pages 194 and 200 courtesy Judy Taylor; page 212 photograph by Bob Brooks, courtesy Judy Taylor; page 219 (right) photograph by Tim Sheesley; pages 219 (left) and 220 photograph by Qing Wang.

THE ART OF BOOKS SINCE 1949

115 West 18th Street
New York, NY 10011
www.abramsbooks.com

PREVIOUS SPREAD: *Pictures by Maurice Sendak*, 1971. Pen-and-ink line and watercolor, 11¾ x 10¼ inches. "Moishe" and "Lady" Wild Things viewing an exhibition in which framed portraits of Mickey, Max, and Alligator hang on the gallery wall.

FRONT ENDPAPER: Preliminary drawing for *You First*, 1997. Pencil, 5⅞ x 16¹⁵/₁₆ inches.

REAR ENDPAPER: *You First*, 1997. Pencil and watercolor, 5⅞ x 16¹⁵/₁₆ inches.

CONTENTS

Opening announcement of Schiller-Wapner Galleries, 1979. Pen-and-ink line, 3½ x 8⅛ inches. This illustration, which Sendak created for the front of a folded card, caricatures the proprietors, Justin Schiller and Raymond Wapner, as jovial bears, frolicking with some of the world's most famous children's book characters: the Tin Woodman and Toto from *The Wonderful Wizard of Oz* by L. Frank Baum, Alice from *Alice's Adventures in Wonderland* by Lewis Carroll, *Struwwelpeter* (*Shock-haired Peter*) by Heinrich Hoffmann, Walt Disney's Mickey Mouse, and a feather-nibbling Wild Thing. These iconic portraits are typical of the original drawings handled by the gallery. Schiller-Wapner Galleries, an adjunct to Schiller's antiquarian children's book business, was among the first galleries to specialize in the works of contemporary children's book artists, including Maurice Sendak, and to offer them alongside original masterworks by John Tenniel, Beatrix Potter, Kate Greenaway, and Walt Disney.

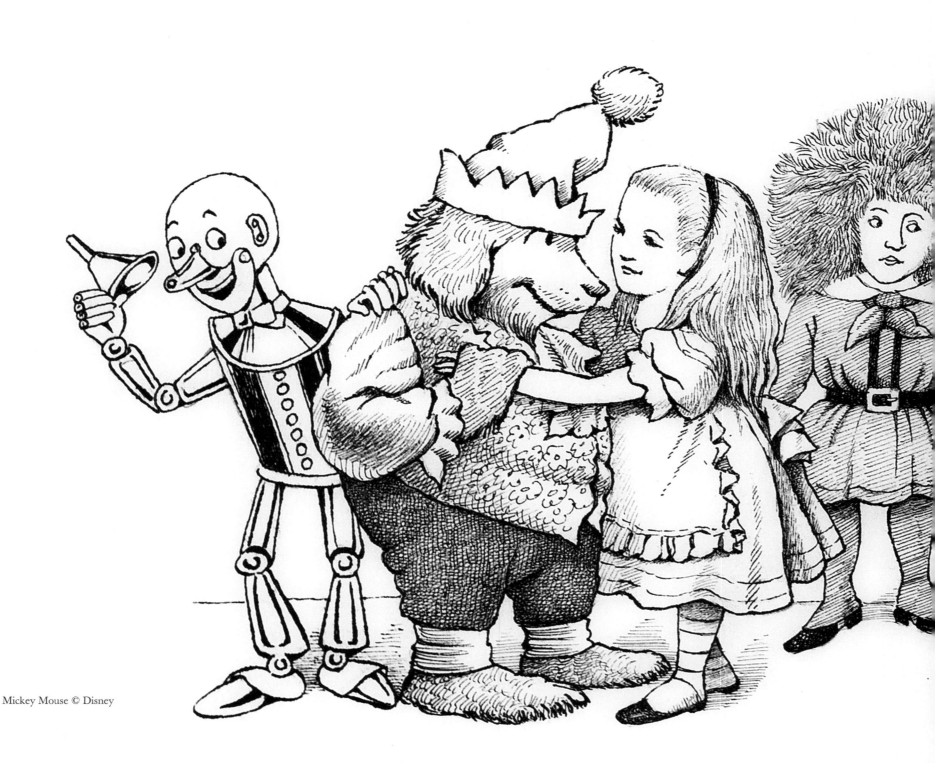

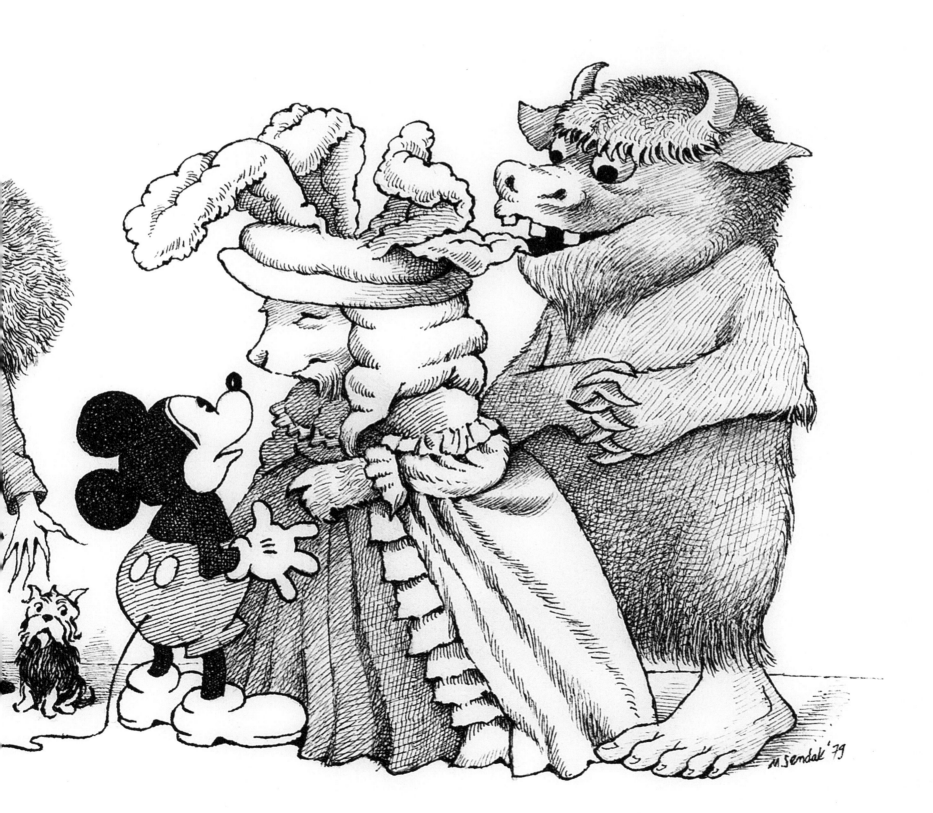

RECOLLECTIONS FOR AN EXHIBITION
by Justin G. Schiller

Forty-five years was not long enough to know a friend, especially when that friend was Maurice Sendak. We met in 1967, the year I was elected into the Antiquarian Booksellers Association of America, introduced by playwright Bill Archibald, who converted Henry James's novella *The Turn of the Screw* into a Broadway play *The Innocents* (1950) and then a screenplay (1961) with Truman Capote. Bill knew me from various antiques shows, where my mother exhibited antique jewelry. She would allow me to set up a table of old books for sale—which I did in between issuing catalogues and writing a monthly column on rare books for *Collectors News*. Maurice and I met at the Antiquarian Book Center, a subterranean, communal shop of dealers located at Rockefeller Plaza, where I showed him a collection of late nineteenth-century movable toy-books designed by Lothar Meggendorfer. Each of us recognized a kindred spirit in the other, the beginning of shared passions, but it was impossible to anticipate the close bonds that were to be formed just a few years later.

During the autumn of 1969 my antiquarian children's books business changed from a proprietorship to a corporation. My partner, Raymond Wapner, and I wanted to issue a series of small catalogues, each with a well-designed cover by a notable illustrator. We approached Maurice with the idea and he agreed to contribute an illustration. That is the origin of our Chapbook Miscellany series (1970). Maurice's drawing was not only used on four different colored paper catalogues the same year, but its top frame also got adapted for our corporate letterhead and envelope. Not until

years later did we realize that the teddy bear caricatures actually represented Raymond and me (see pages 6–7, 9, and 68). These figures were employed again during this same decade. The first time was in a portrait of me in an armchair surrounded by favorite books. This image was intended for use as a personal bookplate, but it was too complex and so we used it instead as another catalogue cover (see page 70). Then both figures together appeared amid a group of children's book characters announcing the opening of Schiller-Wapner Galleries. One needs to look at the facial features, but they are definitely us.

Nineteen seventy was not only our first corporate year in business but also the year that Maurice won the Hans Christian Andersen Award for Illustration, to this day still its only American recipient. This award, presented during the biennial ceremony of the International Board on Books for Young People (IBBY) Congress, is the highest international recognition given to an author or illustrator of children's books for the body of his or her work. Later that year Harper & Row published *In the Night Kitchen*, and having asked Ursula Nordstrom (who was the director of the Department of Books for Boys and Girls) for permission, we were designated the sponsor for its publication-day signing party. I can remember arranging for the sale of other Sendak titles published by Harper, which included several boxes of the limited edition *Zlateh the Goat and Other Stories* by Isaac Bashevis Singer (1966), offered at its original twenty-five-dollar selling price, slip-cased and signed by Mr. Singer and Maurice. We sold four hundred copies of *Night Kitchen* that day and all of the *Zlateh*s, well before Singer was awarded the 1978 Nobel Prize for Literature. Afterward Maurice, Raymond, and I joined a party already in progress at the home of Harper president Winthrop Knowlton to celebrate the publication of *Night Kitchen* and Maurice's receipt of the Hans Andersen illustrators medal.

Maurice had long admired the writings of Isaac Bashevis Singer and was excited when Harper asked him to illustrate *Zlateh.* Aside from the tales in the book, there was an extra story, "Yash the Chimney-Sweep," which was separately published in the *Saturday Evening Post* on May 4, 1968 (see page 162). For this Maurice drew a full-page watercolor, a magnificent image in the style of old master paintings. It included a portrait of his mother, Sadie, with her eyes covered by a shroud (she was terminally ill and would die three months later); his father, Philip (rear center), very distraught; the

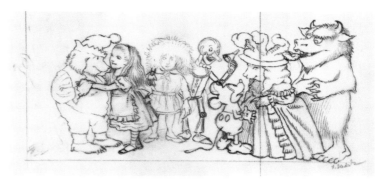

Mickey Mouse © Disney

Preliminary drawing for the opening announcement of Schiller-Wapner Galleries, 1979. Pencil, 3½ x 8⅛ inches. In this sketch, Sendak caricatures the proprietors as bears, mingling with famous children's book characters that inspired him—both as an artist and as a collector.

moon taking on a skull-like design; and a dog (front center) looking down at Maurice's signature on the floorboards. I saw the original in early 1970 while visiting Sendak's studio in the West Village, and he explained that Isaac Singer was also ecstatic over the picture. "I must have it," he told Maurice, "name your price," but it was not a matter of money. Maurice patiently explained that it was a very personal picture because of his parents, and he simply could not sell it. "You must sell it to me," Singer said again, according to Maurice, but once more the possibility was rejected. Maurice explained that Singer became furious and said that if the drawing could not be his, he would never speak to Sendak again. Since that occasion, the pain of losing his friendship with Singer only compounded the sorrow this drawing represented. Innocently, I said, "I assume that means you will never sell this picture," but Maurice surprised me by saying, "If you want to buy it, you can buy it. The picture is too sad every time I look at it." And so we agreed on a price, and this became the very first Sendak original artwork that I purchased. It had never been loaned to an exhibition until 2005, when the Jewish Museum featured a retrospective on Maurice's art. Although Maurice had visited our home many times, this drawing hung in our bedroom, and so he had not seen it again until the day the exhibition opened. That evening, toward the end of the preview, our paths crossed and he told me what a remarkable picture "Yash" was. "Why did I ever sell it?" he asked me, and so I explained to him the circumstance as I remembered it. "Yes, yes," he commented. At that point he looked at me directly and said, "I want it back." That very moment the closing bell rang, like a *deus ex machina* rescue from what otherwise might have

been an impossible predicament. As we all headed toward the exit, I said to Maurice, "We can talk about it sometime." But we never did.

About 1972, after Maurice had moved to Connecticut, he asked for my thoughts on what he should do with his quantities of foreign-language editions of his books. Shipments would arrive each time a title was translated and printed, but he didn't require more than a few file copies. I suggested that he begin doing small sketches on front free endpapers and signing his name below. We priced these copies for sale at our shop: $35 per volume, with a premium on translated copies of *Where the Wild Things Are* ($50 to $75). Many of these books were purchased over the years, and often their endpapers were excised, since original art by Maurice was notoriously rare and everyone knew his pictures were being archived at the Rosenbach Museum & Library in Philadelphia. These thumbnail sketches are not drawings, but it all depends on your point of reference and comparisons. It seems to me that such pictures have more interest nowadays if they are still inside the translated books that generated them.

Klipp-Klapp Kinderbilder by Lothar Meggendorfer, ca. 1895. Ink and watercolor, 10⅝ x 3⅞ inches.

In 1973 we were approached by the heirs of the J. F. Schreiber publishing house in Esslingen, Germany, outside of Stuttgart, who offered to sell us the original manuscript archives of Lothar Meggendorfer, the "father" of modern mechanical-picture toybooks. Meggendorfer was the artist Maurice was interested in collecting at the time we first met, and so this seemed indeed a happy coincidence. As the cost of purchasing this collection was high—and continued to rise as more production files were uncovered—my partner and I organized an investment group to back the project while Maurice agreed to write one of his most poetically beautiful analyses for our 1975 catalogue. "The Art of Lothar Meggendorfer" was reprinted in Sendak's own collected essays, *Caldecott & Co.* (Farrar Straus & Giroux, 1988), while a somewhat unauthorized earlier version of this text appeared in 1985 in *The Genius of Lothar Meggendorfer*, an anthology of various mechanical images from different book titles assembled by Waldo Hunt for Intervisual Communications.

From 1970 through the early 1980s, every time a new Sendak title was produced, our bookshop would promote its sale on publication day with a signing party. Maurice would arrive to autograph, and buyers, often with shopping bags full of other titles they wanted him to sign, would line up. It was an experience we didn't quite know how to handle, and so books got signed until there were no more lines. Gradually the mega-bookshops in New York negotiated with publishers to have Sendak do autograph sessions for them; book tours were arranged during which signed bookplates were inserted into copies of titles—without either the artist or author necessarily being present. We couldn't compete, but for special clients Maurice was always willing to provide inscriptions.

Not much has been written about Maurice as a sophisticated connoisseur of rare books and art, but as his budget allowed, he purchased what he admired most. He told me how, during the 1960s, the great Madison Avenue dealer Lucien Goldschmidt showed him Fernand Léger's *Cirque* (1950) and convinced him to pay for it in small installments. Goldschmidt was also the source for many of Maurice's Bonnards and Vallottons, while Mabel Zahn of Sessler's bookshop in Philadelphia encouraged him to acquire the main works of nineteenth-century British artists Samuel Palmer and Edward Calvert. With the success of *Wild Things* and *Night Kitchen*, so grew Maurice's courage and the financial resources necessary to follow his bibliophilic dreams.

Long an admirer of Herman Melville, he had an opportunity in 1974 to purchase a first printing of *Moby-Dick*. Produced in London by Richard Bentley (1851) under its original title *The Whale*, it had been issued in three volumes, with a gilt pictorial whale handsomely stamped on each spine, one month prior to its appearance in

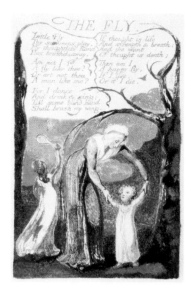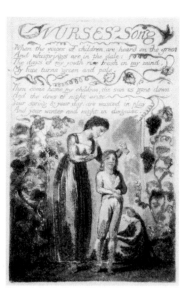

ABOVE, LEFT: *Songs of Innocence and of Experience:* "The Fly" by William Blake, 1794. Color-printed copperplate relief etching, touched by hand, 2¾ x 4⅜ inches. From copy H, formerly in the collection of Justin G. Schiller.

ABOVE, RIGHT: *Songs of Innocence and of Experience:* "The Nurses' Song" by William Blake, 1794. Color-printed copperplate relief etching, touched by hand, 2¾ x 4⅜ inches. From copy H, formerly in the collection of Justin G. Schiller.

America. The library of William Stockhausen was to be auctioned by Parke-Bernet in New York, and so Maurice and I went to the preview. I could see it was love at first sight. Though the book was expected to fetch $4,000–$8,000, Maurice had to have it. I agreed to represent him at the salesroom, and we ultimately bought it a bit above double the top estimate. Ultimately Maurice's collection of Melvilles became one of the best in private hands, enhanced by the Bradley Martin sale at Sotheby's in 1990. His last serious purchase from us was in 2011, when Melville's personal laptop writing desk came onto the market. He acquired it at a bargain price since Melville's ownership had been limited to the last decade of his life. Nevertheless, it is a treasure that Maurice fully appreciated.

Music was much a part of Maurice's life, and there was no one to whom he felt closer than Mozart. In November 1978 an original handwritten letter from Wolfgang Amadeus Mozart to his father (dated April 4, 1787) came up for auction. It was Wolfgang's last known letter to Leopold, in which he contemplated death. We knew the competition would be very strong, especially from Europe, but at virtually any cost Maurice wanted it. He had already begun working on sets and costumes for *The Magic Flute* at Houston Grand Opera, and this appearance at auction was a validation for him. On

the day of the sale we paid what was then a record price of $47,000, but the price could have gone higher; I met the underbidder at the cashier's window moments after the sale ended, and he was extremely distressed to discover that there was no extra 10 percent buyer's premium added on to the hammer price that Sotheby's had already begun charging in London. He and his client had calculated that extra amount in the final total he bid. Lucky for Maurice.

In 1983 my antiquarian rare books shop in New York acquired a four-page autographed letter by Wilhelm Grimm, closely written on 134 lines and dated 1816. It opens with "Dear Mili," and continues to unfold with the familiar "Once upon a time . . . " This unpublished fairy tale, preserved within a letter to a little girl, tells the story of a good mother who sends her daughter into the woods to escape a threatening war, and there she is protected by her guardian angel. My partner and I brought this manuscript to Maurice's attention, which led to his remarkable 1988 picture book *Dear Mili*. Once Maurice agreed to illustrate the text, and Roger Straus broke the story at the Frankfurt Book Fair, we were giving interviews both on radio and television about this recent discovery. In the end, *Dear Mili* stands alone as a mix of German Romanticism, which echoes the plight of childhood, and hope. The color tones used in Sendak's eighteen double-page spreads are reminiscent of paintings by Philipp Otto Runge and Caspar David Friedrich. Although no soldiers are visible, it is the transformation of nature that sets the mood for each segment of this tale. Maurice's artistic genius breathed life into *Mili*, and I am pleased to have contributed to initiating this creativity.

And then there is William Blake. The Bodley Head Christmas book for 1967 comprised a selection of seven poems from William Blake's *Songs of Innocence*, each with an exquisite line drawing by Maurice Sendak, printed in an edition of 275 copies with none for sale. The circumstances regarding the production of this rare booklet are well known, but finding a copy during the 1970s was virtually impossible. There were only enough copies created at the time for holiday presentation by John Ryder to authors, artists, and other friends of the press. Everyone who owned a copy obviously wanted to keep it, and I only acquired one through the generosity of Maurice's British editor Judy Taylor who, in 1980, married the writer and historian Richard Hough, so their joint library brought two copies together. Judy kindly

Liebe Mili, du bist doch schon draußen gewesen im Feld oder auf der grünen Wiese, wo so ein reines Bächlein fließt und hast eine Blume hinein geworfen, eine blaue oder eine rothe oder eine schneeweiße, die ist fortgeschwommen und du hast ihr nachgesehen, so weit du konntest. Siehst du, sie ist still fortgegangen mit den kleinen Wellen, immer weiter den ganzen Tag und auch die Nacht, wo ihr der Mond oder die kleinen Sterne geleuchtet haben; viel Licht brauchte sie nicht, sie wußte doch ihren Weg und kam nicht ab. Und als sie so drei Tage über Nacht und Tag fortgegangen war, da ist ihr auf einem andern Bach eine Blume entgegen gekommen, die hatte ein anderes Kind, wie du eins bist, aber weit, weit von dir, zu gleicher Zeit in sein Bächlein geworfen und die zwei Blumen haben sich geküßt und haben ihren Weg zusammen fortgesetzt und sind bei einander geblieben, bis sie zusammen untergegangen sind. Oder du hast auch schon gesehen, wie Abends ein Vöglein ist über den Berg fortgeflogen, du hast wohl gedacht, es wollte sich schlafen legen; nein, ein anderes Vöglein ist da über'n andern Berg zu ihm gezogen, und wie alles auf der Erde schon dunkel war, sind die beiden oben in dem letzten Sonnenstrahl zusammen gekommen und das Licht hat auf ihre glänzende Schön geschienen und sie haben darin auf und ab gezielt und einander viel gesagt, was wir unten nicht hören konnten. Siehst du, so kommen die Bächlein, die Blumen, die Vöglein und Lichter wohl zusammen, aber die Menschen kommen nicht so zusammen; große Berge, Wälder und Flüsse, viele Städte und Dörfer liegen dazwischen, stehen fest und lassen sich nicht wegrücken, und fliegen und schwimmen können die Menschen nicht. Aber das Herz des Menschen das kommt doch auch zu einem andern Herzen und kümmert sich um nichts, was dazwischen liegt und so kommt jetzt auch mein Herz zu dir und ob dich gleich meine Augen noch nicht gesehen, so hat es dich schon lieb und glaubt es säße neben dir und du sprächst: nicht wahr erzähl mir etwas. "Ja, liebe Mili, antwortet es, hör nur zu."

Es war einmal eine arme Wittwe, die wohnte in einem Dorfe ganz am Ende und hatte nichts als ein kleines Häuschen und ein Gärtchen dabei. Ihre Kinder waren ihr alle gestorben, bis auf eins, das hatte sie sehr lieb. Es war aber auch ein gutes frommes Mädchen, folgte ihr in allen Stücken und betete Abends, wenn es zu Bett ging und Morgens, wenn es aufstand. Und alles was es that, das gelang ihm und wenn es im Gärtchen etwas auf sein Ländchen pflanzte einen Veilbusch oder einen Rosmarinzweig, so ging es an und wuchs sichtbarlich. Und wenn es in die Schule kam, so wußte es immer glücklich darauf geantwortet, so daß die Mutter oft in ihrem Herzen dachte: gewiß hat mein Kind ein Schutzengelein bei sich, das es überall begleitet, wenn ich es auch nicht sehen kann. Aber Gott wollte, daß ihr glückliches Leben, das sie zusammen führten, nicht länger

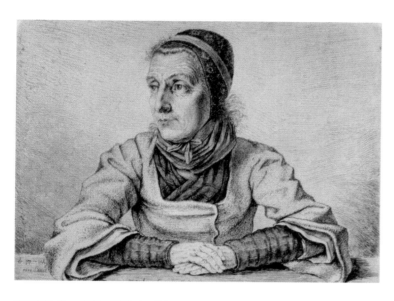

OPPOSITE: *Dear Mili* by Wilhelm Grimm, 1816. First page of the original autograph manuscript for a previously unpublished fairy tale, beginning "Liebe Mili." Its text evokes scenic landscapes and Biedermeier children, which Sendak transformed into one of his most beautiful and haunting picture books. From Justin G. Schiller Ltd., *Realms of Childhood*, 1983. Catalogue 41:113.

ABOVE: *Portrait of Dorothea Viehmann (the Märchen Frau)* by Ludwig Emil Grimm, 1814. Etching, 6¼ x 4⅞ inches. Created by the youngest of the Grimm brothers, this etching shows one of the main sources of fairy tales through all traditions.

BELOW: Maurice signing *Where the Wild Things Are* prints, Battledore Ltd. Gallery, Kingston, New York, 2001.

gave me their duplicate as a gift, whereupon Maurice personally inscribed it in a style uniquely his own (see page 20).

A love of Blake's poetry and art was another bond I shared with Maurice, partly encouraged by him, although I knew *Songs of Innocence and of Experience* from my own childhood. I was fortunate to have been befriended by the great bibliographer Sir Geoffrey Keynes, and through him, learned about a hand-colored copy of *Little Tom the Sailor* (1800), a broadside ballad commissioned by William Hayley that was being offered for sale. With the assistance of my colleague Andrew Edmunds, I was able to acquire this treasure, which would have otherwise been acquired by Sir Geoffrey, had it not been for his sudden death. The expert art framer Bernard Walsh cut down a late eighteenth-century wooden frame to create the perfect portal for this four-plate print. After enjoying it for ten years, I passed it on to Maurice's library, where it permanently hangs in his Ridgefield studio facing his drawing table.

From the Scottish library of the Earl of Crawford and Balcarres, Arthur Freeman at Bernard Quaritch allowed me the

opportunity to purchase a beautiful *Songs of Experience* (1794), since he remembered my underbidding a copy from Arthur Houghton's collection a few years earlier. Copy H comprised seventeen plates, printed in color as opposed to the light hand-tinting Blake used for *Innocence*. I treasured this book for more than a decade, and its energy still lingers inside me, but it was time to share, and so in 1994 I sold this fine series of art prints to Maurice for his personal enjoyment. And then, seven years later, I was able to arrange for Maurice to acquire the companion volume of Blake's poetry, the David Borowitz copy J of *Songs of Innocence* (1789).

These are but a few of many recollections of the crisscross between my life and Maurice's, including opening channels of correspondence between him and Peter and Iona Opie. The Opies admired many of Sendak's titles and found their own *Oxford Dictionary of Nursery Rhymes* drawn into a stack of books about to be devoured by Wild Things (see page 203). I also arranged for Maurice to do his now famous Gryphon drawing for the Osborne Collection, Toronto Public Library, as well as a logo design for the Cotsen Children's Library at Princeton University. We often spoke about organizing an exhibition of his original illustration art, which is why he allowed me to acquire such a quantity and diversity of his pictures and drawings during a period of more than forty years. Originally we thought to create a show in honor of a half-century of *Wild Things*, but with his death, the focus changed and we wanted to celebrate him and his art in a more appropriate manner. We hope you will enjoy this catalogue and only regret that Maurice is not still here to enjoy it with all of us.

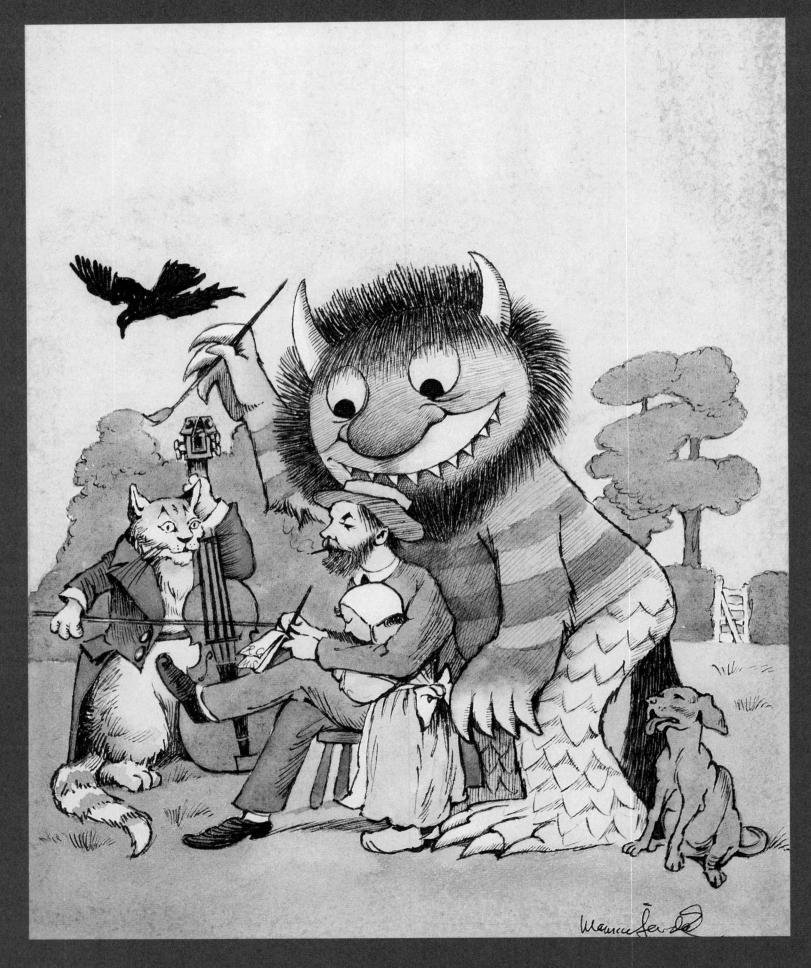

Cover design for the *Horn Book Magazine*, 1985. Pencil and watercolor, 9¼ x 6¼ inches. This scene depicts "Moishe" Wild Thing learning to draw by looking over the shoulder of Randolph Caldecott at work. It is based on an undated Caldecott self-portrait sketched in Brittany.

CHAPTER I: THE ARTIST AND HIS WORK

Fearful Symmetries: Maurice Sendak's
Picture Book Trilogy and the Making of an Artist
by Leonard S. Marcus

Maurice Sendak came of age at the best and worst of times for an artist of his particular gifts and aspirations. As a figurative artist and as a children's book illustrator at the high moment of Abstract Expressionism, Sendak had good reason to regard himself as an art-world outlier twice over—even as New York, his hometown and personal Oz, briskly swept past Paris to become the world's capital city of art.

As America's post-war art establishment deified Jackson Pollock and abstraction became the new orthodoxy, the options open to a figurative artist lay largely in the cultural shallows of advertising, cartooning, graphic design, and illustration, or the so-called "applied" arts. The latter, it turned out, had a hierarchy of their own, with children's book illustration consigned to a position at or near the bottom of the pecking order.

Yet as marginalized as "juvenile" illustration was within the cultural mainstream, the sector of publishing in which its practitioners labored had begun to show signs of unprecedented vitality. By the early 1950s the market for children's books was exploding in tandem with the historic post-war surge in the birthrate, and with the sharp rise in public school and library funding prompted by the new demographics. Established publishing houses expanded their lists and brash new competitors—most notably the publishers of Golden Books—altered the game. An idealistic new generation of editors confidently plied their trade while an equally confident corps of librarian-critics—keepers of the coveted Newbery and Caldecott Medals—asserted their growing influence as the nation's

standard-setters for children's-book excellence. For any illustrator capable of grabbing the brass ring, opportunities abounded. When his chance came, Sendak, though painfully shy and barely twenty, seized the moment to demonstrate a fistful of talent and a boundless eagerness to work.

The youngest of three children of Polish Jewish immigrant parents, Maurice Bernard Sendak was born on June 10, 1928,

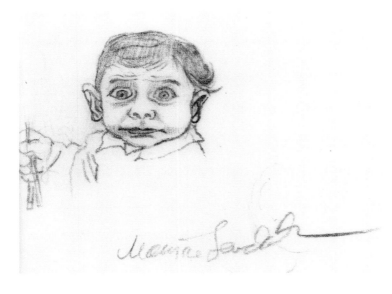

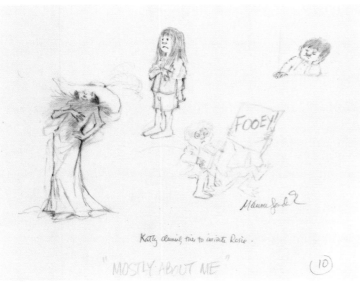

TOP: *Dolore*, 1996. Pencil, 1½ x 1½ inches. Study for the boy's head in the *Madame Butterfly* poster designed for Houston Grand Opera. The boy's wide-eyed, riveted gaze is a classic Sendak expression.

BOTTOM: *Mostly About Me*, 1974. Pencil, 5½ x 8½ inches. This study for *Really Rosie* recalls Sendak's childhood habit of positioning himself by the window of his family's Brooklyn apartment and drawing the children in the street below.

in Brooklyn, New York. His high-strung, athletic father, Philip Sendak, was a dressmaker and a natural storyteller; his mother, Sadie, a distant presence and a worrier. Young Maurice—or Moishe—grew up a frail introvert, the "baby" of the family who had nearly died of scarlet fever at the age of four. Drawing, toy making, and other forms of make-believe were the absorbing passions he shared with his adored older brother, Jack. While looking out from his family's apartment, he developed his drawing skills by making endless sketches of the children playing in the street below: drawings that recorded not only the children's body language and facial expressions but also their emotional weather. Drawing became the talent for which he was known. While he was still in his teens, a teacher who had coauthored a science primer called *Atomics for the Millions* (1947), asked him to illustrate it.

Brooklyn for Sendak was a mournful, oppressive place not unlike the Old Country that his parents had fled. Manhattan, on the other hand, was the magical mother lode of movies, art, and everything worth being and doing. Bypassing college, he headed straight for "the city" and a job as the assistant window decorator at the legendary Fifth Avenue toy emporium FAO Schwarz.

Sendak, by then, already saw himself as an artist and knew that his subject, or "obsession," was childhood: the question of how children survive in a world largely indifferent to their fate. And he knew that the picture book was the art form that presented the best opportunity to pursue that obsession. Unlike more than a few of his contemporaries, he seems not to have felt much pressure to abandon representation and visual narrative. Splattering paint was not for him.

Window-dressing was low-paying work that came with the extraordinary side benefit of providing an aspiring young artist with priceless, billboard-like public exposure at the very crossroads of New York art and publishing. Any number of new arrivals had had the same smart idea: Jasper Johns and Robert Rauschenberg showed off their talents in the windows of the deluxe women's specialty shop Bonwit Teller, Andy Warhol at the I. Miller shoe salon. In Sendak's case, employment at the store with the city's best selection of juvenile books gave him not only the chance to study the tradition of his chosen specialty, but also to have a series of life-changing encounters. There he met Leonard Weisgard, the Caldecott Medal winner who became his first professional

role model and a lifelong friend. Schwarz's book department manager, Frances Chrystie, also took a liking to him, and after paging through his sketchbooks introduced him to the director of Harper's Department of Books for Boys and Girls, Ursula Nordstrom. The next day, Nordstrom hired the earnest young man to illustrate a book. Apart from his teacher's oddball atomic energy tome, *The Wonderful Farm* (1951), by the French writer Marcel Aymé, would be Sendak's first book to be published by a major house. More importantly, it marked the start of a fateful association with the field's most audacious editor and inspired mentor.

In 1950, the year they met, Ursula Nordstrom had been on the job for ten years and was firmly established as America's most daring publisher of books for young people. A maverick by temperament, she regarded children's books as an underrated literature of largely untapped potential: an art form trapped in sentimental taboos and conventions, some of which dated from Victorian times. She cut a colorful figure as she made it her mission to catapult the literature into the modern age. If to do so meant challenging the authority of the librarians, Nordstrom was prepared to do so. In fact, she relished the prospect, as well as the chance to commiserate with her fellow comrades-in-arms—the like-minded authors and artists whose work she championed—about the uphill battle they faced. A letter to novelist Meindert DeJong was typical: "Some mediocre ladies in influential positions," Nordstrom observed, "are actually embarrassed by an unusual book and prefer the old familiar stuff which doesn't embarrass them and also doesn't give the child one slight inkling of beauty and reality." To Nordstrom's delight, young "Mr. Sendak," as she teasingly called him, was as prepared as she was to lead the charge.

The self-educated daughter of vaudevillians and a child of divorce, Nordstrom was a combustible blend of saucy wit and impassioned concern for the well-being of young people. She boasted of publishing "good books for bad children," and of having qualified for her job not—like so many of her professional peers—by having come to it with prior experience as a librarian or parent, but rather, quite simply, by being "a former child" who had not "forgotten a thing." While she cherished her associations with the established greats of the Harper list—Laura Ingalls

Wilder, E. B. White, and Margaret Wise Brown—whom she had inherited on assuming the directorship in 1940, she reserved her highest level of devotion for the artists and writers she plucked from obscurity, and whose careers she felt privileged to guide from the beginning onward.

Nordstrom recognized Sendak's arrival on the Harper list as a turning point in both their careers. Henry Higgins–like, she immediately went to work masterminding his education. In that long-ago era, when an editor in authority had the power to have a contract drawn up while an illustrator waited in her office, she gave him a steady stream of assignments aimed at challenging his skills and expanding his range as an interpretive artist. She fed Sendak manuscripts as fast as he could draw. Draw he did, illustrating two Harper books in 1952, four in 1953, and three in each of the two following years. In a letter dated November 28, 1956, the editor laid out a proposed schedule that called for the publication of two books in the spring of 1957 (Ruth Krauss's *Birthday Party* and Sendak's own *Very Far Away*); three books that fall (Meindert DeJong's *Little Hen*, Else Holmelund Minarik's *Little Bear*, and Jack Sendak's *Circus Girl*); two books in the following spring; and an astounding nine books in the fall of 1958. When Sendak's first major press profile appeared, in the September 26, 1956, issue of the *Village Voice*, it marked the publication of the twenty-fourth book he had illustrated, *The Happy Rain*, written by his brother, Jack.

Nordstrom offered her protégé a great deal besides steady employment. She lavished praise on him, gently probed and ministered to his every insecurity, introduced him to critics and others in a position to advance his career, and at every turn encouraged him to consider the House of Harper his spiritual home. On at least one occasion, she reminded him not to forget his sweater.

Nordstrom was a famously compulsive letter writer whose correspondence with Sendak, which continued even when the two of them were both in town, became an important part of his education. Typical of the letters was one intended to cheer him up in response to the litany he had sent her of his supposed inadequacies as an artist: "You referred," Nordstrom gamely observed, "to your 'atom's worth of talent.' You may not be Tolstoy, but Tolstoy wasn't Sendak, either. You have a vast and beautiful genius. You wrote, 'It would be wonderful to want to believe in

God. The aimlessness of living is too insane.' That is the creative artist—the penalty of the creative artist—wanting to make order out of chaos. The rest of us plain people just accept disorder (if we even recognize it) and get a bang out of our five beautiful senses, if we're lucky."

Nordstrom planned early on to pair Sendak with Margaret Wise Brown, the author of *Goodnight Moon* and a poet whose protean, playful imagination was sure to push Sendak into creative overdrive. Brown's unexpected death while vacationing in France, in November of 1952, at the age of 42, brought a sudden end to this glorious prospect even before the two of them had had the chance to meet. But Nordstrom had already teamed up Sendak with another writer for young children—a near match for Brown in originality and daring—named Ruth Krauss, and it would be his first collaboration with her, *A Hole Is to Dig: A First Book of First Definitions*, that established him as a talent to reckon with.

Krauss and her husband, the cartoonist and author/illustrator Crockett Johnson, opened their home in the coastal town of Rowayton, Connecticut, to Sendak as a weekend getaway, and became, in effect, his backup mentors. In Connecticut, Sendak found a new circle of friends, including a couple whose young son dressed for bed in fanciful leopard pajamas, complete with big-cat ears and tail—an image that the creator of Max would put to excellent use. During the summer of 1963, as Sendak, with the clock ticking, struggled to finalize the text of *Where the Wild Things Are*, Johnson himself contributed the single word that came to stand for the sense of exultation and abandon experienced by Max in the dream-space of Wild Things island. *Rumpus*, he said: "Let the wild rumpus start."

The real rumpus had begun ten years earlier, with *A Hole Is to Dig*. The insistent weight of the line in Sendak's black-ink drawings, and the quirky proportions of that book's figure drawings, combined to give his small subjects an extraordinary appearance of groundedness—a concentration both of emotional and physical heft that pointedly counterbalanced their vulnerability. Here, expressed for the first time, was the theme that was to remain the keynote of Sendak's vision of childhood: his ultimate faith in the resilience of children. The stumpy, dark-haired unattractiveness of the children in the drawings signaled a radical departure from the sun-splashed idealizations of picture-book convention: the carefree world of childhood as depicted not only by illustrators at the commercial end of the spectrum but also by Caldecott Medal winners from the d'Aulaires and Petershams to Robert McCloskey and Nicolas Mordvinoff.

More surprising still was the Sendak children's rambunctious, self-absorbed, generally unruly behavior, and the fact that the design and layout of the book itself—the freewheeling placement of figures on the page—conveyed something of the same anarchic spirit. In accomplishing all this, Sendak had succeeded in bringing the substance and style of the book into perfect alignment, just as Krauss and Johnson had done in *The Carrot Seed*. In the years to come, his overriding goal would be to achieve the same degree of aesthetic unity in a picture book that he both wrote and illustrated.

Sendak approached his early illustration work with a nearly anthropological concern for accuracy of observation. He had visited the progressive Bank Street School, where Krauss, like Margaret Wise Brown before her, had studied, and where "direct observation"—the empirical study of toddlers and preschoolers—was considered invaluable preparation for the creation of picture books that effectively spoke to young children on their own terms. Krauss had not so much written *A Hole Is to Dig* as collected—on 3 x 5–inch index cards—the definitions offered to her, in response to her prompts, by preschool children she surveyed with the book in mind. (Krauss then gave her collaborator his pick of the index-card definitions to illustrate.) While Sendak generally preferred to draw from memory rather than from a model, he built up his memory bank in part by taking copious pictorial "notes" of his own. As he told a *Village Voice* reporter in 1956, he carried a sketchbook with him "almost constantly."

To Sendak, however, observational realism was never more than the half of art. Doris Orgel, another Harper collaborator (and the mother, as it happened, of that little boy in the leopard pajamas), recalled him saying once: "Every book has to have a dimension of the fantastic." Long before turning his hand to designing for the stage, Sendak treated the page-openings of a picture book as a kind of proscenium frame, a theatrical space for the unfolding of stories in which the mundane and the magical might freely mix and merge. Treating the picture book as a kind of tabletop theater was not just a metaphorical exercise or clever device; rather, it both suited and

expressed the essence of the young child's natural impulse to improvisation and self-reinvention. He knew this to be the case from the homemade stage productions that he and his brother and sister had cobbled together for relatives, and from having watched in googly-eyed amazement the street shows of the flamboyant young Brooklyn neighbor he immortalized in *The Sign on Rosie's Door* and its musical adaptation, *Really Rosie*. It was in *A Hole Is to Dig* that one first caught sight of this concern for the child acting as well as acting out. In his 1964 essay "The Shape of Music," Sendak wrote: "The spontaneous breaking into song and dance seems so natural and instinctive a part of childhood. It is perhaps the medium through which children best express the inexpressible; fantasy and feeling lie deeper than words."[1]

Throughout what critic and biographer Selma G. Lanes called his "long apprenticeship" of the 1950s, Sendak displayed a restless, chameleon-like talent and need for self-reinvention. Each new book, it seemed, arrived under the flag of a different presiding spirit, the artist or artists whom Sendak had chosen to study and, as he had sly fun acknowledging, to steal from: George Cruikshank and Gustave Doré for *The Wonderful Farm* (1951); William Blake and Marc Chagall for *Charlotte and the White Horse* (1955); Winslow Homer for *Mr. Rabbit and the Lovely Present* (1962). The significance of style as the defining characteristic of an artist's work was to remain a matter of contention for him. In a 1971 public interview with Virginia Haviland at the Library of Congress, he spoke about style as a trap, and about his preference for the freedom to "walk in and out of all kinds of books" by drawing, as the occasion demanded, in "a fine style, a fat style, a fairly slim style, and an extremely stout style."[2] A decade later, in referring to *Outside Over There* as the third volume of a "trilogy," the clear implication, when one considered that the three books bore scarcely any stylistic resemblance to one another, was that the visual manner and medium of a book mattered far less than the emotional truth it had to tell. To Sendak, illustration was the expression of a style, but art was the expression of a vision.

Sendak, meanwhile, sought out kindred spirits wherever he could find them. Among the practitioners of the Western illustration tradition were William Blake, Edward Lear, Heinrich Hoffmann, Sir John Tenniel, Richard Dadd, Randolph Caldecott, Beatrix Potter, Wilhelm Busch, Maurice Boutet de Monvel, Lothar

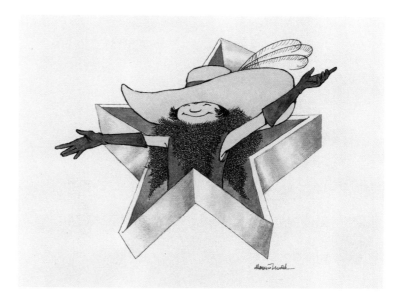

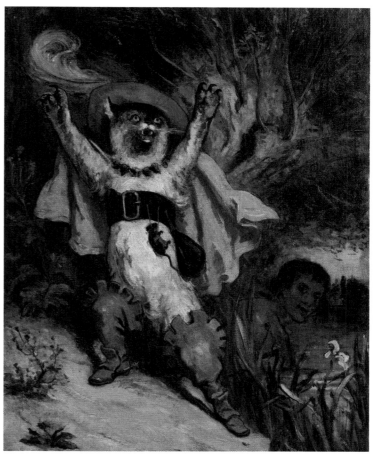

TOP: *Rosie as a Star*, 1976. Pen-and-ink line and watercolor, 5¼ x 6⅜ inches. Sendak's young heroine, whom the artist modeled after a Brooklyn neighbor, shares a flair for the theatrical with Puss in Boots.

BOTTOM: *Puss in Boots* by Gustave Doré, ca. 1867. Oil on canvas, 18¼ x 30 inches. This painting is based on a popular woodcut the artist created in 1862 for his well-known collection of Perrault's fairy tales. Private collection.

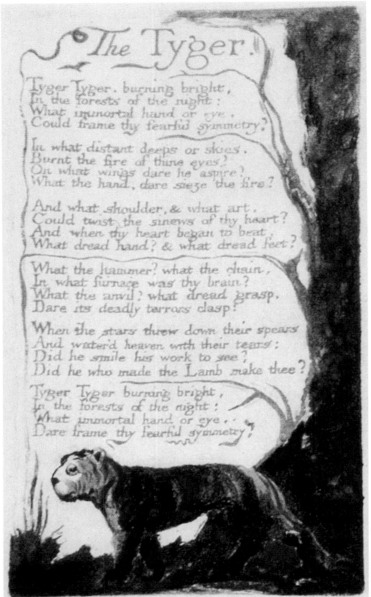

LEFT: *Songs of Innocence and of Experience:* "The Tyger" by William Blake, 1794. Color-printed copperplate relief etching, touched up by hand, 3¹/₁₆ x 2³/₈ inches. From copy H, formerly from the collection of Justin G. Schiller.

ABOVE: *Songs of Innocence*, 1980. Pen-and-ink line, 3¹/₄ x 2³/₈ inches. Sendak added this illustration inside Bodley Head's 1967 keepsake.

Meggendorfer, William Nicholson, Maud and Miska Petersham, Jean de Brunhoff, and Edward Ardizzone. Of this group, Caldecott, the late nineteenth-century English innovator who brought text and image into a kinetic new relationship, thereby inventing the modern picture book, loomed as perhaps the greatest inspiration and challenge to Sendak's own sense of mastery of the genre. Sendak's abandoned dummy of 1955, titled *Where the Wild Horses Are*, had been a fledging attempt at crafting a picture book that was part Caldecott pastiche, part loose-limbed fantasia in the dynamic spirit of the creator of *The Three Jovial Huntsmen*. When he returned to

the project in the first weeks of 1963, he did so not only with the experience of having illustrated a total of well over fifty books, but also of having undergone psychoanalysis, and of thereby having reflected deeply on the "child within" as well as the children of his observation. Nordstrom's letter to him of February 19, 1963, following a conversation in her office, shows just how much remained to be determined about the book he so urgently wished to create: "You were speaking," she reminded him, "of something, or someone, or some little animal, getting out of some enclosure—and I think that might grow and develop into a basic and beautiful

story."[3] That was it! *Where the Wild Things Are* came together quickly during the spring and summer of 1963, with Nordstrom anxiously stretching Harper's production schedule to the limit in the hope of having the book out in time for Caldecott Medal consideration for that calendar year.

Having decided that he did not draw horses well enough, Sendak realized that if he called his characters "things" he could make them look any way he wished. It was one of many inspired choices. Another such decision furthered his pictorial exploration of the duality of realism versus the theater of fantasy. He drew the palm trees and other background details of Wild Things island as stage flats, or bits of artifice intended to suggest without being mistaken for the real thing. By this device, Sendak thrust his more realistically drawn, fully rendered cast of characters all the closer to the reader—the better for us to lock eyes and form an immediate emotional connection with Max and his shaggy-haired alter egos.

The overall scheme of the book's page layouts was perhaps the most inspired choice of all, with the illustrations of the opening sequence expanding in stepwise fashion, each one pressing the picture frame out a bit farther toward the margins before finally pushing out words and white space altogether. Then, following the purely visual and aptly named *rumpus*, the illustrations of the third and final sequence gradually receded from the margins, and toward the center of the page, as Max found his way home. What Sendak had done was to equate language (the narrator's words) with the experience of conscious thought, and pictoral art with the unnamable, *felt* experience of our unconscious fantasies and dreams. No artist before him had put the text and images of a picture book in so compelling a symbolic relationship, one that both revealed and reflected the conscious and unconscious lives of its hero. With *Where the Wild Things Are*, the picture book had at long last entered the Freudian age, and Sendak had achieved the complete book he had longed to do.

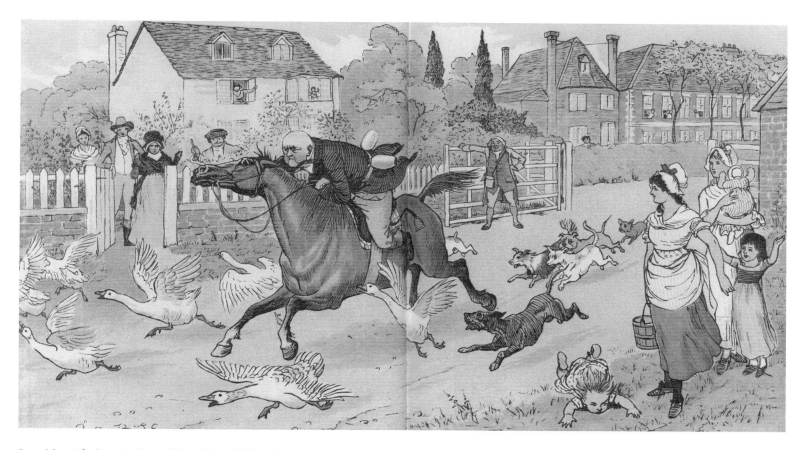

Spread from *The Diverting History of John Gilpin* by William Cowper, illustrated by Randolph Caldecott, 1878. Wood engraving, 8⅛ x 14¾ inches (as published). The footloose "rumpus" sequence of *Where the Wild Things Are* owes much to the verve of Caldecott's action scenes. Courtesy Library of Congress.

"*Mickey fell through the dark, out of his clothes*," 1970. Pencil and pen-and-ink line, 6⅞ x 7¼ inches. This study for *In the Night Kitchen* shows Mickey, like Winsor McCay's Little Nemo (see illustration on opposite page), tumbling toward Dreamland.

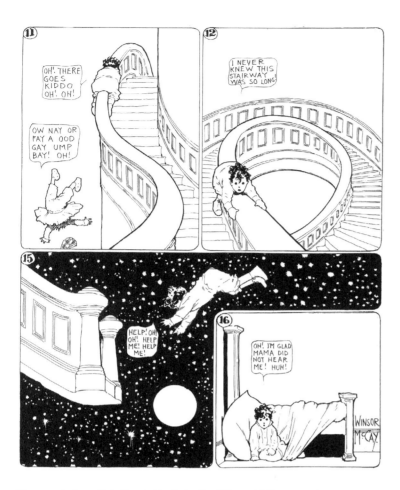

Four panels from *Little Nemo in Slumberland* by Winsor McCay, ca. 1908. Comic strip.

The idiosyncratic title was a telltale clue to what Sendak had aimed to accomplish, and it was not by chance that the titles of each subsequent book of his trilogy conformed to the same pattern. "Where the Wild Things Are," "In the Night Kitchen," and "Outside Over There" all conjure up suggestions of a magical place and a way to get there. In doing so, the titles promise readers the fulfillment of what Theseus, in the final act of Shakespeare's *A Midsummer Night's Dream*, declares to be the essential role of art—to give form to chaos, and a safe space within which to confront one's demons:

> And as imagination bodies forth
> The forms of things unknown, the poet's pen
> Turns them into shapes, and gives to airy nothing
> A local habitation and a name.

One of Sendak's great strengths lay in his ability to layer a story with multiple meanings—allusions ranging from history to high and low culture, to his own private life and back—without disrupting the playful music of the strong, clear, spine-like narrative. *Where the Wild Things Are* reverberates with powerful echoes of the Grimms' "Hansel and Gretel," with its nightmarish journey into the woods and back bookending a life-and-death dance that leads to a redemptive homecoming. Clad in his wolf suit, Max is simultaneously Everychild getting ready for bed *and* a wild beast with truly menacing claws *and* a lyrical, moonlit figure dressed in what might also be read as traditional white Pierrot regalia. Likewise, Mickey falling "out of his clothes" and "into the light of the Night Kitchen" is not *just* a deeply curious, insomniac child but also Alice falling down the Rabbit Hole *and* Peter Rabbit "leaving his jacket behind him" as he ventures ever deeper into forbidden territory and his own untamed self—*and* Little Nemo dropping off into Slumberland. The mantle of an entire literary tradition of healthy childhood curiosity and rebellion seems to wrap itself around Mickey's small shoulders, even as he emerges stark naked from the batter.

A rare break from the old insistence that illustration art had no business on a museum's walls came with a 1966 Metropolitan Museum show featuring a cache of original drawings by the turn-of-the-century comics master Winsor McCay, creator of the *Little Nemo* cartoon strip. The fine art world had only recently opened its doors—*some* doors, at any rate—to the Pop Art mash-ups of Andy Warhol, Roy Lichtenstein, and their fellow merry pranksters. The McCay exhibition suggested that the mass-market imagery that had inspired Pop Art's rising stars might be overdue for a closer look by everyone.

Sendak too had been revisiting the ephemera of his childhood, starting with all things Mickey Mouse, the scrappy, impudent Disney hero of animated cartoons and Big Little Book compilations. It was all, he explained to a writer for the *New York Times* in 1970, part of his continuing education as an artist: "Over the years," he said, "I've been feeding myself artistic, culture things—Blake, the English illustrators, Melville—but those crappy toys and those tinsel movies are much more directly involved in my life than certainly William Blake ever was, though Blake is really important, my cornerstone. [But] the cheap crap I had to grow up with is what made me. Those movies and Mickey Mouse. And I love it! I love it! I love it!"[4]

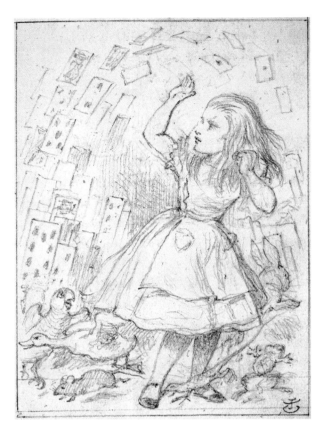

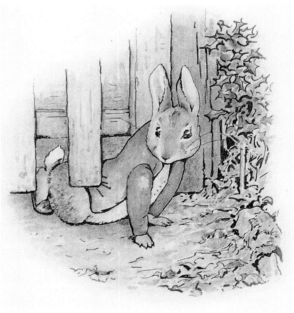

TOP: "*You're nothing but a pack of cards!*" by John Tenniel for *Alice's Adventures in Wonderland* by Lewis Carroll, 1865. Pencil, 4½ x 3¼ inches. Sendak heroes such as Max and Mickey emulate Alice and Peter Rabbit by seeking out adventure in forbidden territory. Formerly from the collection of Justin G. Schiller.

BOTTOM: "*And squeezed under the gate!*" from *The Tale of Peter Rabbit* by Beatrix Potter, 1902. Photo mechanical illustration, 2⅝ x 2½ inches.

After seeing the McCay show, Sendak dispatched Ursula Nordstrom to do so as well. The latter's enthusiastic response stood them both in good stead when, three years later, he composed the first draft of the story that was to become, in part, his tribute to McCay, advertising jingles, classic film comedies, and other bits and scraps from the irreverent underbelly of childhood culture: *In the Night Kitchen.*

For decades, librarians and educators had heaped scorn and ridicule upon the "funny papers" and their variant magazine and novelty-book formats. Even post-Pop, a picture book meant to evoke the look and spirit of the supposedly sub-literary and sensationalistic art of the comics was bound to strike some juvenile book world critics as a provocation. Sendak, of course, was perfectly well aware of all this. And lest anyone simply accept his impeccably drawn and elaborately choreographed book, with its funky Claes Oldenburg soft-sculpture airplane and Andy Warhol–esque Oliver Hardy multiples, as his own high-flying foray into the realm of Pop Art, Sendak planted naked Mickey at the center of everything, a jaw-dropping departure from picture-book convention that was guaranteed to blow up in controversy. To her great credit, Ursula Nordstrom stood unwaveringly behind his decision to do so, not for its shock value but because the hero of a story about forbidden pleasures and the awakening sense of self needed to be naked.

On publication, the book met with the predictable challenges, but also with important validation from the American Library Association in the form of a Caldecott Honor (runner-up to the medal). In the decades that followed, the picture-book literature would swell with the ranks of Wild Things look-alike characters, but latter-day Mickeys would be few and far between. If Sendak had touched a particularly touchy cultural nerve, he had also inserted the picture book into the larger art world's reconsideration of the relationship between "high" and "low" culture. Sendak's Mickey, in a certain sense, pointed the way to Art Spiegelman's *Maus*, to the rise of the mongrel art form of the graphic novel in which the once-fixed categories of "high," "low," "adult," and "child-appropriate" art would all turn richly and provocatively fluid.

The third book in the trilogy appeared in 1981—eleven years after *In the Night Kitchen*—and was officially the last title published under the "Ursula Nordstrom Books" imprint that served

Modes de Paris: Costumes d'enfans, Paris, ca. 1810. Hand-colored engraving, 5¼ x 4 inches. Beidermeier child with doll. Designs similar to this one were inspirational in creating the illustrations for *Outside Over There*.

The Rabbit Hutch by Richard Dadd, 1861. Pencil and watercolor, 7½ x 5⅛ inches. Sendak studied the English visionary artist Dadd and his scenes of childhood while working on his own illustrations for *Outside Over There*.

as Nordstrom's lifeline to Harper in the years following her 1973 retirement as department director. Nordstrom lived in Connecticut and worked from home with a small core group of the artists and writers she had published over the years. Sendak was, of course, at the top of that most select of publisher's lists. But over the last decade he had grown immeasurably in self-assurance and technical prowess, and it would appear that Nordstrom had, in fact, contributed little to the making of *Outside Over There* besides her invaluable moral support. When the finished art was ready for delivery to Harper, Sendak stopped by Nordstrom's home to show it to her. Her last editorial comment to him was, simply, to weep with joy.

It had been during the long run-up to the publication of *Outside Over There* that Sendak first spoke publicly about his "trilogy," though he later claimed to have already known when *Where the Wild Things Are* was just out that "it was such a good idea that I would have to play variations on it."[5] Notwithstanding the awarding of the 1970 international Hans Christian Andersen Medal, and the critical success of his Grimms' fairy tale collection, *The Juniper Tree* (1973), and the professional opening up to him of the opera world, Sendak continued to feel culturally ghettoized. In 1977, in a public conversation with Houghton Mifflin's Walter Lorraine, he complained about the dearth of serious appreciation of the picture book as an art form. "Too often," he said, "children's books are

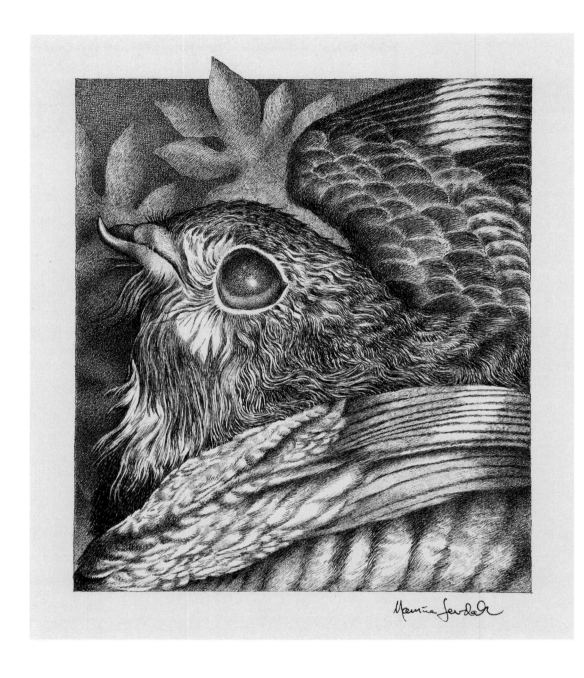

Book jacket design for *Beyond the Bedroom Wall* by Larry Woiwode, 1975. Fine pen-and-ink line, 6¹⁄₈ x 5¹⁄₁₆ inches. This illustration recalls the psychological intensity of the artist's *Juniper Tree* illustrations published two years earlier.

1932 Lindbergh kidnapping to his lifelong trust in the power of music (as represented in the story by Ida's wonder horn) to unlock the imagination. Here again were the big-footed children who, like Max and Mickey before them (and, afterward, Mili as well), had "a rootedness," as Sendak told an interviewer, that left them less vulnerable to the cruelty and indifference of the people around them.[7] Here again was the storm-tossed moonlit world, this time as channeled via Blake and the German Romantic interpreters of transcendent childhood, Caspar David Friedrich and Philipp Otto Runge. The saucer eyes that gazed and stared straight out from image after image in Sendak's earlier books—compelling emotional engagement, working their "magic trick" on Wild Things and the reader alike—were here transformed into the sunflowers that peered with ever more urgency from "outside" into a terrifying scene, where absent parents had left imperiled children to their own devices.

Sendak first considered illustrating the harrowing tale with drawings rendered in a shaded ink outline, with the addition of watercolor. He abandoned this plan, however, on discovering a four-hair brush that allowed him to work directly in watercolor with jeweler-like precision. For all the baroque complexity of the compositions, the finished art radiates dramatic immediacy. The

judged" not as art at all, but rather "by whether they conform to well-meaning but misguided rules about what children ought or ought not to be reading."[6] With *Outside Over There*, he seems to have determined to create a picture book of such grandeur and virtuosity that it simply could not be ignored as art.

The incantatory narrative, which seemed a bit mannered when read on the page but not when heard, rested on the briefest of the *Juniper Tree* tales, "The Goblins." But Sendak's new book also drew on the full complement of his previously acknowledged obsessions, from the childhood fears prompted by the sensational

sheer power of the images led to the ironic result that while few critics doubted that Sendak's latest book was an authentic work of art, some questioned whether it could possibly be a book for children. In this regard, the skeptics were, at best, only half right. In the picture-book canon, *Outside Over There* continues to stand apart as a uniquely rewarding and demanding work for readers at whatever age they discover it for themselves.

Sendak lived to see not only his own work but also that of colleagues of the next two generations exhibited, collected, and written about knowledgeably. He had instructed a few of these artists himself during teaching stints at Yale College and the Parsons School of Design, and had informally mentored a great many others. With the advent in the United States and elsewhere of museums devoted to children's book art, and with the newfound interest of traditional museums and art schools in illustration, Sendak might well have concluded that the battle over just what it was that he and others like him had been doing all those years had at last been won.

Yet while these wished-for developments unfolded, the publishing industry, which had once provided him with such a nurturing home base, had been busy transforming itself, turning so relentlessly market-driven as to have become largely hostile territory for an editor of Ursula Nordstrom's maverick temperament and perhaps even for an artist like himself.

It was the best and worst of times all over again. Sendak titled his last major public statement, the 2003 May Hill Arbuthnot Lecture, delivered at MIT, "Descent into Limbo," intending, in part, a mordant comment on the current state of publishing. The title derived from that of a small, subtly staged panel by the Italian Renaissance master Andrea Mantegna, depicting the liberation of the prophets by Jesus from a maw-like limbo cave, as Adam and Eve, among others, looked on. Sendak had adapted the scene as the template for the cover image of *We Are All in the Dumps with Jack and Guy* (1993), reimagining the cave mouth as the yawning mouth of the man in the moon, a protective spirit but one that, like the Wild Things of long ago, was not without his hint of menace.

In the Mantegna image, he had also found the "perfect metaphor" for a personal limbo he had lived with all this life. Here at a glance, Sendak remarked in his valedictory lecture, was "the incoherence of the creative act, the artist's perilous dive into the interior of the self."

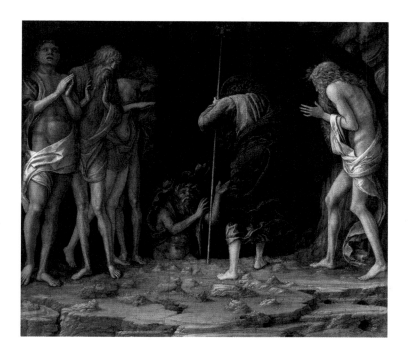

Christ's Descent into Limbo by Andrea Mantegna, ca. 1470–75. Oil on panel, 15 x 16 inches. Painting on a scale roughly akin to that of a picture book, Mantegna infused this scene with high drama and a monumental dimension. Private Collection.

Sendak's diving career lasted for more than sixty years. The result was an unparalleled body of truth-bearing, darkly comic art for the youngest among us, but not only for them.

NOTES

1. Maurice Sendak, *Caldecott & Co.: Notes on Books and Pictures* (New York: Farrar Straus & Giroux, 1989), 4.

2. John Cech, *Angels and Wild Things: The Archetypal Poetics of Maurice Sendak* (University Park: Penn State University Press, 1996), 184.

3. Leonard S. Marcus, *Dear Genius: The Letters of Ursula Nordstrom* (New York: HarperCollins, 1998), 158.

4. Cech, 189.

5. Leonard S. Marcus, *Show Me a Story! Why Picture Books Matter* (Somerville: Candlewick Press, 2012), 197.

6. Sendak, 191.

7. Marcus, *Show Me a Story!*, 201.

About Alligators from
No Fighting, No Biting!,
1958. Pen-and-ink line,
5½ x 5⅜ inches.

CHAPTER II: INFLUENCES ON BOOK ILLUSTRATION

Some Influences on the Work of Maurice Sendak
by Judy Taylor

I first encountered Maurice Sendak's drawings more than sixty years ago, in a collection of stories for children by Marcel Aymé called *The Wonderful Farm*, and I believe that it was the first book he illustrated for the New York publisher Harper & Brothers. At the time, I had just joined the London publishing house The Bodley Head (in a very junior position), and the firm was about to publish the British edition of *The Wonderful Farm*. However, they had chosen to replace the Sendak illustrations with a set of new drawings by the wife of the managing director!

As the years went by, and as I became increasingly involved with The Bodley Head children's list, I witnessed Maurice Sendak's growing body of outstanding illustration work for US publishing houses—mainly for Harper. In 1956, overwhelmed and deeply moved by his wonderful drawings for Meindert DeJong's *The House of Sixty Fathers*, I resolved that one day The Bodley Head would publish a book illustrated by him.

On my first visit as the children's books editor to New York in the early 1960s, I was lucky enough to meet Mr. Sendak, and we became friends. However, it would be some years before I was able to publish a book that had his illustrations. My chance came in 1966, when a copy of *Where the Wild Things Are* arrived on my desk from the British literary agent who was acting for Harper & Row. The accompanying letter informed me that this extraordinary book had been seen and rejected by seven other British publishers—and that after eight unsuccessful submissions it would

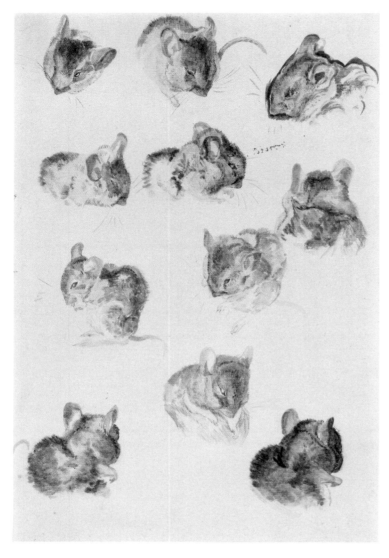

Studies of Mice by Beatrix Potter, 1890. Pencil and watercolor, 9¼ x 6 inches. Maurice Sendak and Judy Taylor shared a deep affection for Beatrix Potter's animal studies, such as this observation in watercolor of a single mouse drawn from different angles.

In the years that followed, when Maurice and I met, either in London or Connecticut, he would tell me what had been in his mind while he had been working on a particular book, and I made notes of his comments. Looking at those notes now and re-reading them in retrospect, some of them come as quite a surprise, even to me.

The major influences on *Where the Wild Things Are*, however, presented little surprise, for they were the 1933 film *King Kong* (which had scared him as a five-year-old boy); William Nicholson's 1929 picture book *The Pirate Twins*; and the Sealyham terrier who was, of course, his beloved Jennie. What was a surprise, however, was that I had forgotten that the jacket for the book was a homage to George MacDonald's *Phantastes: A Faerie Romance for Men and Women*, and that the transformation scene— "That very night in Max's room a forest grew"—had also been influenced by MacDonald's dream sequence in *Phantastes*.

The most detailed of all my notes are on *Higglety Pigglety Pop!* and *In the Night Kitchen*. It was immediately plain that the heroine of *Higglety* is Jennie, but the framed portrait hanging on the wall in the frontispiece for the book had always puzzled me. All became clear when Maurice explained that in 1953, when he and his partner, Gene Glynn, first acquired the three-month-old Jennie, her name on her papers was "Mona Lisa"—and that her father's name was "Pre-Raphael or Praffy."

My note for the picture on page 10 concerns the milk wagon and reveals that it was Maurice's favorite toy, given to him by his Aunt Esther when he was three or four. "I adored it and gave it up only when it was a total ruin . . . '*Ketzle*', on the side of the wagon, is Yiddish for pussycat or kitten—my father's name for me when I was a child, thus the 'cat milkman.'"

The picture on page 14 of *Higglety* is "a vision of my hill that I often imagined as a child to put myself to sleep. The style is strangely influenced by Victorian illustrators, especially George Pinwell and Myles Birket Foster." And again George MacDonald's influence is noted for the picture on page 38, "particularly his use of the ash tree," and the double spread following page 49 is "in homage to Samuel Palmer," one of Maurice's favorite artists, who had a strong, and repeated, influence on his work.

The saddest part of the *Higglety* story is that the final proofs of the book had to be sent to England for Maurice's approval while he was still in the hospital—and that Jennie died only a few

have to be returned to the US as "un-saleable." I loved the *Wild Things* immediately, but it would be some time (and a certain amount of serious discussion would have to take place) before I was able to convince my colleagues that the book would not terrify every child in the British Commonwealth.

The story of the eventual acceptance and publication of the book by The Bodley Head has been recounted elsewhere, as has been the cementing of my friendship with Maurice—for I happened to be nearby when he suffered his first heart attack in 1967, during the campaign in England to launch The Bodley Head's edition of *Where the Wild Things Are*.

weeks after he returned home. "I miss her so badly. She was so sweet—so funny, and she had the prettiest face a puppy ever had."

Following Maurice's safe return to the US in 1967, he was invited to choose the subject and to design the next Bodley Head annual booklet, a publication limited to an edition of 275 copies that were sent to friends of the company at Christmas. In accepting the invitation, Maurice stipulated that his work would be a gift in gratitude for the care he had received while he was in the UK. For the booklet he chose seven of William Blake's poems from *Songs of Innocence*, and for each one, he drew a small, simulated woodblock picture in the style of his beloved Samuel Palmer. His roughs were drawn in pencil on tracing paper, and his final drawings were printed in a deep sepia.

The first book on which Maurice worked after his full recovery was *A Kiss for Little Bear*, the fifth (and last) in that delightful series. So shocked was she by the news of Sendak's illness, Else Holmelund Minarik had been spurred on to finish the new story in case he did not survive, and it was the only work that Sendak did during that first year after his return. Into the illustration for page 28, where the skunks decide to get married, Sendak drew the miner's lamp that had been given to him by his favorite nurse in the Gateshead Queen Elizabeth Hospital. The lamp had belonged to her late father.

My notes for *In the Night Kitchen*, which was published by Harper & Row in 1970, are by far the most extensive, and there is a comment for nearly every spread. It is hardly surprising that the artistic influence for the book was Mickey Mouse, one of Maurice's obsessions, particularly the comic books published between 1928 and 1932, "with the graphic whizz-bang quality of the cartoons . . . as beautiful as anything by Winsor McCay," and throughout the book's preparation, he always referred to *Night Kitchen* as "the Mickey book" or simply "Mickey." Although the Mickey Mouse comics at that time were in black-and-white, Maurice knew that his book must have the color of the later cartoons.

The dedication, "To Sadie and Philip," was Maurice's farewell to his mother, who had just died, and for his father, who was in the process of dying. "Mickey becomes smaller and is calling them. I, age forty, was fast becoming an orphan."

Every spread in *Night Kitchen* has traceable pictorial and written references to friends, to toys, and to products that were part of

Printed book cover of *Songs of Innocence*, 1967. This Bodley Head Christmas keepsake was inspired by Sendak's friendship with his British publisher and is among the rarest of Maurice's books, with only 275 copies printed. Herein he illustrated seven poems from William Blake's 1789 *Songs of Innocence*.

Maurice's childhood, as well as to later events in his life, and to his "heroes." The latter included Winsor McCay, Stan Laurel and Oliver Hardy (particularly Oliver: "Hardy is a passion of mine"), Buster Keaton, Busby Berkeley, The Jollie Ollies from the 1939 World's Fair and, of course, Jennie. (Even I have a fancy green jar to myself on the fifth spread. And on that same spread, across the gutter of the book, is the address where Maurice lived in Brooklyn as a child—"but certainly not in the gutter!" was his comment.)

He explained that "the aeroplane is made of dough because I cannot draw a proper aeroplane," and that Mickey is turning the propeller "just like in the movies." The word "Champion" on the flag on the eleventh spread comes from the north of England and means "very good"; and "Q. E. Gateshead" on the building on the last page is his final reminder of "his heart attack hospital."

Maurice Sendak is already sorely missed, but his work will remain for both children and adults to enjoy forever.

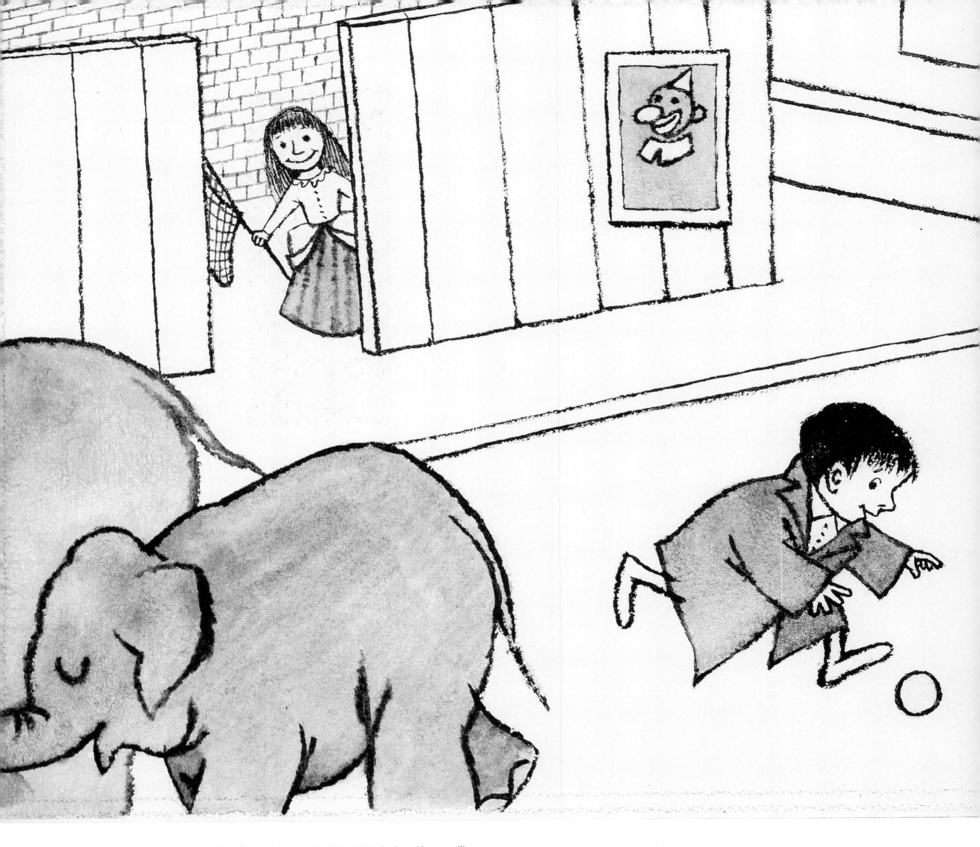

Elephants, 1958. Pen-and-ink line and gray wash, 7¼ x 16¹⁵/₁₆ inches. Alternate illustration for *What Do You Say, Dear?* This version of the drawing depicts a boy chasing a ball into the street while elephants scurry in opposite directions.

TOP: *The Sparrow's Tale*, 1957. Pen-and-ink line and gray wash, 7½ x 5¾ inches. Alternate illustration for *Very Far Away.*

BOTTOM: *Cat and Martin Arguing in the Cellar*, 1957. Pen-and-ink line and gray wash, 7⅜ x 5¾ inches. Alternate illustration for *Very Far Away.*

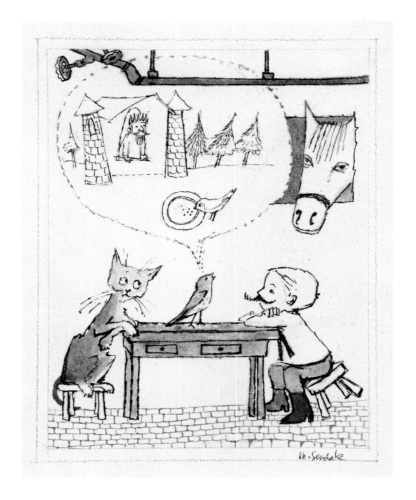

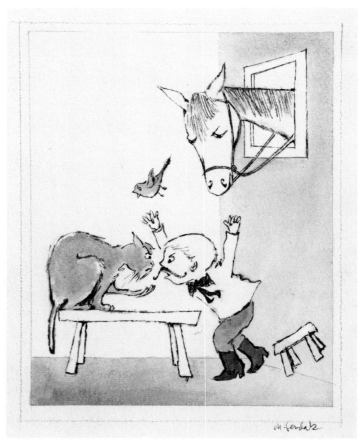

34

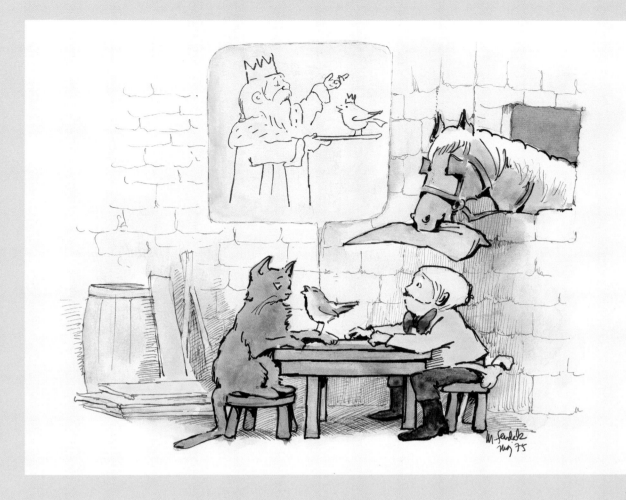

Very Far Away Animated Film Project

Following the success of *Really Rosie* as an animated story set to music, Sendak began work in early 1975 on an animated film of *Very Far Away*. Various typescripts and storyboards exist, some dating as late as September 1990, but nothing was put into production and the artist apparently abandoned the project soon afterward.

TOP: *Martin Listening to His Friends' Stories*, 1975. Pen-and-ink line and watercolor, 7 x 9 inches.

BOTTOM: *Martin Arguing with Cat*, 1975. Pen-and-ink line and watercolor, 7 x 9½ inches.

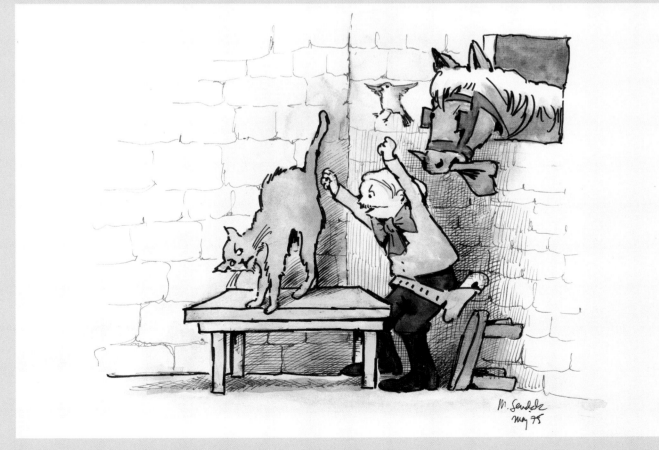

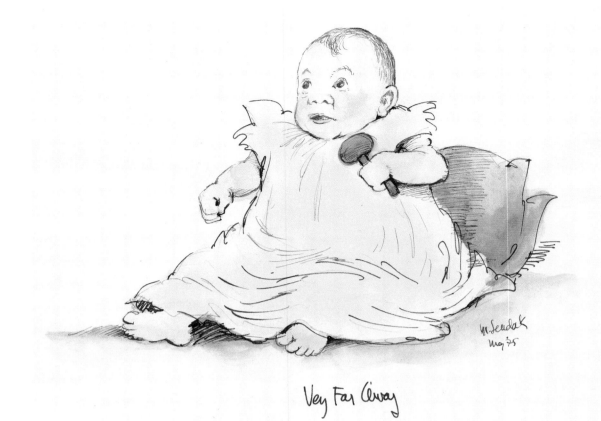

Very Far Away

TOP: *Baby with Red Rattle*, 1975. Pen-and-ink line and watercolor, 6 x 9 inches.

BOTTOM: *Martin and Five Images of Baby with Rattle*, 1975. Pen-and-ink line and watercolor, each 3³/₈ x 4⁷/₈ inches or smaller.

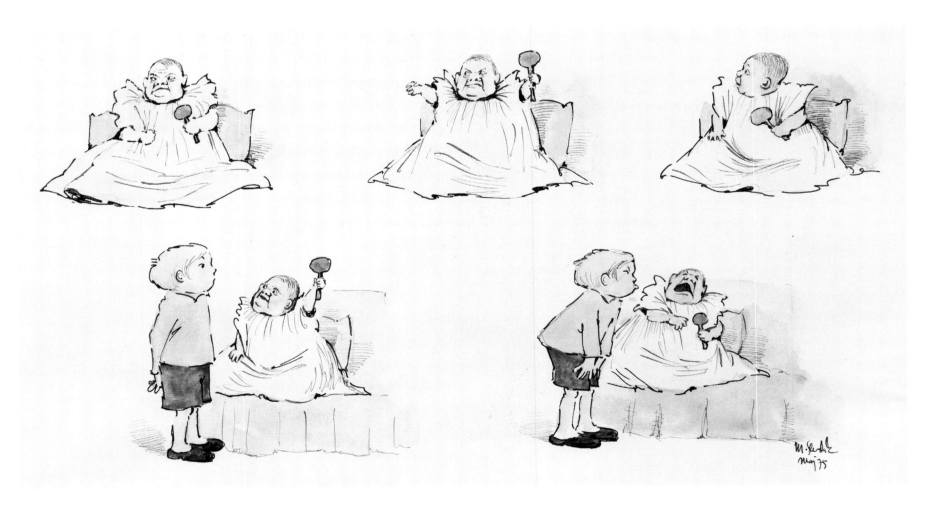

TOP: *Martin the Artist*, 1975. Pen-and-ink line and watercolor, each 4 x 4 inches or smaller. Four studies of Martin drawing, clockwise from top left, a rooster, horse, demon baby with rattle, and cat.

BOTTOM: *Five Martins*, 1975. Pen-and-ink line and watercolor, 10½ x 13½ inches. Five studies of Martin, four of which depict him in Western traveling garb.

The Tale of Gockel, Hinkel & Gackelia

These pen-and-ink line and gray-wash studies of scenes from
a German fairy tale by Clemens Brentano (1778–1842) are
variants of published images.

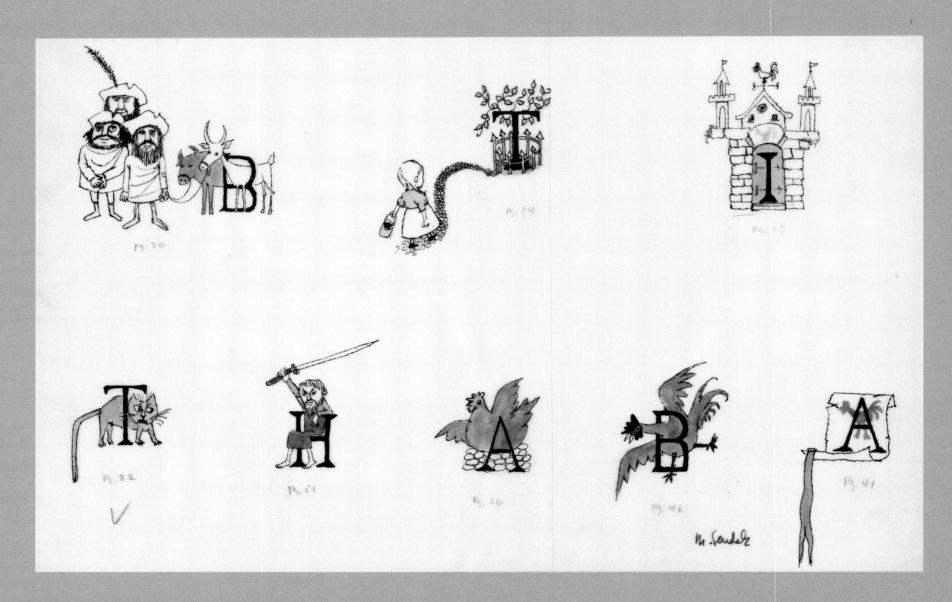

Pictorial Initial Letters, 1961. Pen-and-ink line and wash on
acetate, 8½ x 12 inches. Studies for B, T, I, T, H, A, B, and A
vignettes.

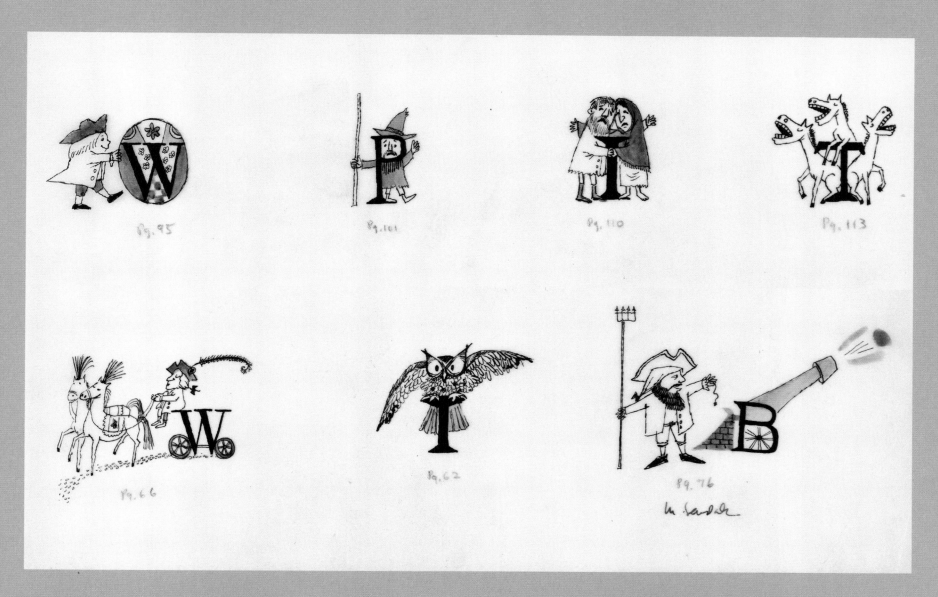

Pictorial Initial Letters, 1961. Pen-and-ink line and wash on acetate, 8½ x 12 inches. Studies for W, P, I, T, W, I, and B vignettes.

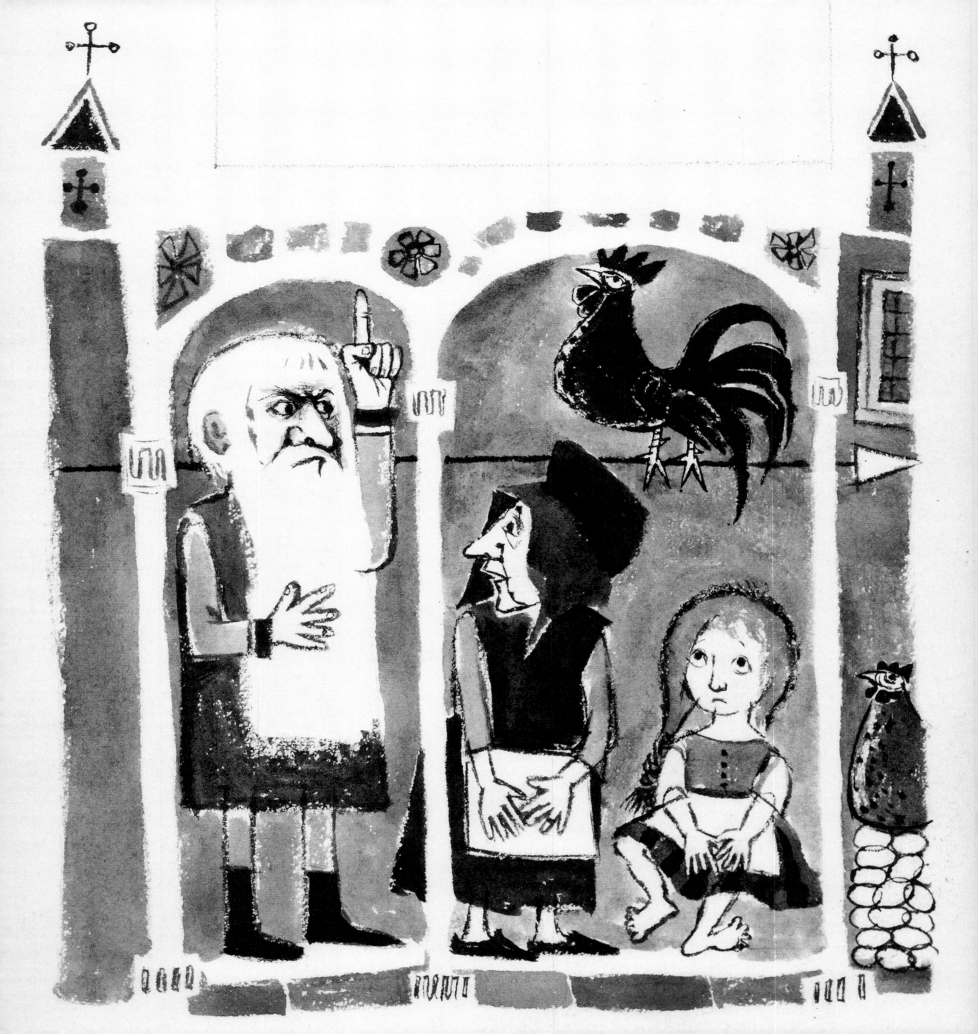

Variant designs for illustrations from *The Tale of Gockel, Hinkel & Gackelia*.

OPPOSITE: *Gockel Pointing to the Sky*, 1961. Pen-and-ink line and wash, 6¾ x 5¾ inches.

LEFT: *The Rooster* [Alektryo] *Could Speak*, 1961. Pen-and-ink line and wash, 7½ x 6¼ inches.

BOTTOM, LEFT: *Service at the Castle Chapel*, 1961. Pen-and-ink line and wash, 7⅞ x 6 inches.

BOTTOM, RIGHT: *At the Edge of the Rock*, 1961. Pen-and-ink line and watercolor wash on paper, 9¼ x 7½ inches.

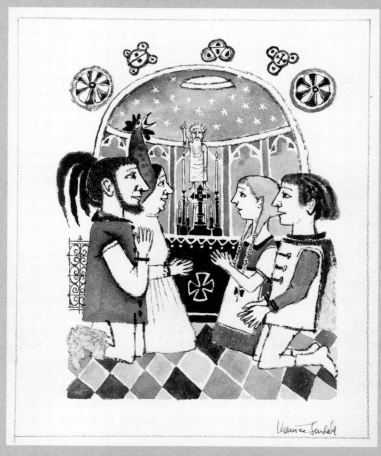

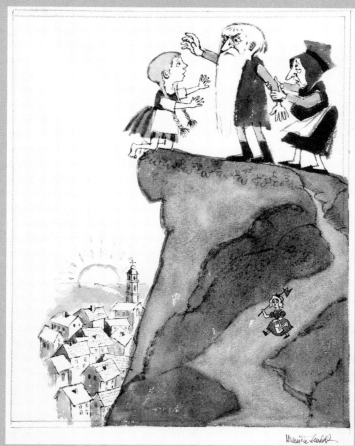

Illustrated letter about *The Nutshell Library*, 1962. Pen-and-ink line with watercolor, 8 x 5 inches.

Nov. 18, 62

Dear Lyn,

This is a picture of me after reading your letter.

My dog Jennie who rejoices with me.

So Thank you!

P.S. Tho I look 6½ I am really 34!

P.P.S. Regards to Mr. Fass

M. Sendak

Dec. 9, 62

Dear Mrs. Duff,

I THANK YOU FROM THE VERY BOTTOM OF MY CHICKEN SOUPY HEART!

ME TOO!

Maurice Sendak

P.S. How really marvelous of you to write !!!

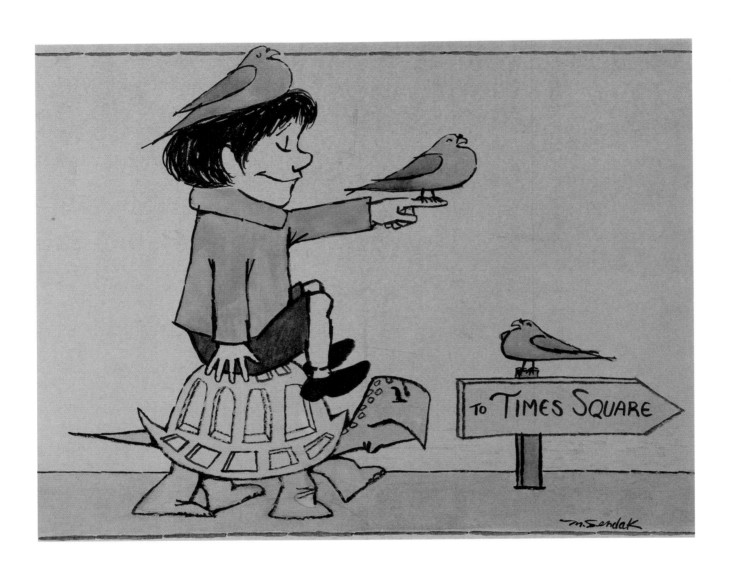

ABOVE: Study for *How Little Lori Visited Times Square* by Amos Vogel, 1963. Brush and watercolor on newsprint, 13¾ x 17½ inches.

RIGHT: *Lessons*, 1963. Pen-and-ink line, 3¼ x 3½ inches. Headpiece for chapter 4 of *Nikolenka's Childhood* by Leo Tolstoy.

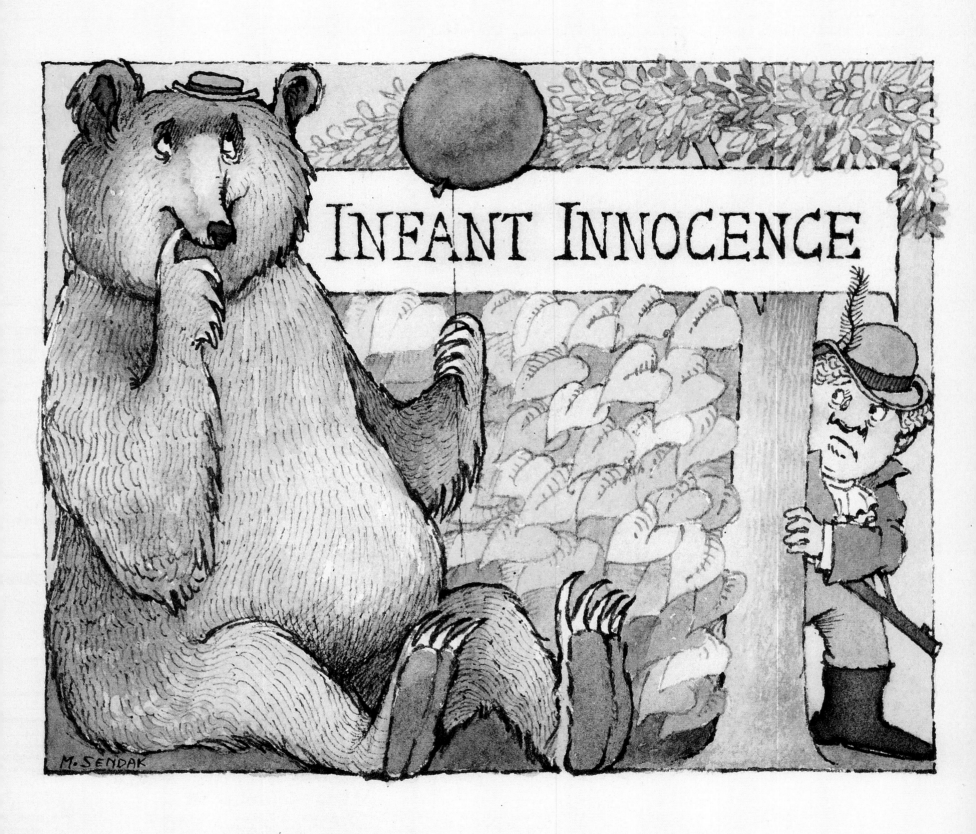

INFANT INNOCENCE

M. SENDAK

Study for the A.E. Housman poem – "lullabies & night songs – alec wilder –

OPPOSITE: *Infant Innocence*, 1965. Pen-and-ink line and watercolor, 6 x 7¼ inches. Alternate illustration for *Lullabies and Night Songs*.

LEFT: Variant illustration for *Higglety Pigglety Pop!*, 1967. Pen-and-ink line, 4⅜ x 3½ inches.

ABOVE: Final version of illustration for *Higglety Pigglety Pop!*, 1971. Print, 4⅜ x 4⁹⁄₁₆ inches. Published in *Pictures* (Harper & Row, 1971), for which Sendak selected nineteen favorite drawings from eight books for reproduction as fine art prints.

Variant illustrations for *In the Night Kitchen*.

TOP: *Mickey in Bed: "FLUMP"/"QUIET DOWN THERE!,"* 1970. Pencil and ink on paper, 6⅞ x 7¼ inches on larger paper.

BOTTOM: *"HUM"/"MAMA! PAPA!,"* 1970. Pencil and pen-and-ink line, 6⅞ x 7¼ inches.

OPPOSITE: *"Milk in the batter! Milk in the batter! Stir it! Scrape it! Make it! Bake it!,"* 1969. Pencil and colored marker, 9⅞ x 7¼ inches.

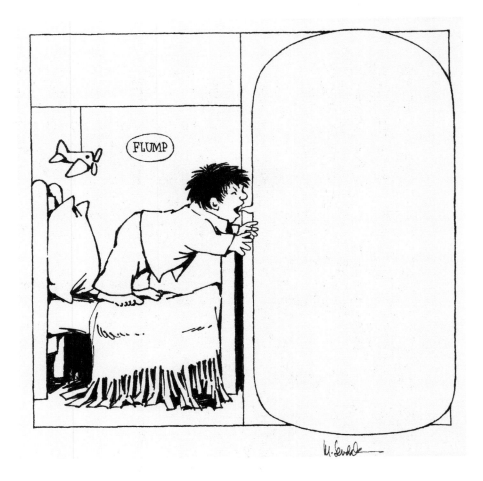

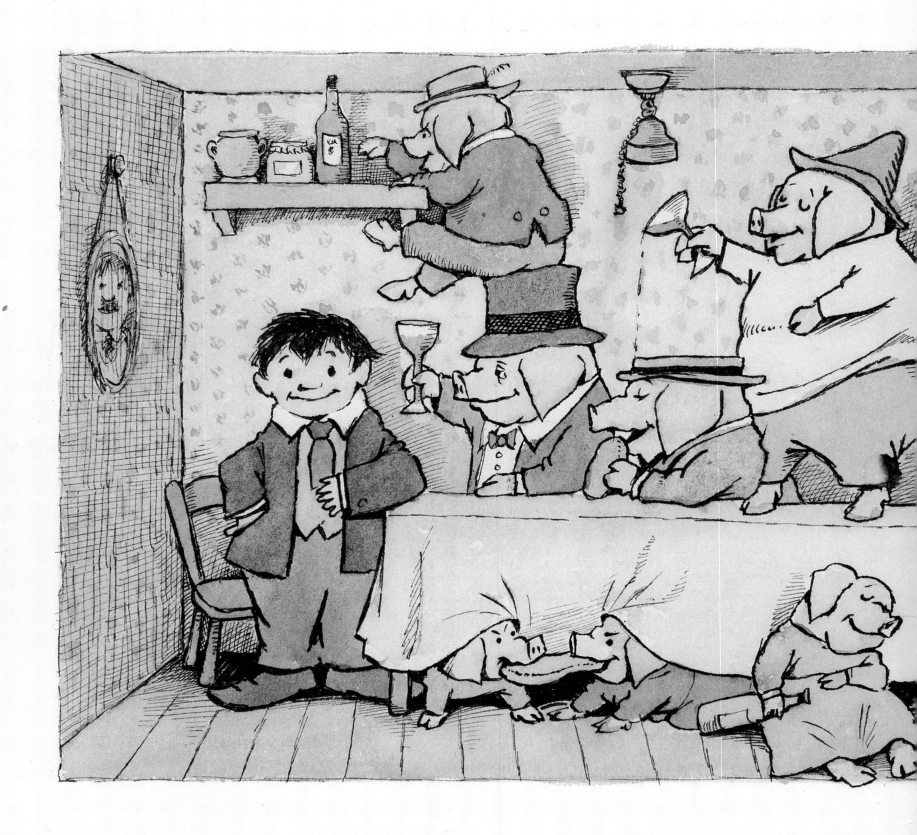

LEFT: *Bumble-Ardy*, 1970. Pen-and-ink line and watercolor, 5¼ x 10¼ inches. This concept drawing, made for an animated sequence on *Sesame Street*, portrays a boy at a birthday party with swine as his aunt enters the room carrying a grocery bag in her arms. Over the course of the next forty years, Sendak would transform what began as a counting rhyme into *Bumble-Ardy*, the last of his picture books to be issued during his lifetime.

ABOVE: *Bumble-Ardy* (HarperCollins), 2011. Printed book. Published just eight months before Sendak's death, *Bumble-Ardy* was, for the artist's last thirty years, the only book that he both wrote and illustrated. The final pictures are more sophisticated in style than what he conceived early on.

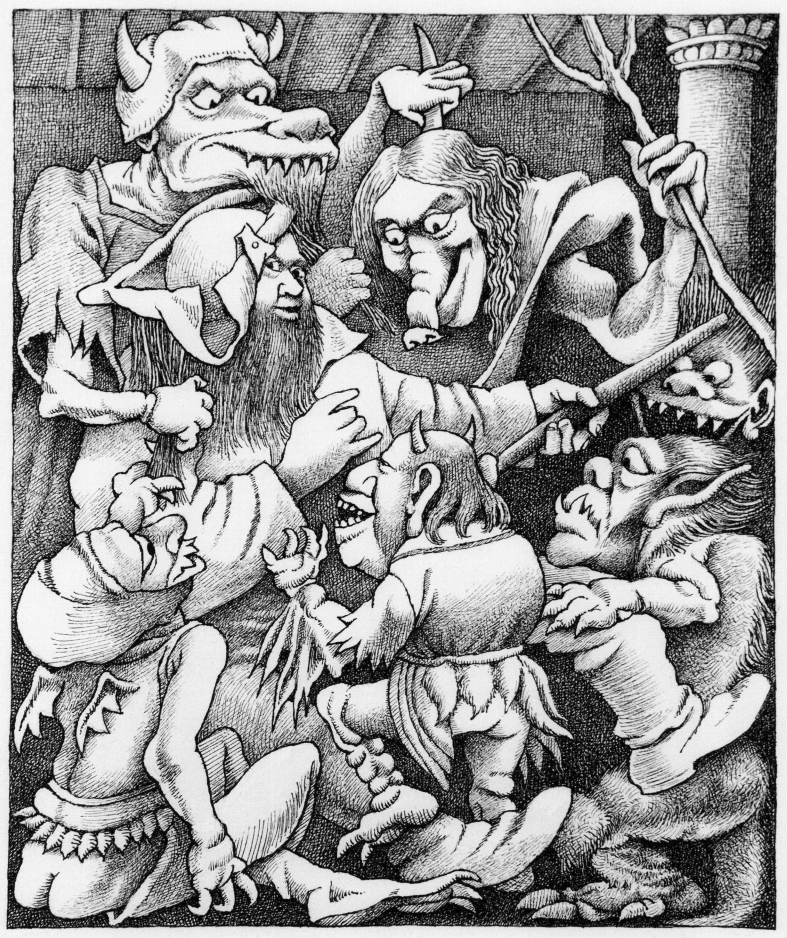

Study for book jacket/cover design for *Outside Over There*, 1979. Pencil, 9¼ x 10 inches. This alternate cover design for the book, which received a Caldecott Honor award, shows Ida holding her baby sister with her back to the shore, looking out to sea while a pair of cloaked goblins huddle to the right; a tall-masted ship is seen on the bay. This image was incorporated in the double-page illustration "*When Papa was away at sea*." Sendak's designs are fiercely influenced by German Romanticism, reflecting elements of Philipp Otto Runge and Caspar David Friedrich, as well as the British painters Richard Dadd and Samuel Palmer.

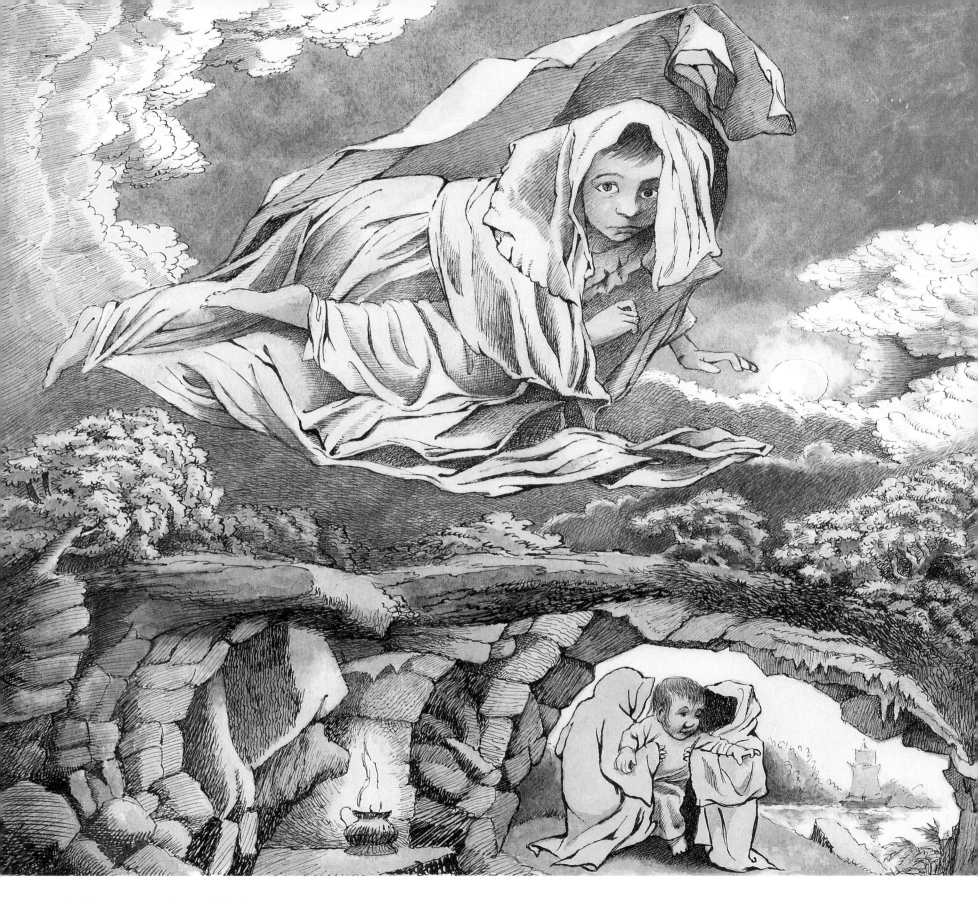

Study for "*Ida whirling by the robber caves*," 1977. Pen-and-ink line and watercolor, 9 x 10 inches. An early developmental drawing for *Outside Over There*, this illustration was made before Sendak began using a four-hair brush to achieve the luminescence visible in his final, published drawings. This technique was used by Renaissance miniaturist painters.

THE CUNNING LITTLE VIXEN

RUDOLF TESNOHLIDEK

PICTURES BY MAURICE SENDAK

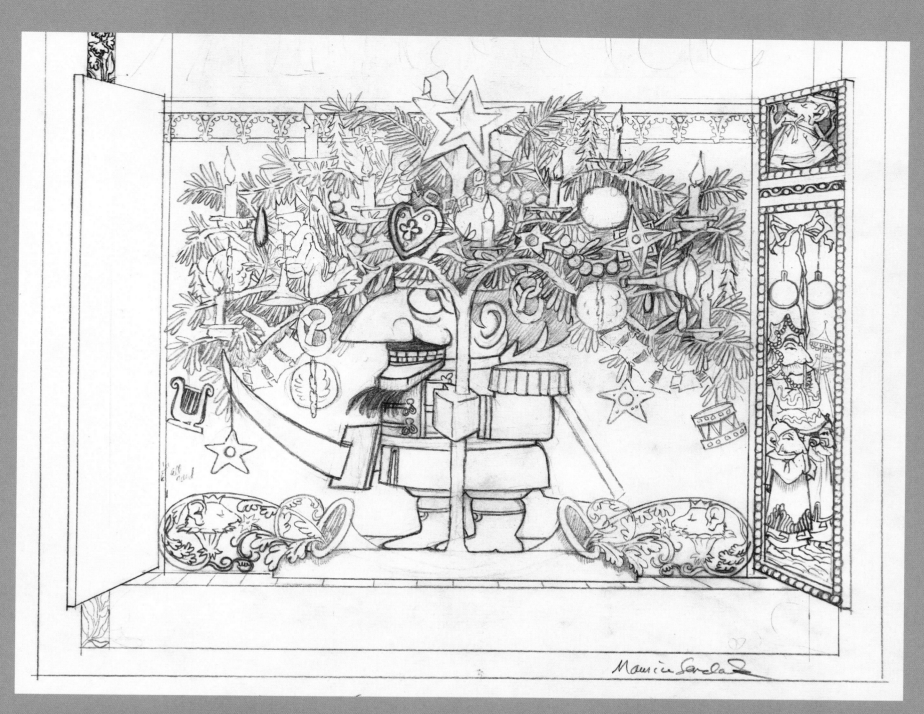

OPPOSITE: Study for the book jacket/cover for *The Cunning Little Vixen* (Farrar, Straus & Giroux), 1985. Pencil, 9 x 7³⁄₁₆ inches. The illustrations in this storybook version of the well-known Czech tale are based on the stage sets and costume designs Sendak created for the 1981 production of Leoš Janáček's famous opera, directed by Frank Corsaro.

ABOVE: Study for the book jacket/poster design for *Nutcracker*, 1983. Pencil, 15 x 15 inches. Inspired by E. T. A. Hoffmann's original story *The Nutcracker and the Mouse-King* (1816), Sendak's set and costume designs were commissioned by artistic director and choreographer Kent Stowell for the Pacific Northwest Ballet production, which premiered in 1983. Annotations in the margin of this drawing indicate the size of the book's cover and how the image might be adapted for use as a poster. A film version of the Stowell/Sendak production was released in 1986.

LEFT: *Nutcracker* (Crown), 1984. Printed book. Maurice Sendak was persuaded to create several picture books based on his original stage-set and costume designs for opera. The first, published by Farrar, Strauss & Giroux in 1984, was *The Love for Three Oranges* by Sergei Prokofiev, created for the 1982 Glyndebourne Festival production, directed by Frank Corsaro.

Tail Feathers from Mother Goose: The Opie Rhyme Book

This book was created to aid an appeal for funding the acquisition of the Opie Collection of children's books for the Bodleian Library in Oxford, England. Afterward it was reproduced as a serigraph silkscreen for the *Mother Goose Portfolio* (1990), a project limited to three hundred copies and prepared as a fund-raiser for the Children's Health Fund, which was founded by Paul Simon to provide health care for disadvantaged children.

ABOVE: Study for book jacket/cover design for *Tail Feathers from Mother Goose*, 1987. Pencil, 8⅜ x 8½ inches. This drawing portrays Iona Opie as Mother Goose, but it was deemed too kindly an image, and ultimately a more traditional rendering was substituted.

RIGHT: Book jacket/cover design for *Tail Feathers from Mother Goose*, 1987. Watercolor, 8½ x 10 inches.

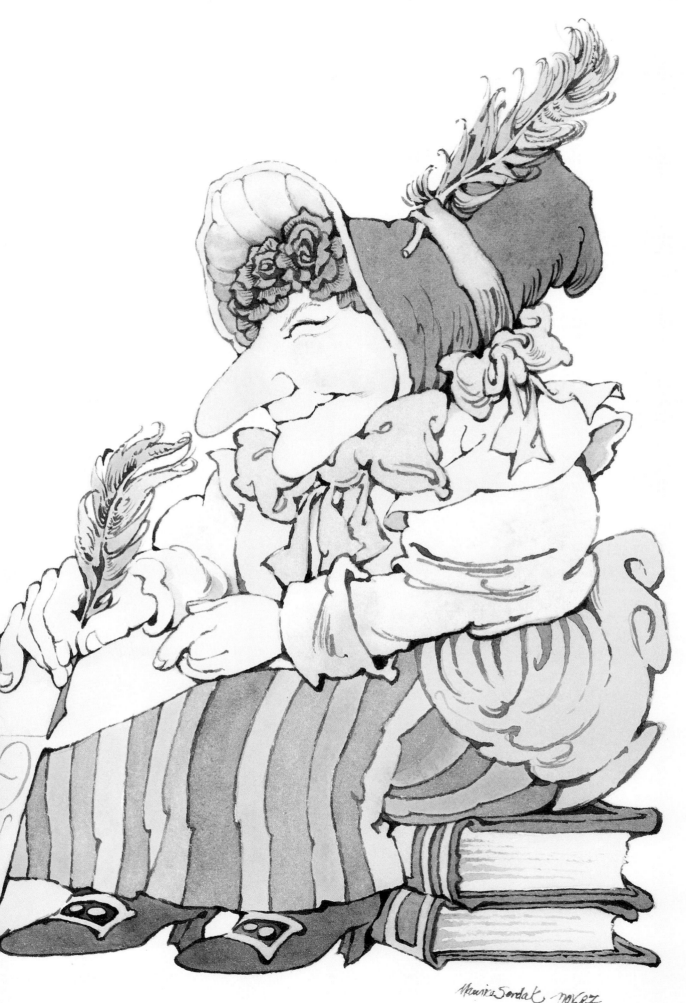

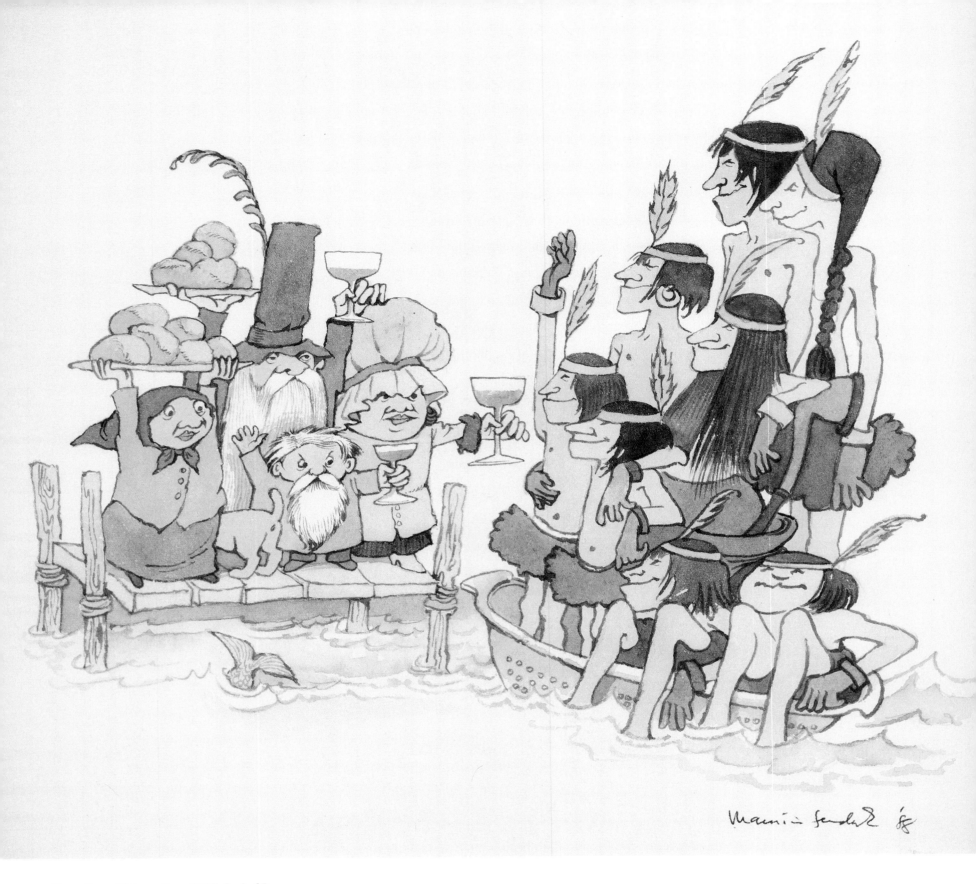

Sing a Song of Popcorn, Every Child's Book of Poems

Sing a Song of Popcorn is a collection of poems illustrated by nine Caldecott Medal winners and dedicated to the memory of Arnold Lobel.

ABOVE: "The Jumblies" by Edward Lear, 1988. Pencil and watercolor, 6 x 7½ inches.

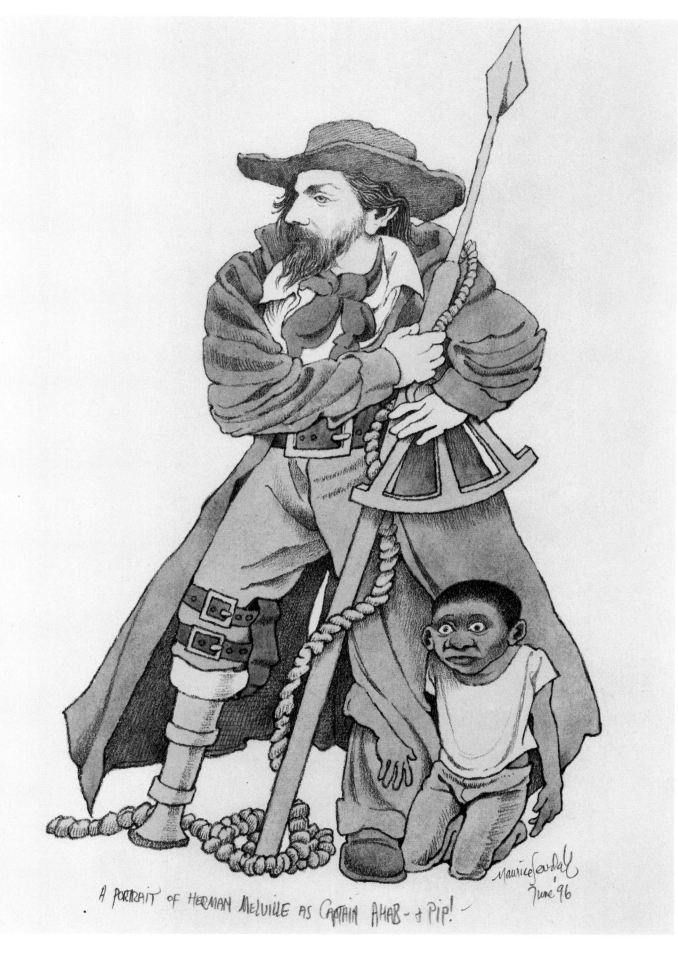

A PORTRAIT OF HERMAN MELVILLE AS CAPTAIN AHAB — & PIP!

LEFT: *Melville as Captain Ahab*, 1996. Pencil and watercolor, 8⅝ x 5⅜ inches. This portrait of Captain Ahab and Pip was drawn on the front free endpaper of volume one of Rockwell Kent's monumental three-volume edition of *Moby-Dick* by Herman Melville.

BELOW: Rockwell Kent's edition of *Moby-Dick* by Herman Melville, published by Lakeside Press, 1930.

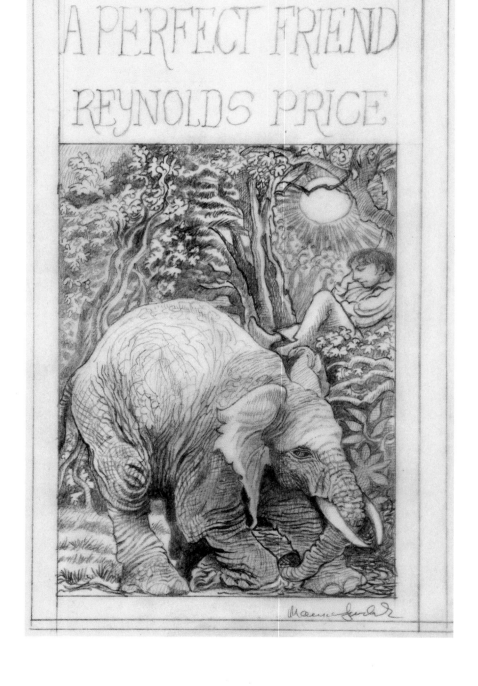

A Perfect Friend

ABOVE, LEFT AND RIGHT: Book jacket/cover designs
for *A Perfect Friend* by Reynolds Price, 1999. Pencil,
6¼ x 4½ inches.

OPPOSITE: *A Perfect Friend*, 1999. Pencil and watercolor,
6¼ x 4½ inches on larger paper.

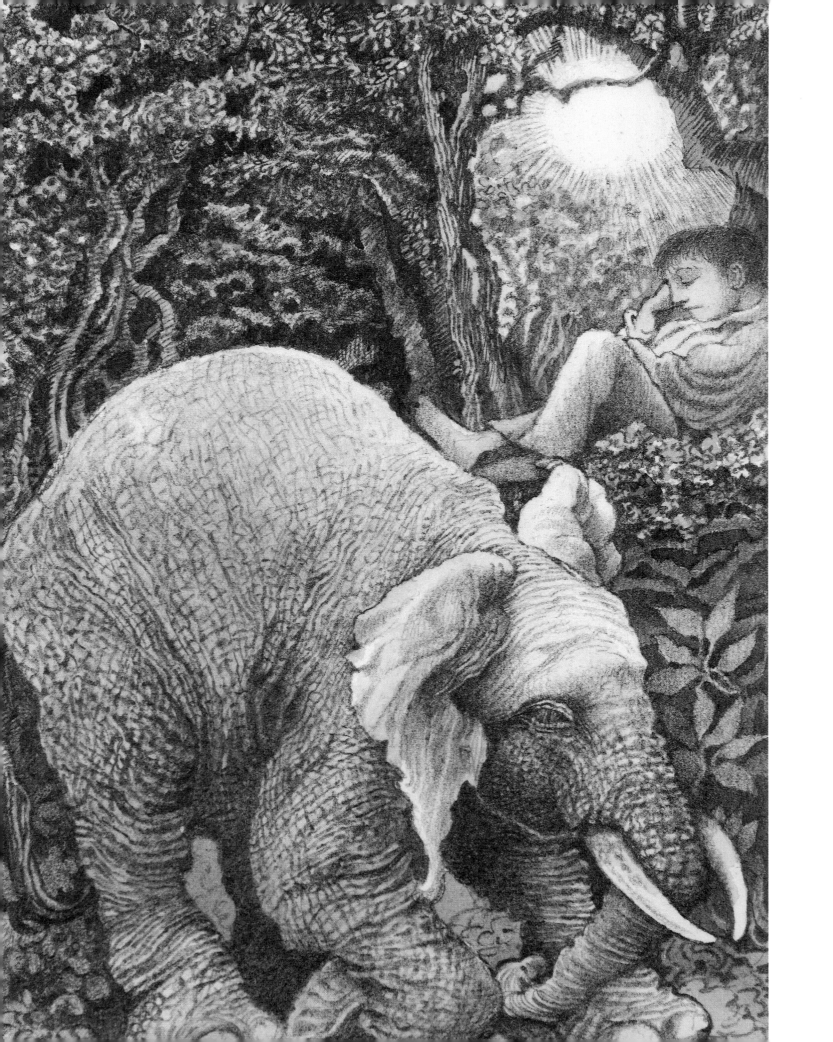

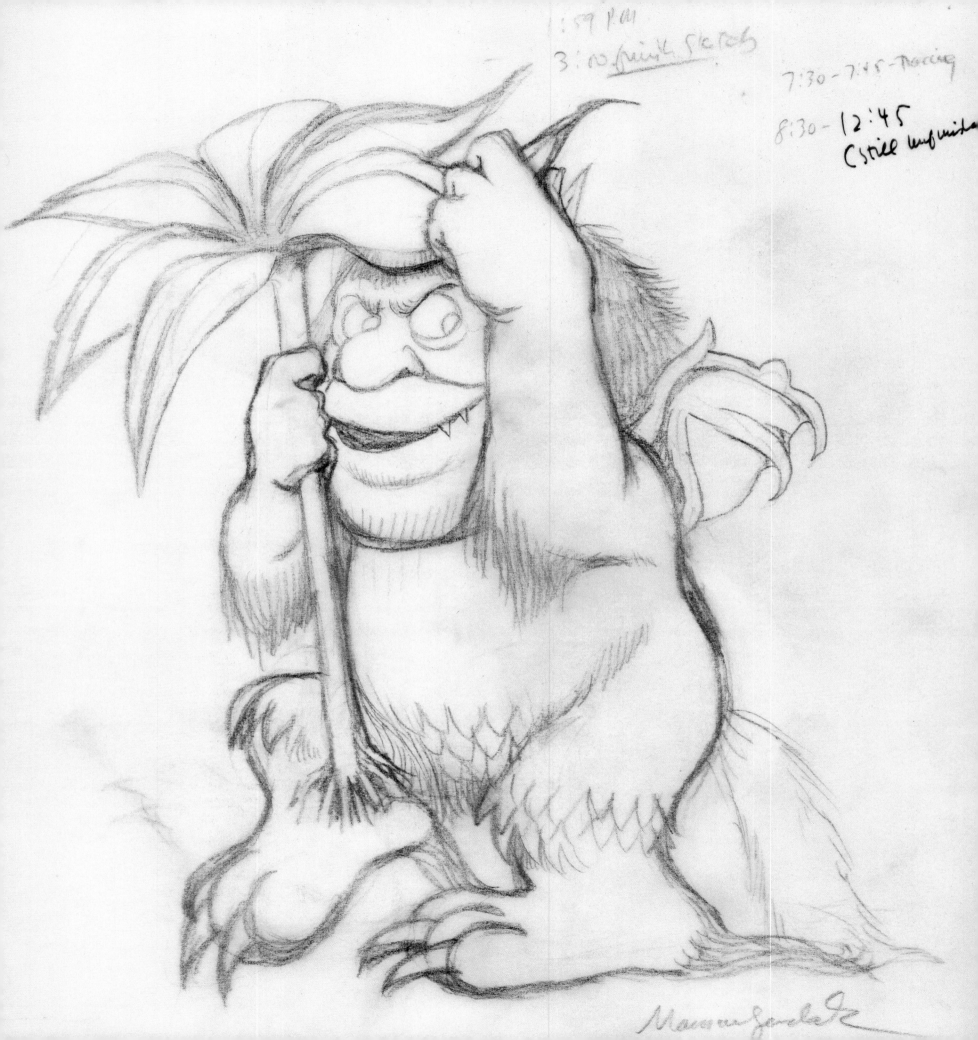

CHAPTER III: ADVERTISING AND COMMERCIAL ART

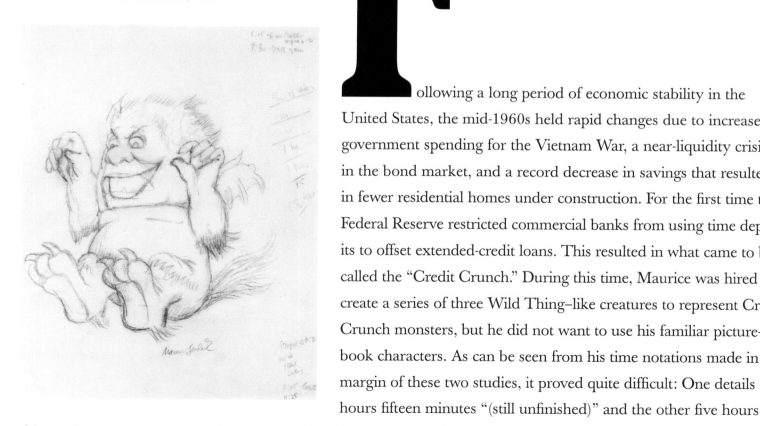

Following a long period of economic stability in the United States, the mid-1960s held rapid changes due to increased government spending for the Vietnam War, a near-liquidity crisis in the bond market, and a record decrease in savings that resulted in fewer residential homes under construction. For the first time the Federal Reserve restricted commercial banks from using time deposits to offset extended-credit loans. This resulted in what came to be called the "Credit Crunch." During this time, Maurice was hired to create a series of three Wild Thing–like creatures to represent Credit Crunch monsters, but he did not want to use his familiar picture-book characters. As can be seen from his time notations made in the margin of these two studies, it proved quite difficult: One details four hours fifteen minutes "(still unfinished)" and the other five hours thirty minutes. The finished ink drawing of the third creature with its tongue out is reproduced on the front cover of a special "Sendak at 75" November/December 2003 issue of the *Horn Book Magazine*.

ABOVE: Preliminary drawing for *Chapbook Miscellany*, 1970. Pencil, 5½ x 4 inches.

RIGHT: *Chapbook Miscellany*, 1970. Pen-and-ink line, 5¼ x 4 inches. Illustration for the front cover of Justin G. Schiller Ltd.'s first catalogue of antiquarian children's books, issued in four parts (each with a different colored wrapper). The two bears are caricatures of the gallery's proprietors.

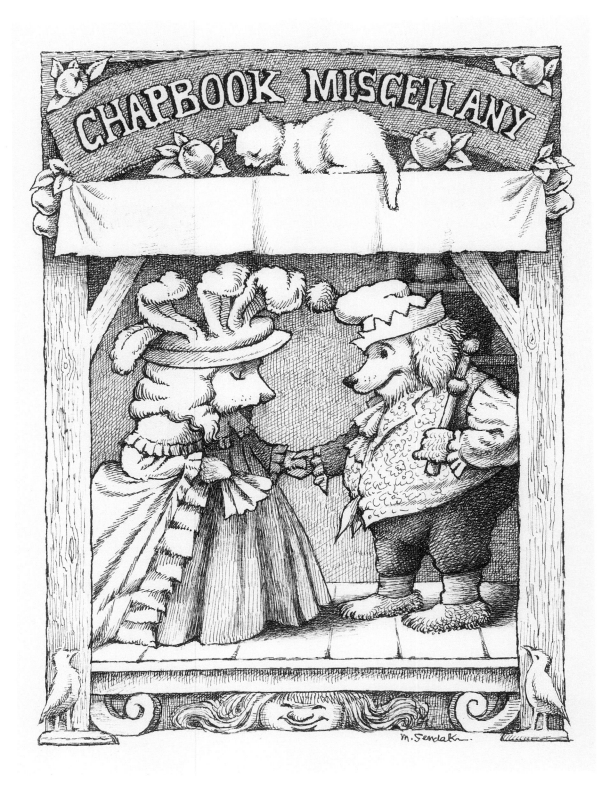

LEFT: *Saucy Susan Chicken*, 1971. Pen-and-ink line, 9 x 10 inches. Design for an advertisement for Saucy Susan sweet plum sauce, commissioned by Saucy Susan Products, Inc., in Briarcliff Manor, New York.

ABOVE: Saucy Susan advertisement, 1971. Printer's proof, 13¼ x 11 inches. It is believed that Sendak objected to having parts of his drawing obscured (by a product shot and coupon), and so consequently, this advertisement never went to press.

ABOVE: Preliminary drawing for *Bear Caricature of Justin G. Schiller in His Study*, 1973. Pencil, 5⅝ x 5⅜ inches.

RIGHT: *Bear Caricature of Justin G. Schiller in His Study*, 1973. Pen-and-ink line, 5⅛ x 5½ inches. This illustration, created for Justin Schiller, depicts a bear in his study. A copy of an illustration by Maxfield Parrish for *Mother Goose in Prose* (1897) hangs on the wall. The composition of Sendak's drawing became too detailed for a small bookplate, and so it was used instead for the cover of Justin G. Schiller Ltd.'s Catalogue 29: *Children's Books from Four Centuries* (1973).

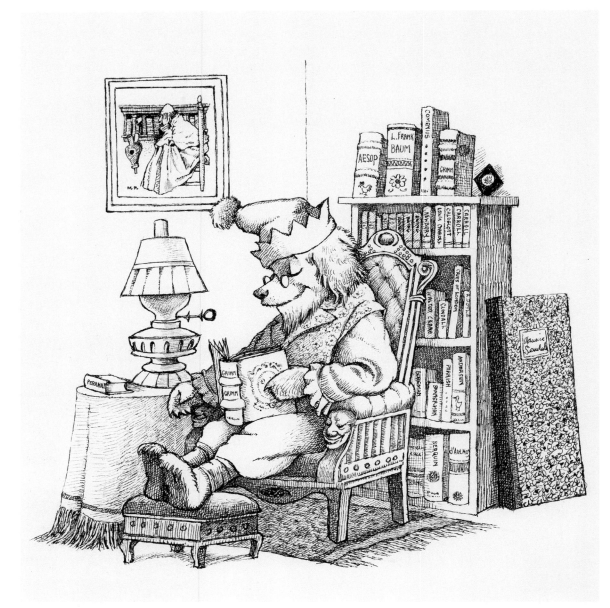

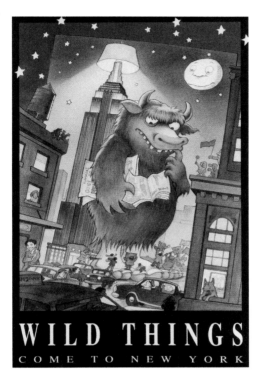

Sony Metreon: *Wild Things Come to New York,* **1996**

In 1996 six windows of the AT&T building on Madison Avenue, between 55th and 56th Streets, were decorated for Christmas with animated three-dimensional tableaux (each 9 x 12 feet). With the help of characters from *Where the Wild Things Are* and New York City icons and landmarks, they signaled a new collaboration between Sony and Maurice Sendak and highlighted Sony's newly created flagship store. The AT&T building was purchased by Sony in 2002.

LEFT: Preliminary drawing for Sony's *Wild Things Come to New York* Christmas window, 1996. Pencil, 8¼ x 6⅝ inches.

ABOVE: *Wild Things Come to New York*, 1996. Postcard depicting one of the mechanical Christmas displays created by Sendak for the Sony windows.

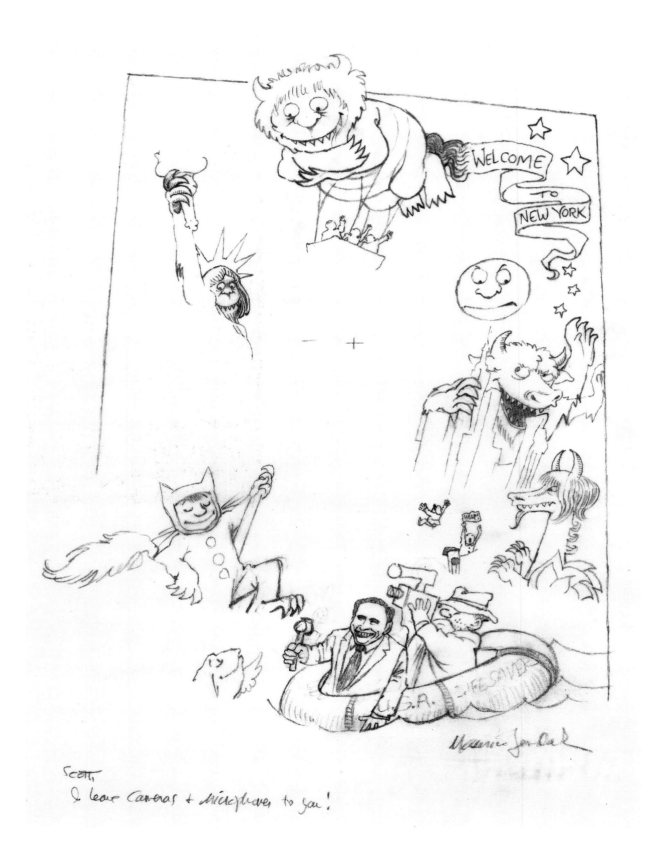

Scott,
I leave Cameras + Microphones to you!

LEFT: Preliminary drawing for Sony's *Wild Things Come to New York* Christmas window, 1996. Pencil, 8¼ x 6⅝ inches on larger paper.

ABOVE: *Wild Things Come to New York*, 1996. Postcard depicting one of the mechanical Christmas displays created by Sendak for the Sony windows.

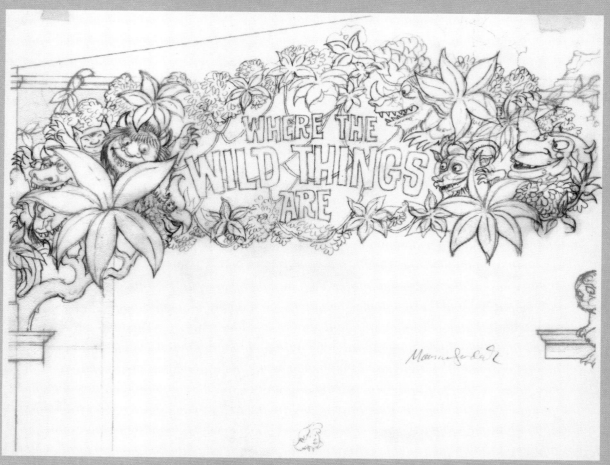

Sony Metreon San Francisco, 1999–2004

The collaboration between Sony and Maurice Sendak extended to the Metreon Complex in San Francisco, which opened in June 1999 with an interactive *Where the Wild Things Are* play area and *In the Night Kitchen*–themed restaurant, with an adjoining gift shop.

LEFT: Preliminary drawing for Wild Things fretwork overhang, 1997. Pencil, 8 x 10½ inches. This sketch shows the entrance to the *Where the Wild Things Are* play area.

BELOW: Preliminary drawing for Wild Things forestscape, 1997. Pencil, 5¾ x 10½ inches. Instructions on the bottom right read, "Move head so tongue lies in pool of water."

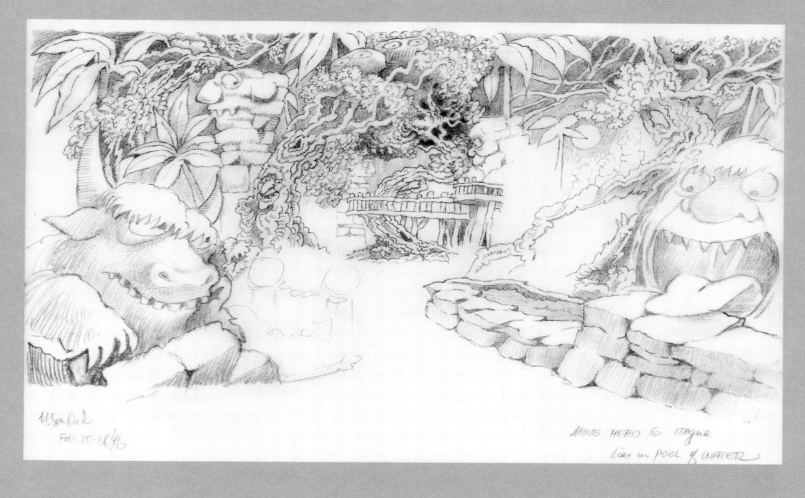

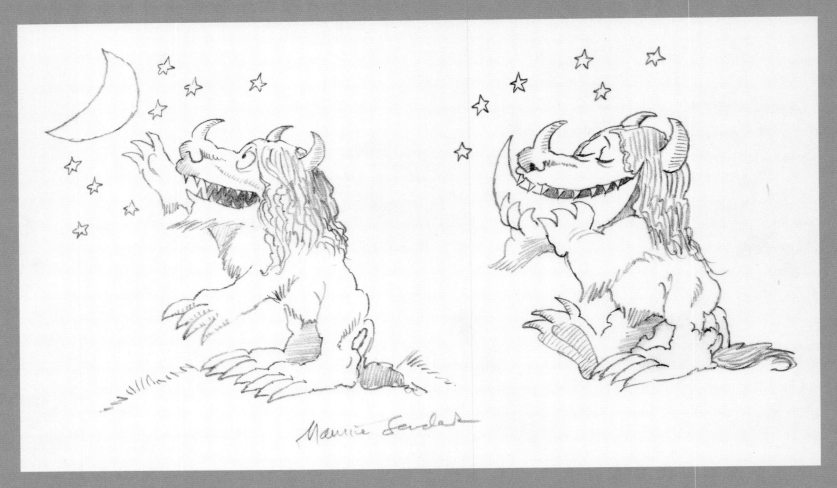

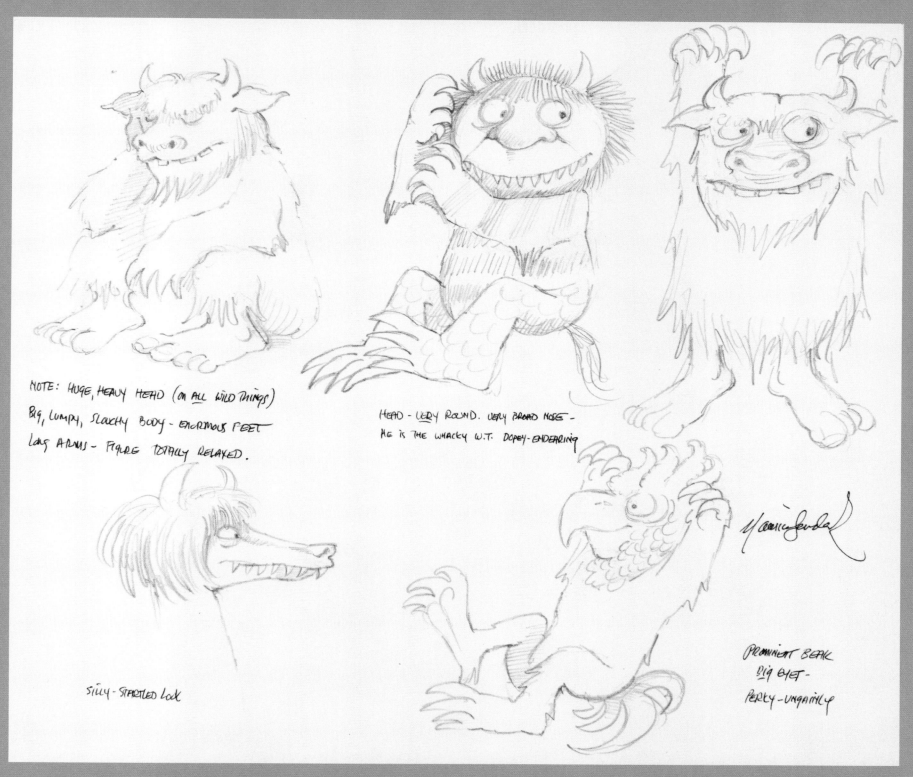

NOTE: HUGE, HEAVY HEAD (ON ALL WILD THINGS) BIG, LUMPY, SLOUCHY BODY - ENORMOUS FEET LONG ARMS - FIGURE TOTALLY RELAXED.

HEAD - VERY ROUND. VERY BROAD NOSE - HE IS THE WHACKY W.T. DOPEY - ENDEARING

SILLY - STARTLED Look

PROMINENT BEAK BIG EYES - PERKY - UNGAINLY

OPPOSITE, TOP: Preliminary drawing for *Wild Thing Transformation: Watermelon Moon*, 1997. Pencil, 5 x 9¾ inches. This conceptual design and the one below it suggest what would be a mechanized installation.

OPPOSITE, BOTTOM: Preliminary drawing for *Wild Thing Transformation: Max Missing! Max Found!*, 1997. Pencil, 4¾ x 8⅛ inches.

ABOVE: Studies of five Wild Things characters, 1997. Pencil, 11 x 12¼ inches. This drawing includes descriptive notations for the animators and designers at Metreon that indicate individual characteristics of the figures depicted.

Studies for R. O. Blechman's Japanese-German Beer Man Commercial, 1997.

RIGHT: Pencil on paper, 10⅝ x 8⅜ inches.

OPPOSITE: Pencil and watercolor on paper, 9¼ x 6¼ inches.

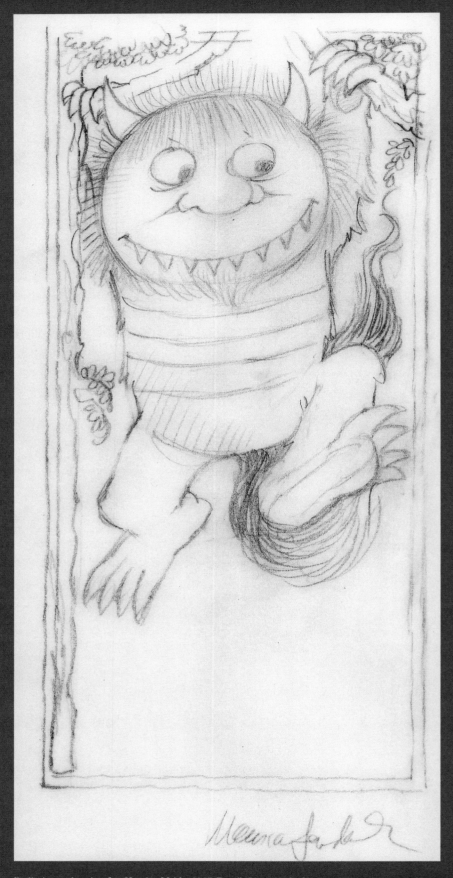

Preliminary drawing for *Hanging Moishe*, 1997. Pencil, 7½ x 3¾ inches.

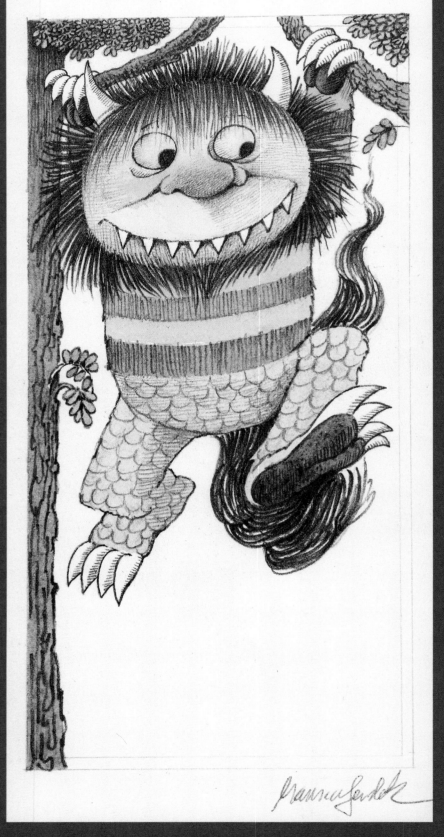

Hanging Moishe, 1997. Pencil and watercolor, 8⅞ x 4¼ inches. This design was conceived for promotional material, print, and poster advertisements promoting the telecommunications giant's "Wild Things Are Happening" IT campaign.

Wild Things Are Happening:
Bell Atlantic's Corporate Advertising Campaign
by Ahron D. Weiner

The Telecommunications Act of 1996 ushered in an era of deregulation that provided increased choice and confusion for the average customer. Strange new technologies were emerging, and the long-distance carriers, as well as a plethora of small upstart companies were promising to offer these new services.

The regional Bell companies started merging to achieve the scale needed to compete in this dynamic marketplace—the 1997 merger of NYNEX and Bell Atlantic created the largest company of its kind.

There was concern that customers, already confused by rapid changes in the marketplace, would be intimidated by the prospect of dealing with a company as large as the newly merged Bell Atlantic. We knew that Bell Atlantic was a huge company, but that it also had the ability to provide tailored solutions and an unparalleled level of customer care.

Enter Maurice Sendak's Caldecott Medal–winning *Wild Things*–the perfect allegory for a gentle giant (once tamed by Max's magic trick, of course). The Lord Group, a New York–based advertising agency, developed the idea of using Maurice's beloved characters to humanize Bell Atlantic and presented the concepts to a very enthusiastic client. At that point, Maurice was approached, and he agreed to work with the agency provided he retained ultimate creative control of the finished product.

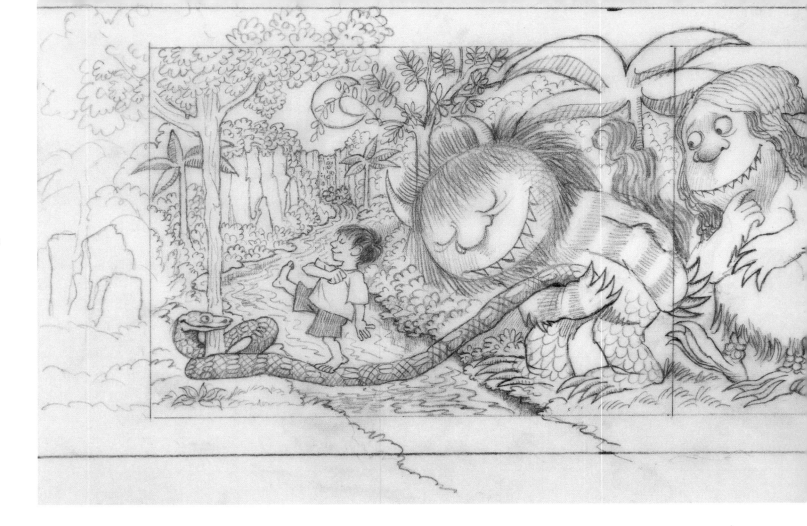

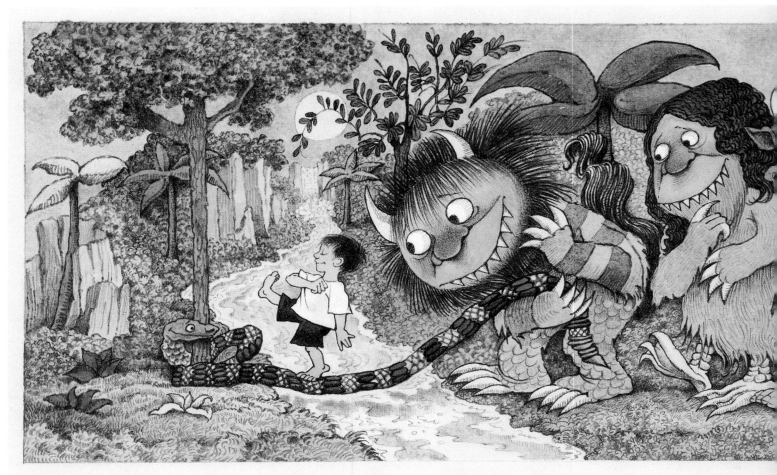

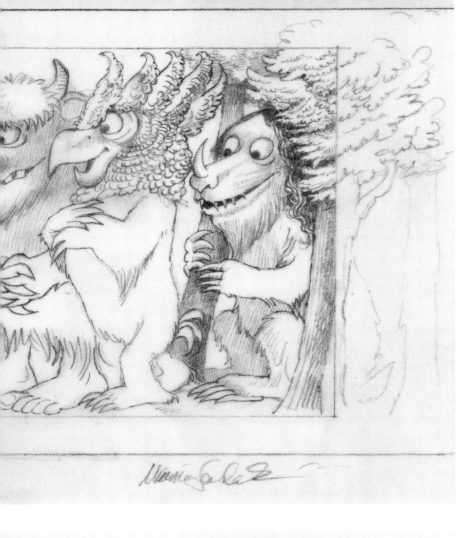

Having reached this agreement, the agency worked closely with Maurice to craft a remarkable series of advertisements. The allegorical campaign featured Wild Things and children in natural settings, which maintained the integrity of the characters and concept. While modern technology is never seen, the advertisements communicated a wide range of messages—from basic phone service and calling plans to complex technological concepts of supply-chain management and the benefits of high-speed data products.

In terms of the actual production of the ads and animation, Maurice illustrated each of the five print ads and all of the billboards, and drew key frames for each of the TV spots. These key frames were then sent to a well-known London-based animation studio to be brought to life.

From early 1997 to the end of 1998, we created seven animated TV spots, a massive teaser outdoor campaign, five print ads, and a giant Moishe *Wild Things* balloon for the Macy's Thanksgiving Day Parade, which Maurice imagined "breaking free and climbing to the top of the Empire State Building."

The campaign won a highly coveted Effie award, which is given for campaigns that maintain excellence in creativity and marketing effectiveness, and Maurice also won a Clio award in 1998 for his print ad illustrations.

This project was the most significant commercial use of the *Wild Things* characters. It is fair to say that everyone who was involved in the project—including Maurice—took great pleasure in this collaboration.

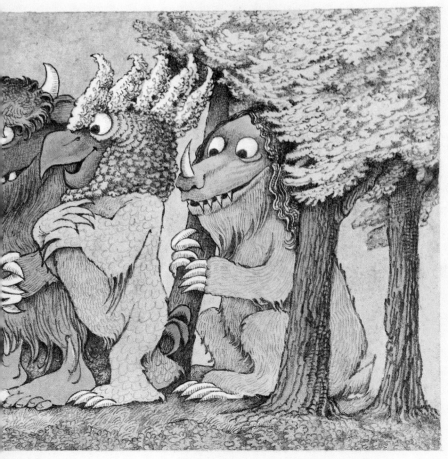

Preliminary drawings for sequential *Transformation: "Moishe" Wild Thing Tearing into Paper Screen*, 1997. Pencil, or pencil and watercolor, each 3³⁄₈ x 8⁷⁄₈ inches. These studies were made for the large panels concealing the restoration and repair work underway at Grand Central Terminal New York.

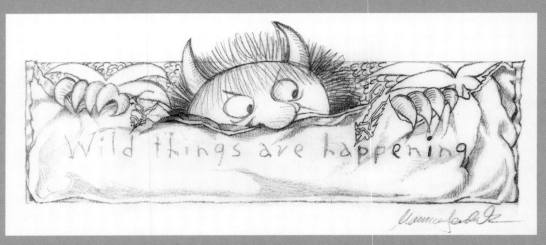

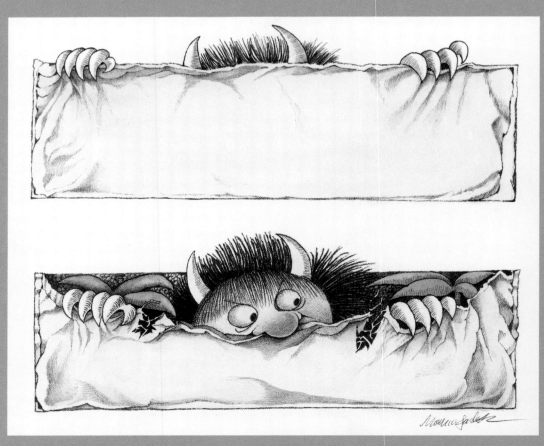

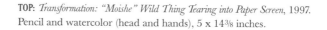

TOP: *Transformation: "Moishe" Wild Thing Tearing into Paper Screen*, 1997. Pencil and watercolor (head and hands), 5 x 14⅜ inches.

MIDDLE, LEFT: *"Bernard" Wild Thing*, 1997. Pencil and watercolor, 4⅛ x 6¼ inches. This image and the one above it were used for print advertisements and promotional leaflets.

MIDDLE, RIGHT: *Two Pairs of Eyes and Bull Tearing into Paper Screen*, 1997. Pencil and watercolor, 2¼ x 4½ (eyes) and 2⅝ x 11⅝ inches (bull). The eyes were used as subway car "teasers," while Bernard appeared in printed advertising campaigns and on the panels concealing the restoration and repair work underway at Grand Central Terminal.

BOTTOM: *Three Pairs of Eyes and Two Grass Landscapes*, 1997. Pencil and watercolor, 2¼ x 4½ inches (eyes) and 4⁵⁄₁₆ x 4⁷⁄₁₆ inches (grass landscapes). These designs were used for Bell Atlantic's subway and print advertising campaigns.

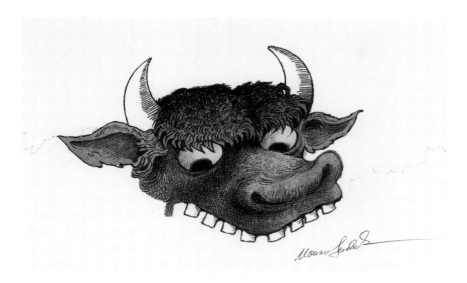

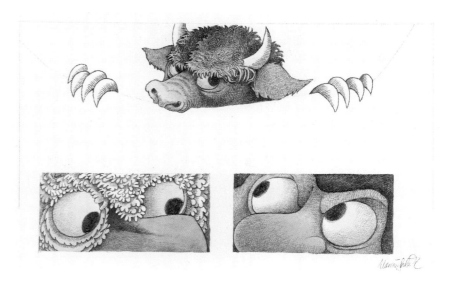

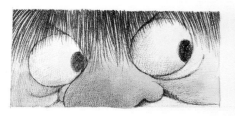

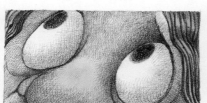

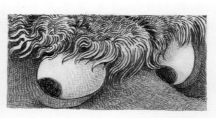

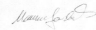

Wild Things in the Grass, 1997. This series of Wild Things emerging from a grassy landscape was used in various print advertisements and posters, as well as on subway displays as four sheets in sequence.

ABOVE: Pencil and watercolor, 3½ x 5⅞ inches.

RIGHT: Pencil and watercolor, 1¾ x 5⅞ inches.

LEFT: Pencil and watercolor, 1¾ x 5⅞ inches.

BELOW: Pencil and watercolor, 3½ x 5⅞ inches.

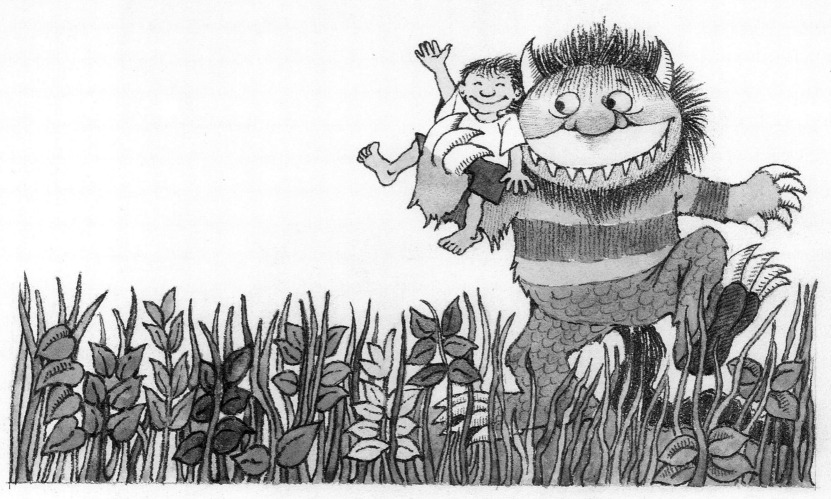

**Wild Things Are Happening:
Omnibus**

Studies of a boy, 1997. Pencil,
10⅝ x 7⅜ inches. The annotation
reads, "M. Sendak–Aug. 1,
'97–Melville's Birthday."

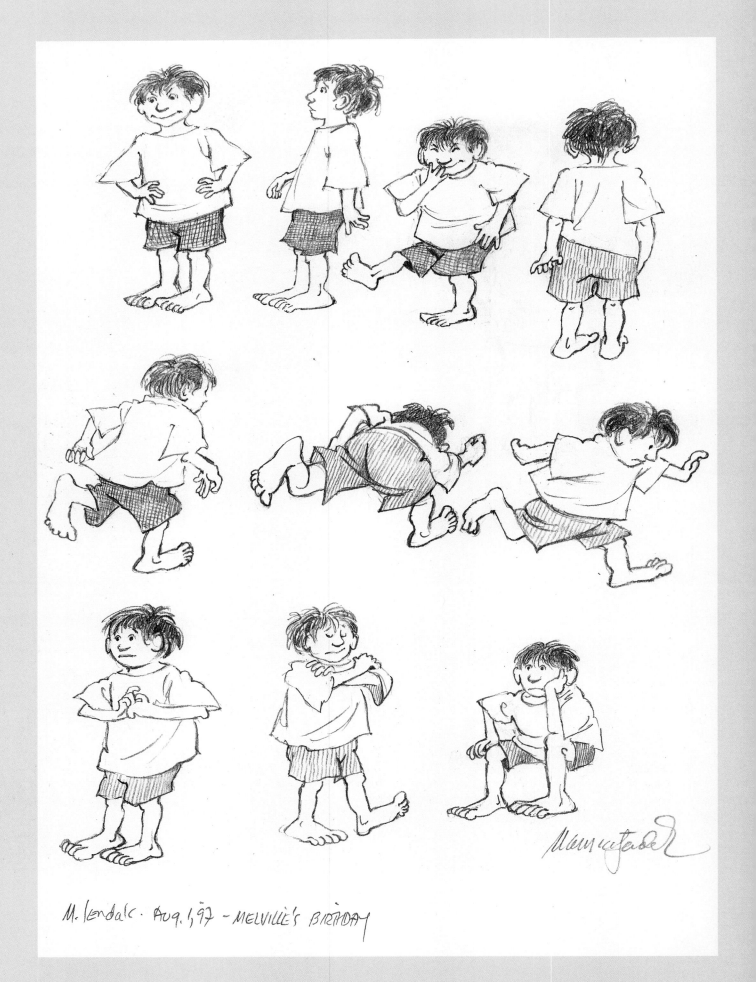

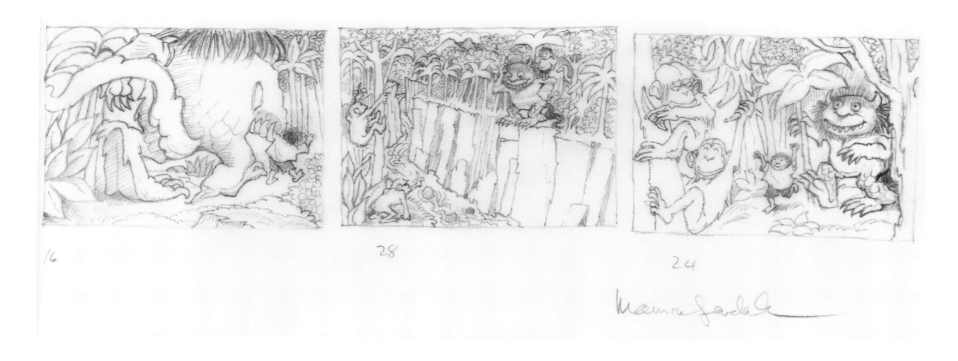

16 28 24

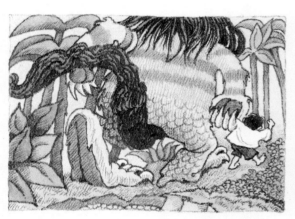 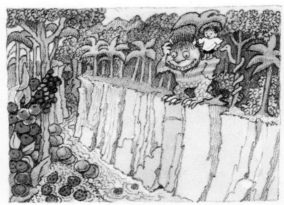 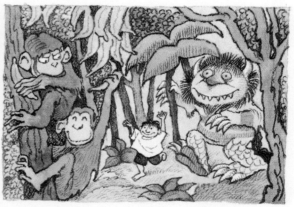

Wild Things Are Happening: Precipice

TOP: Preliminary storyboard sketches for *Crossing a Precipice*, 1997. Pencil, each panel approximately 2½ x 3½ inches.

BOTTOM: Storyboard for *Crossing a Precipice*, 1997. Pencil and watercolor, each panel approximately 2⅝ x 3½ inches. "Moishe" helps a boy to cross a chasm.

Wild Things Are Happening: Business

ABOVE: Preliminary storyboard sketches for *Martha's Coconuts and Masks*, 1997. Pencil, each panel approximately 2½ x 3½ inches.

OPPOSITE: Storyboard sketches for *Martha's Coconuts and Masks*, 1997. Pencil and watercolor, each panel approximately 2½ x 3¼ inches.

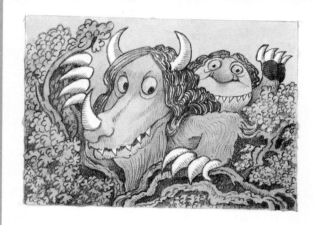 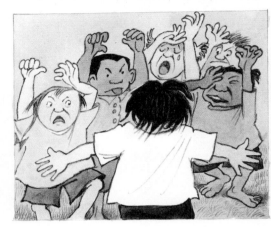

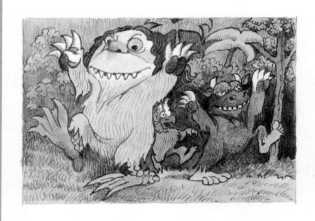

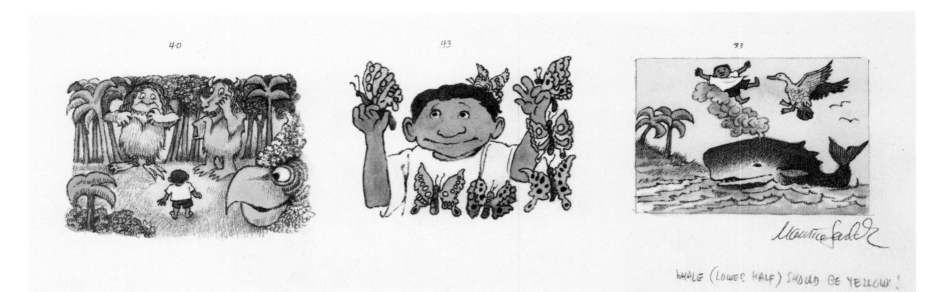

WHALE (LOWER HALF) SHOULD BE YELLOW!

Wild Things Are Happening: Internet

TOP: Storyboard sketches for *Boy with Wild Things, Catching Butterflies and Whales*, 1997. Pencil and watercolor, each panel approximately 2½ x 3½ inches.

BOTTOM: Storyboard sketches for *Swimming into the Ocean*, 1997. Pencil and watercolor, each panel approximately 2½ x 3¼ inches.

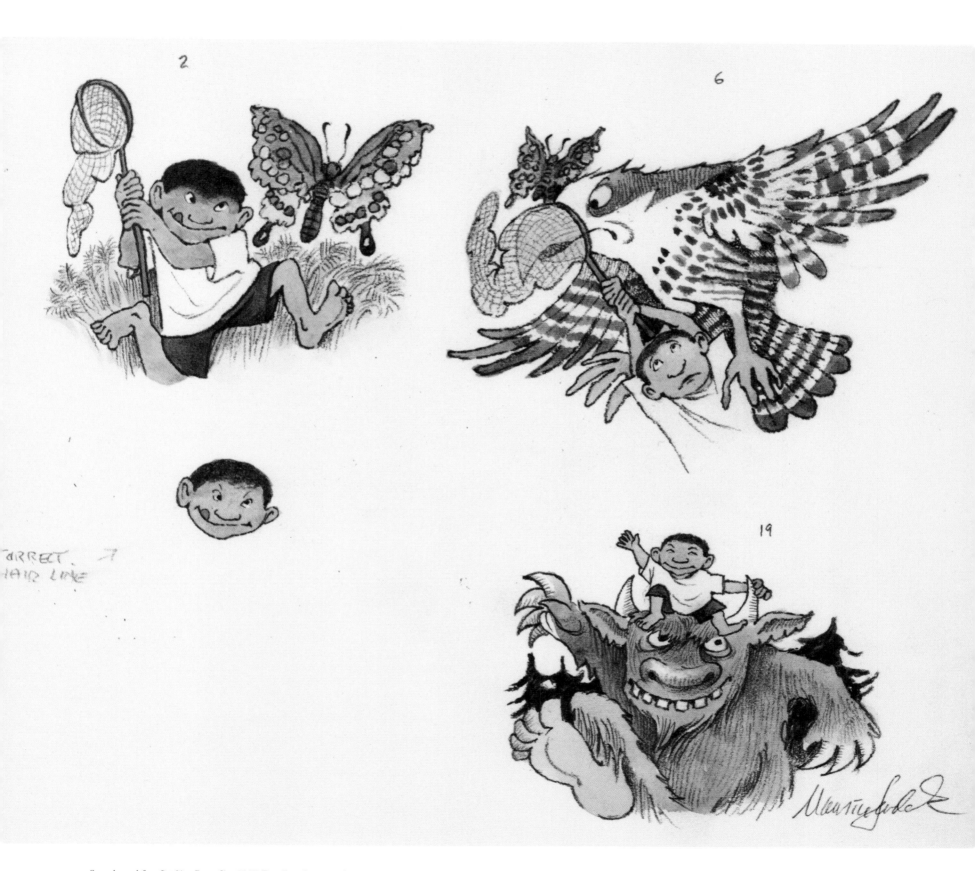

Storyboard for *Catching Butterflies*, 1997. Pencil and watercolor,
each panel approximately 2½ x 3½ inches.

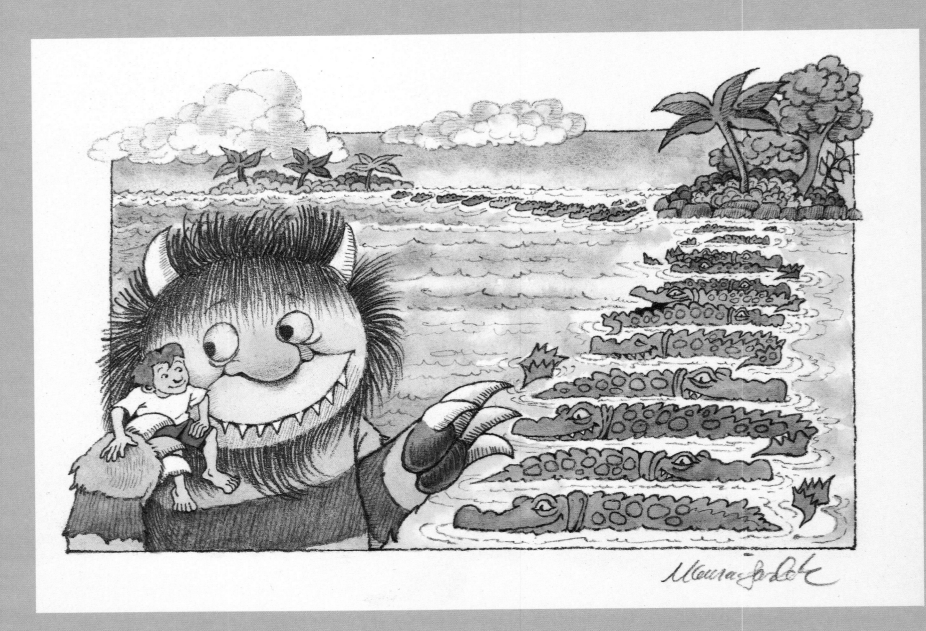

ABOVE: *Alligator Bridge*, 1997. Pencil and watercolor, 4½ x 6⅞ inches.

RIGHT: Preliminary drawing for *Alligator Bridge*, 1997. Pencil, 4¼ x 7 inches.

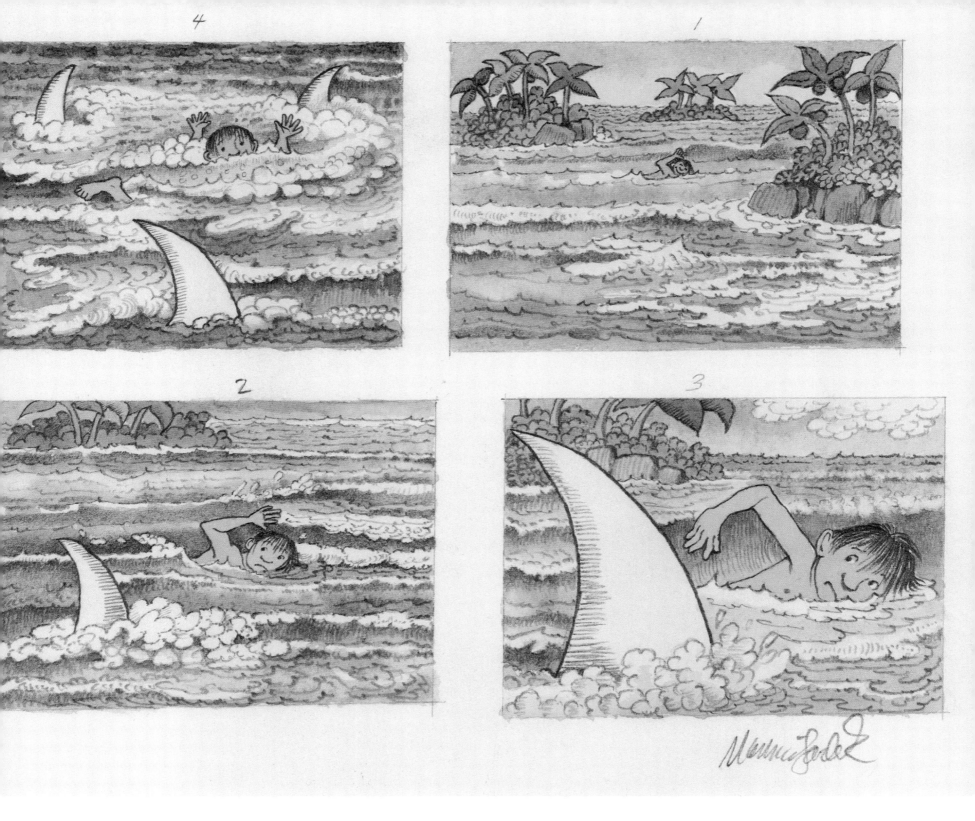

Wild Things Are Happening: Seahorse

This fourteen-panel storyboard depicts an animation sequence of a boy swimming among what appear to be sharks. Upon surfacing, however, the sharks turn out to be four Wild Things ready to assist. They present the boy with options of conveyance, and he chooses a seahorse (over a squid). He then departs on the back of a friendly *Hippocampus*, signifying the reliability of Bell Atlantic's services.

ABOVE: Storyboard for *Seahorse*, 1997. Pencil and watercolor, each panel approximately 2½ x 3¼ inches.

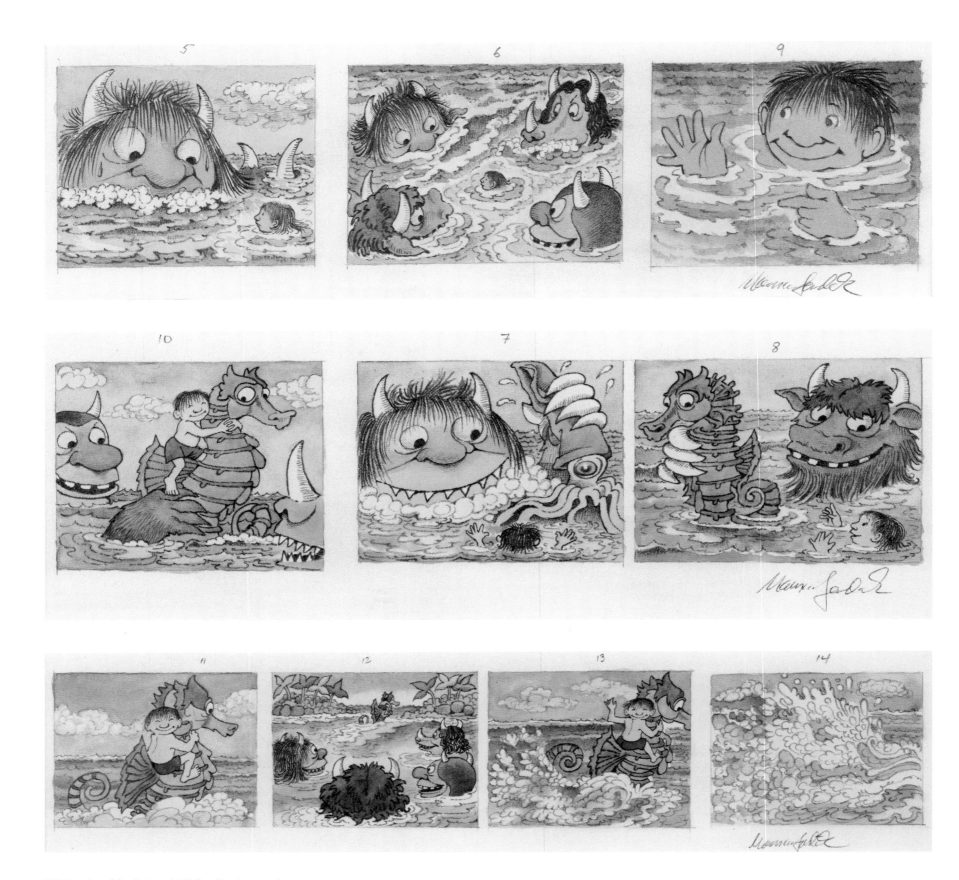

TOP: Storyboard for *Seahorse*, 1997. Pencil and watercolor, between 2³⁄₈ x 3¹⁄₈ and 2⁵⁄₈ x 3¹⁄₂ inches.

MIDDLE AND BOTTOM: Storyboard for *Seahorse*, 1997. Pencil and watercolor, each 2¹⁄₂ x 3¹⁄₄ inches.

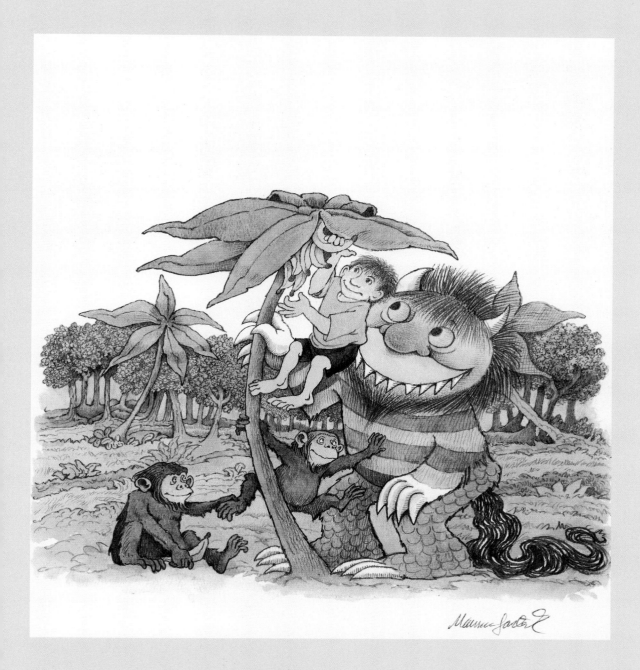

Wild Things Are Happening: Tailored Solutions

LEFT: *Tailored Solutions*, 1998. Pencil and watercolor, 7¼ x 10 inches.

ABOVE: Preliminary drawing for *Tailored Solutions*, 1998. Pencil, 10½ x 10 inches.

1

2

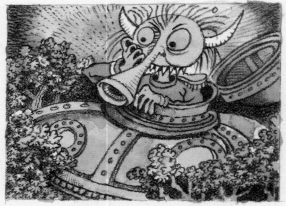

4 *[signature]*

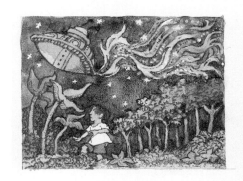

1 (Jonathan's Board)

3 (Jonathan's Board)

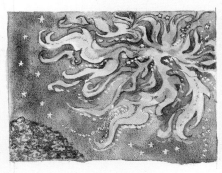

18 (Jonathan's Pearl) *[signature]*

Just-in-case-Moons!

5

6

7

5

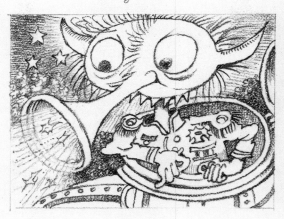

6

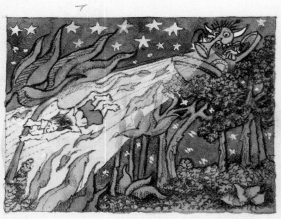

7 *[signature]*

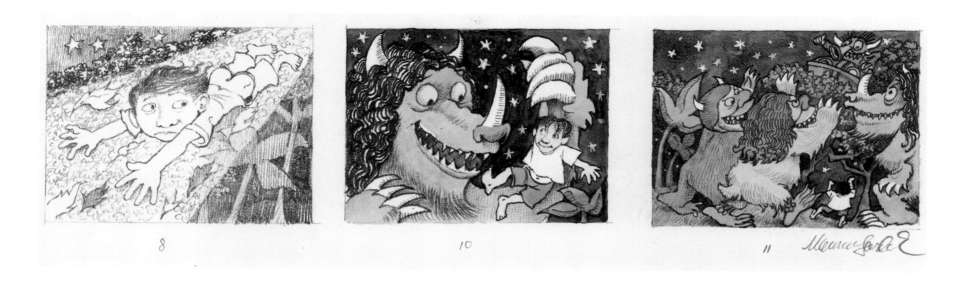

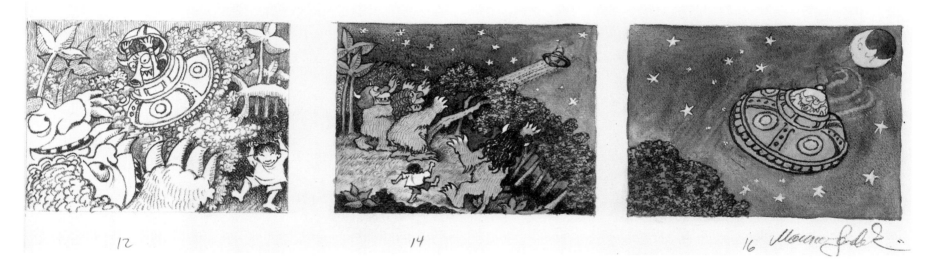

Wild Things Are Happening: Aliens

OPPOSITE: Storyboards for *Aliens*, 1998. Pencil and watercolor, each panel 2½ x 3⅜ inches.

ABOVE: Storyboards for *Aliens*, 1998. Pencil and watercolor, each panel 2½ x 3¼ inches.

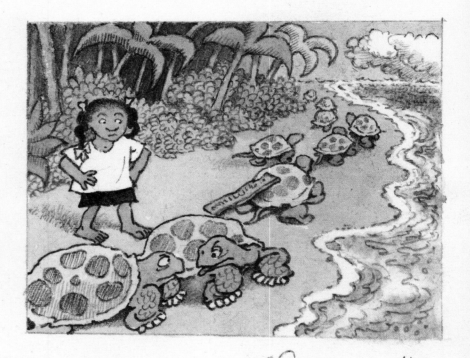

Wild Things Are Happening: Turtles

ABOVE: Storyboard for *Turtles*, 1998. Pencil and watercolor, each panel 2½ x 3¼ inches.

OPPOSITE: Storyboards for *Turtles*, 1998. Pencil and watercolor, each panel 2½ x 3¼ inches.

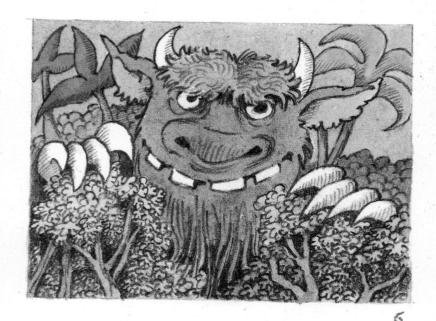

6

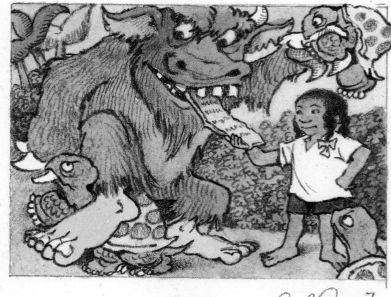

7

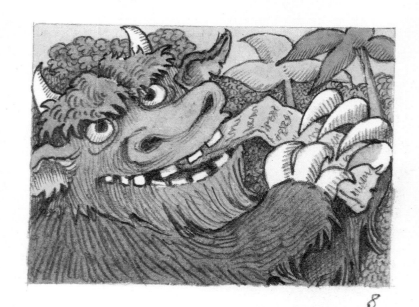

8

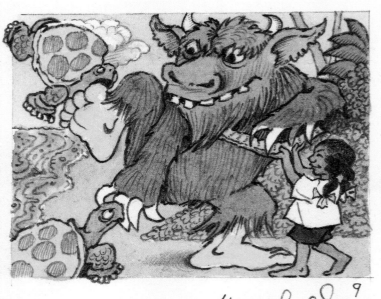

9

RIGHT: Study for *Turtles*, 1998. Pencil, 9¼ x 8⅞ inches.

BELOW: Storyboard for *Turtles*, 1998. Pencil and watercolor, each 2½ x 3¼ inches.

OPPOSITE, TOP: Preliminary drawing for "*Something even scarier could be lurking in your phone bill*," 1998. Pencil, 5½ x 6¼ inches.

OPPOSITE, BOTTOM: "*Something even scarier could be lurking in your phone bill*," 1998. Pencil and watercolor, 5½ x 6⅞ inches. Created for Bell Atlantic's print advertising campaign, this illustration appeared on a flyer that addressed cramming-and-slamming practices by rival companies.

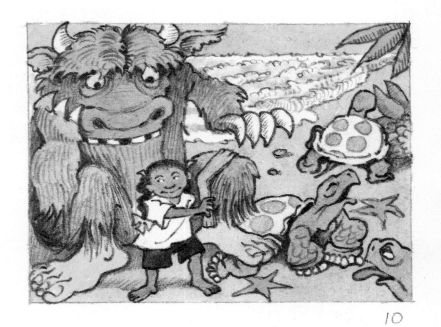

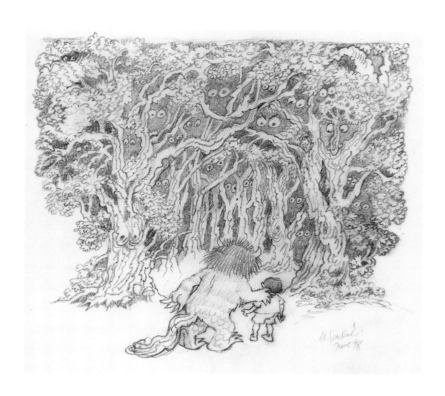

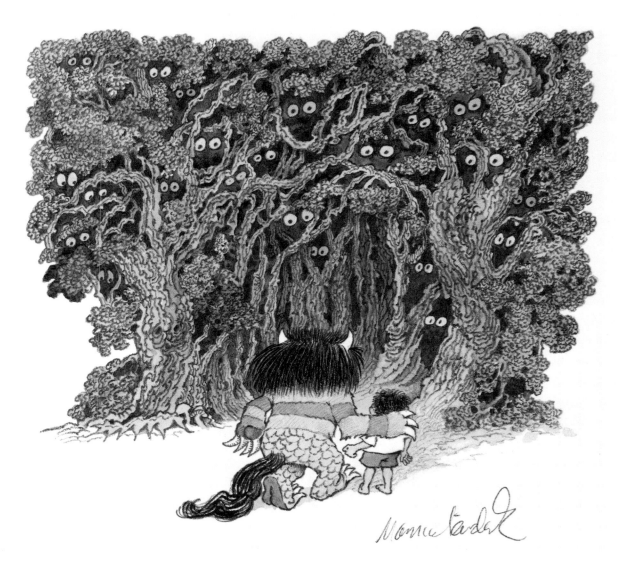

New York Is Book Country, 1979. Printed poster, 24 x 9 inches. The New York Is Book Country Festival was a popular event held annually for a quarter century to promote literacy and the joy of reading. It featured contemporary children's publishers and booksellers, related-craft sellers, a benefit auction, and eventually, an antiquarian books section. Maurice Sendak designed full-color posters for the first (1979), tenth (1988), twentieth (1998), and twenty-fifth (2003) celebrations.

CHAPTER IV: POSTERS

Sendak's Few but Significant Posters
by Steven Heller

Maurice Sendak was not a poster designer. Well, not one per se, but he made some beautiful posters, which are collected in a handsome jumbo-sized book titled *Posters by Maurice Sendak* (1986). You'd think, then, that this would qualify him as a bona fide *affichiste*.

Perhaps.

The poster is a distinctive genre with its own conventions; it is not simply a blown-up image that is larger than a book or magazine illustration. The quintessential poster designers—from Toulouse-Lautrec in the nineteenth century to Milton Glaser in the twentieth—conceive of their posters to be for, well, posting, but also as one of many in an oeuvre that must be considered as one of their main bodies of work. Sendak stated in the introduction to his book that posters "make up a very small part of my picture making." Yet he added, "Paradoxically, I have a disproportionate affection for these easy images."

Lautrec and Glaser probably would not classify their respective posters as "easy images." Posters require forethought and attention to typographic and imagistic details. They are made, in most cases, to be viewed from distances, rather than contemplated from nearby. But for Sendak, "they came easy" because "they were painted in rare moments of relaxation." He wrote, "Often they were the happy summing up of conglomerate emotions and ideas that had previously been distilled into picture books and theatrical productions."

Not all of the images in *Posters by Maurice Sendak* are, in fact, posters, if the genre is defined as a deliberate combination of word and picture to convey a clearly defined message or to sell a product or idea. Some are just large narrative pictures—beautiful and convincing to be sure, but tableaux and not strictly posters. Others are indeed advertisements for events like International Children's Book Day or New York Is Book Country, wherein Sendak's hand-lettering plays a crucial part in communicating specific information. So while Sendak did not set out to be a poster designer, he might well be considered an honorary one because in aggregate, posters are indeed an aspect of his overall work.

There are some real gems, too. The theatrical bill for *Really Rosie*, a performance written and production designed by Sendak, with music by Carole King, is a freeze-frame of two engaging Sendakian characters. Everything about the poster—from the smart hand-lettering of the title and credits to the compositional acuity and delightful color decisions (Rosie's red dress jumps out of the frame)—is brilliantly conceived and executed. Likewise, the exquisite layered image and handsome art nouveau lettering for *The Cunning Little Vixen* echo Lautrec's Folies Bergère posters. In the poster for *The Magic Flute* performed by Houston Grand Opera, he pays homage to his beloved composer Wolfgang Amadeus Mozart while at the same time tipping his hat to Henri Rousseau's jungle in *The Dream*.

Sendak enjoyed quoting the past and the artists he admired. He referenced Winsor McKay (of *Little Nemo in Slumberland* fame) in his classic *In the Night Kitchen*, and so why not Lautrec? Why not Rousseau? But he also enjoyed the ease of being himself, which involved a considerable amount of wry wit and subtle satire. In a poster for Children's Book Showcase, he riffs on Little Red Riding Hood with hilarity and conviction while staying true to the conventions of poster making. Dressed as Grandma, the hungry wolf wears a sandwich board that captures Red's eyes and hints at something foreboding. Full of overt and subtle details, this is nonetheless a classic poster because the huge sign, on which the lettering sits, draws the eye into the image and then to the picture and its story.

Sendak's posters were rarely occasions to experiment with entirely new methods. Many poster designers do, as a rule, use the genre to try new vocabularies and styles. On the contrary, Sendak used the extra space to stretch out with his favored characters and allow them a chance to breathe more than they could on a book page. "About the presence of Wild Things in so many of my posters," he wrote, "they are, for better of worse, the best known of my characters, and therefore their suitability as poster people seems self-evident to me." A poster for the Junior Museum of the Art Institute of Chicago is a case in point. Drawing on his Wild Things, Sendak devised a comic tableau of two monsters, one a sculptor and the other the sculpted. It is the perfect evocation of art for children. His characters evoke so much that it would have been a shame not to employ them. He wrote that they were consciously "used to turn a pompous occasion into a simple amusement." One such joyful amusement was a poster/album cover he created for a performance of *Kenny's Window*, with music by the eternal Mozart, sung by the unsinkable Tammy Grimes. It features an imposing chicken with four legs that has not reappeared elsewhere to my knowledge.

Posters are a distinct genre, but after perusing this "small part" of Sendak's picture making, it is easy to see that in whatever he created, he had the heart of a poster maker, the eye of a book illustrator, and the soul of an artist.

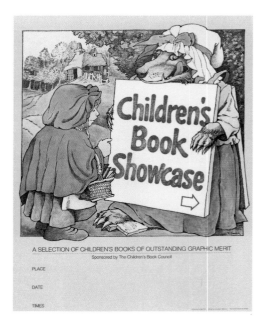

ABOVE: *Children's Book Showcase*, 1976. Printed poster, 21⅞ x 18 inches. The Children's Book Council of New York held annual exhibitions of children's books of graphic merit. In this poster design, Little Red Riding Hood inspects a sandwich board held by the Big Bad Wolf, pointing the way to the Book Showcase display at Irving Plaza, a music-hall venue near Union Square in Manhattan.

OPPOSITE: *Children's Book Showcase: Little Red Riding Hood*, 1976. Pencil, pen-and-ink line, and watercolor, 15⅜ x 16⅛ inches. This poster design is Sendak's first published depiction of Little Red Riding Hood. (See page 183 for Sendak's mechanical pop-up Red Riding Hood based on a childhood toy he created with his brother, Jack.)

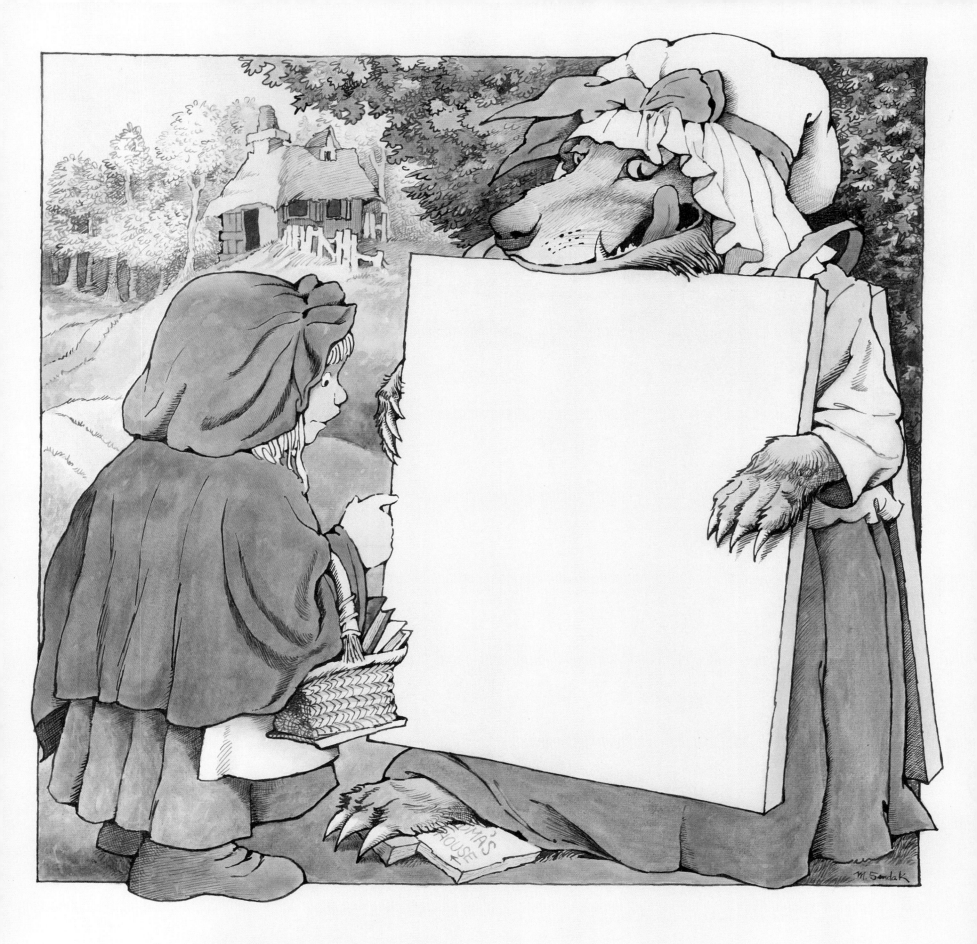

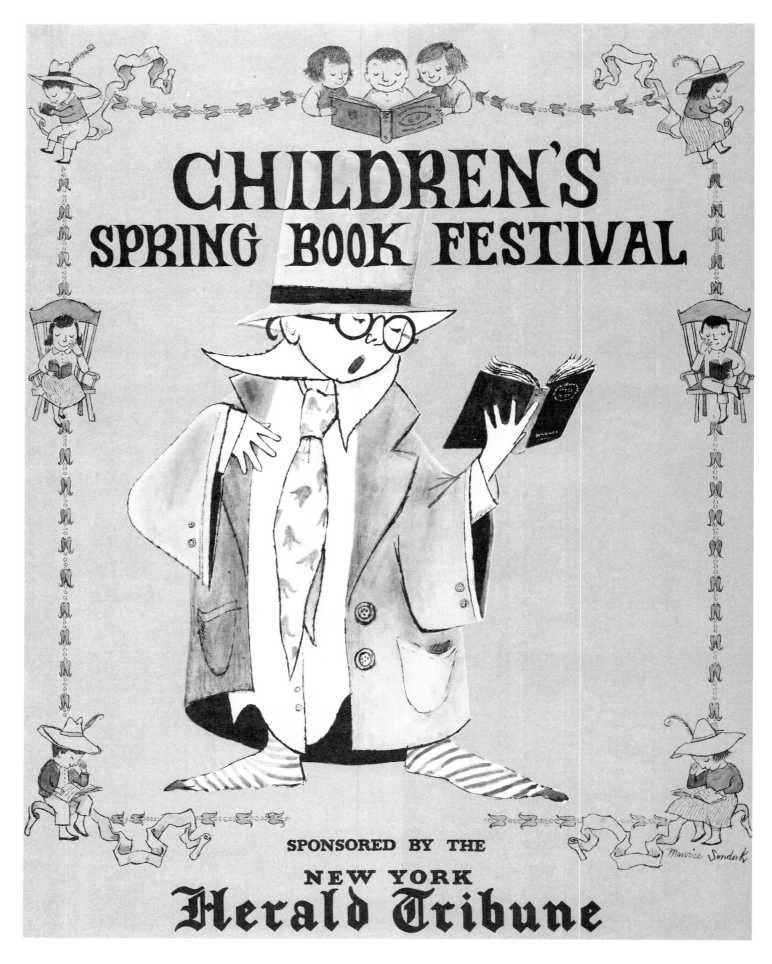

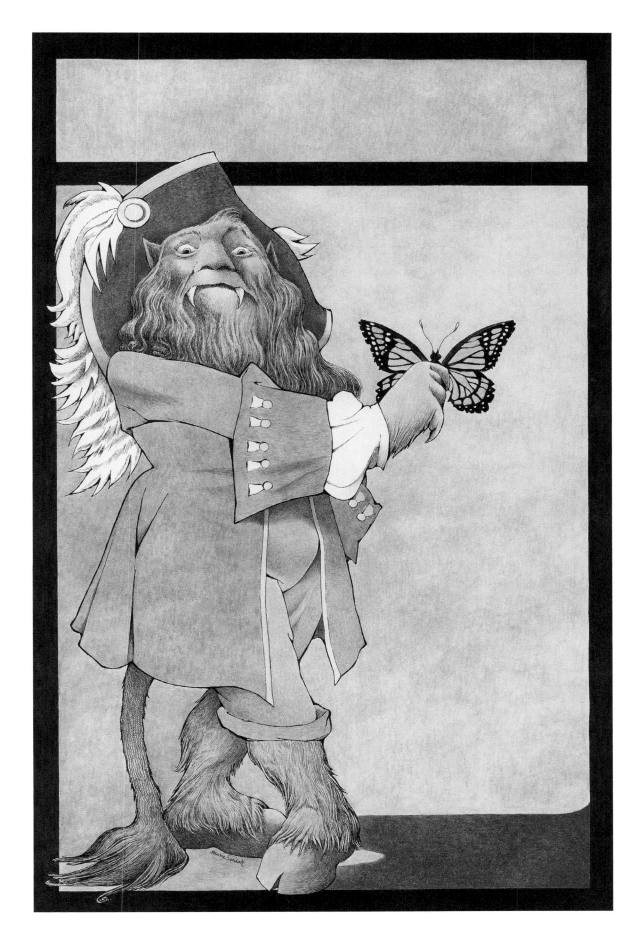

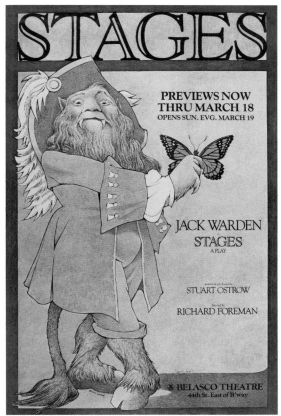

LEFT: *Stages*, 1977. Pen-and-ink line and watercolor, 27⅞ x 14 inches. Maurice Sendak's first theatrical poster design for a Broadway show.

ABOVE: *Stages*, 1977. Printed poster, 45 x 29½ inches. Written by Stuart Ostrow, *Stages* premiered at the Belasco Theatre on March 19, 1978. It ran thirteen previews (beginning March 4, 1978) but closed after opening night. Consequently, *Stages* is among the rarest of Sendak's posters.

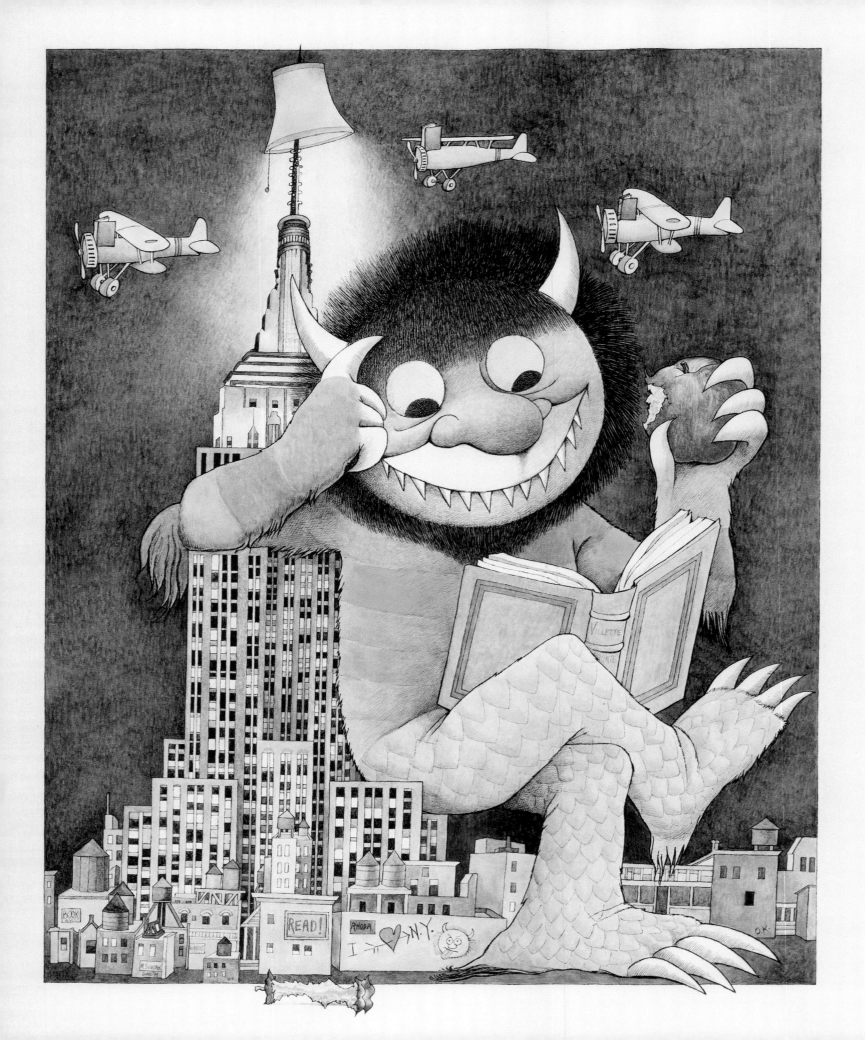

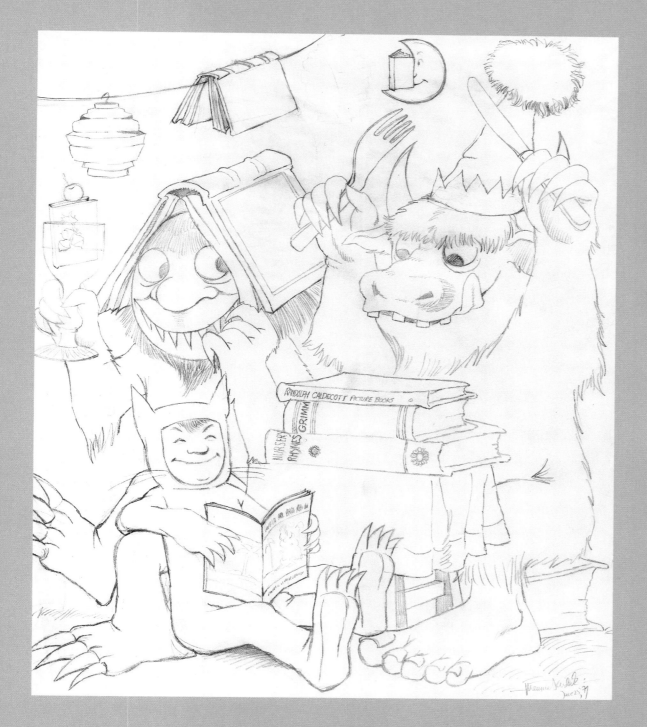

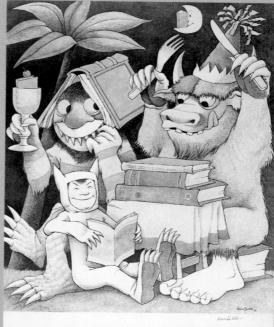

READING IS FUN!

INTERNATIONAL YEAR OF THE CHILD 1979

Reading Is Fundamental, Inc.
Maurice Sendak

OPPOSITE: *New York Is Book Country*, 1979. Pen-and-ink line and watercolor, 19⅛ x 15¾ inches. Sendak's original design for the poster created for the first annual New York Is Book Country Festival. (See printed poster on page 102.)

LEFT: Preliminary drawing of *Reading Is Fun!* 1979. Pencil, 20¾ x 17¾ inches. Sendak created this poster design for Reading Is Fundamental, Inc. (RIF), a nonprofit organization promoting children's literacy.

ABOVE: *Reading Is Fun!*, 1979. Printed poster, 37 x 23½ inches. Original poster created for Reading Is Fundamental, Inc. (RIF), to celebrate the International Year of the Child.

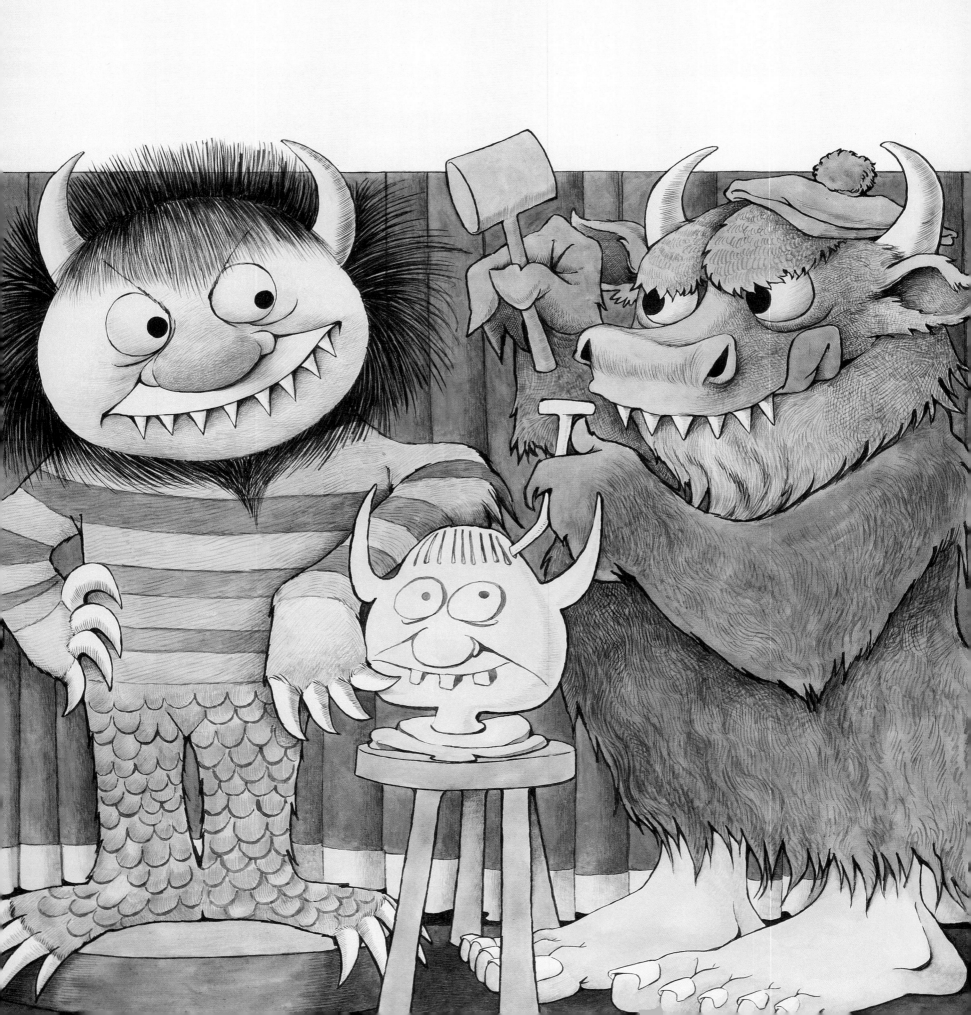

OPPOSITE: *The Junior Museum, The Art Institute of Chicago*, 1985. Pencil, brush, and watercolor, 22⅛ x 19¼ inches. This original drawing depicts "Moishe" Wild Thing modeling while "Bernard" Wild Thing sculpts a bust. The Junior Museum was founded in 1964 by the Woman's Board of the Art Institute of Chicago, under the direction of Museum Education. This facility opened with a gallery devoted to exhibitions for school children, and original works of art were an integral part of these installations.

LEFT: *Jewish Book Month*, 1985. Pencil and watercolor, 12⁷⁄₁₆ x 12½ inches. Sendak created this poster in honor of Jewish Book Month, an event sponsored by the Jewish Book Council to promote Jewish books. This annual celebration was initiated in Boston in 1925 as a weeklong event; it was eventually extended to a full month in 1943 and continues to be observed annually.

BOTTOM, LEFT: *The Junior Museum, The Art Institute of Chicago*, 1985. Printed poster, 22 x 19 inches.

BOTTOM, RIGHT: Preliminary drawing of *Jewish Book Month*, 1985. Pencil, 12⅜ x 12½ inches.

LEFT: Preliminary drawing for *Sundance Children's Theater*, 1988. Pencil on acetate tracing paper, 24 x 19 inches. This study for the poster, a haunting montage, features handwritten text. It is among Sendak's finest and most precise nature studies.

ABOVE: *Sundance Children's Theater*, 1988. Printed poster, 22 x 17 inches. Created for the Sundance Institute, a collaboration between Sendak and Robert Redford to create a repertory theater for children. The poster was initially released as a fundraiser but later withdrawn when the joint venture ended.

OPPOSITE: *Sundance Children's Theater*, 1988. Pencil and watercolor, 22½ x 17½ inches. This drawing was created while Sendak was working with Robert Redford's Sundance Institute to develop a national repertory theater for children. Eventually this joint venture proved too difficult to organize, and Sendak went on to create his own Night Kitchen Theater with Arthur Yorinks.

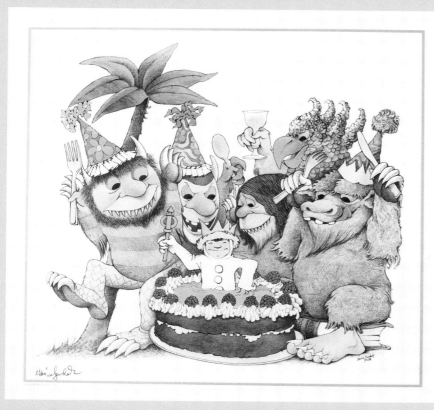

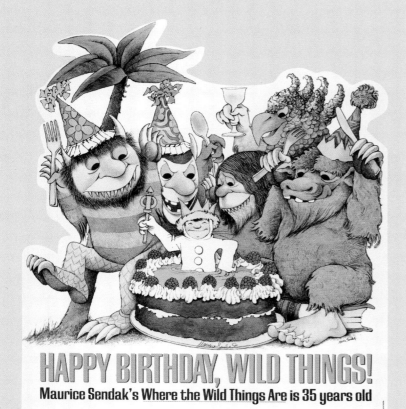

OPPOSITE: *Happy Birthday, Wild Things!*, 1988. Pen-and-ink line and watercolor, 15 x 16¼ inches. Created for the twenty-fifth anniversary of *Where the Wild Things Are*, this commemorative illustration was used by Harper & Row for promotional posters and advertisements; it was then reused by HarperCollins in 1998 as a cutout poster for the book's thirty-fifth anniversary.

ABOVE: *Let the Wild Rumpus Start!*, Harper & Row, 1988. Printed poster, 19 x 25½ inches. This commemorative poster was issued in celebration of the twenty-fifth anniversary of *Where the Wild Things Are*.

LEFT: *Happy Birthday, Wild Things! Maurice Sendak's* Where the Wild Things Are *is 35 years old*, 1998. Printed poster, 24¾ x 22 inches. This die-cut poster was issued by HarperCollins.

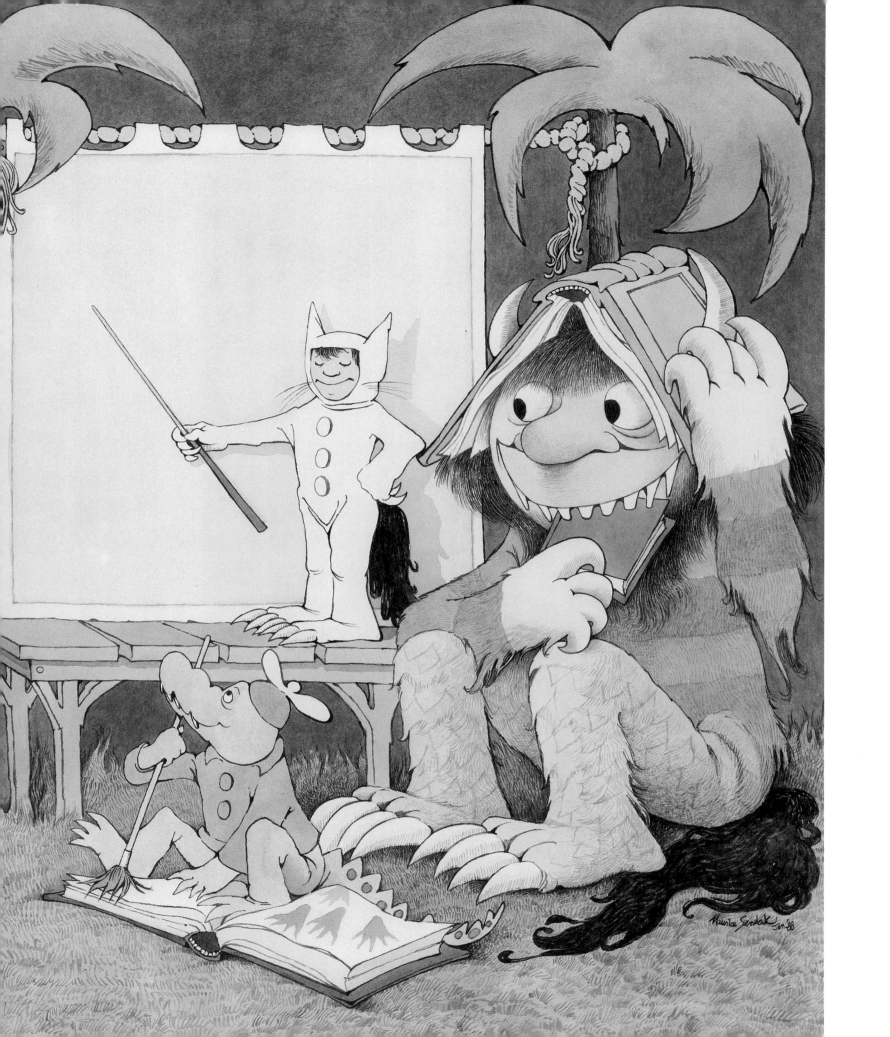

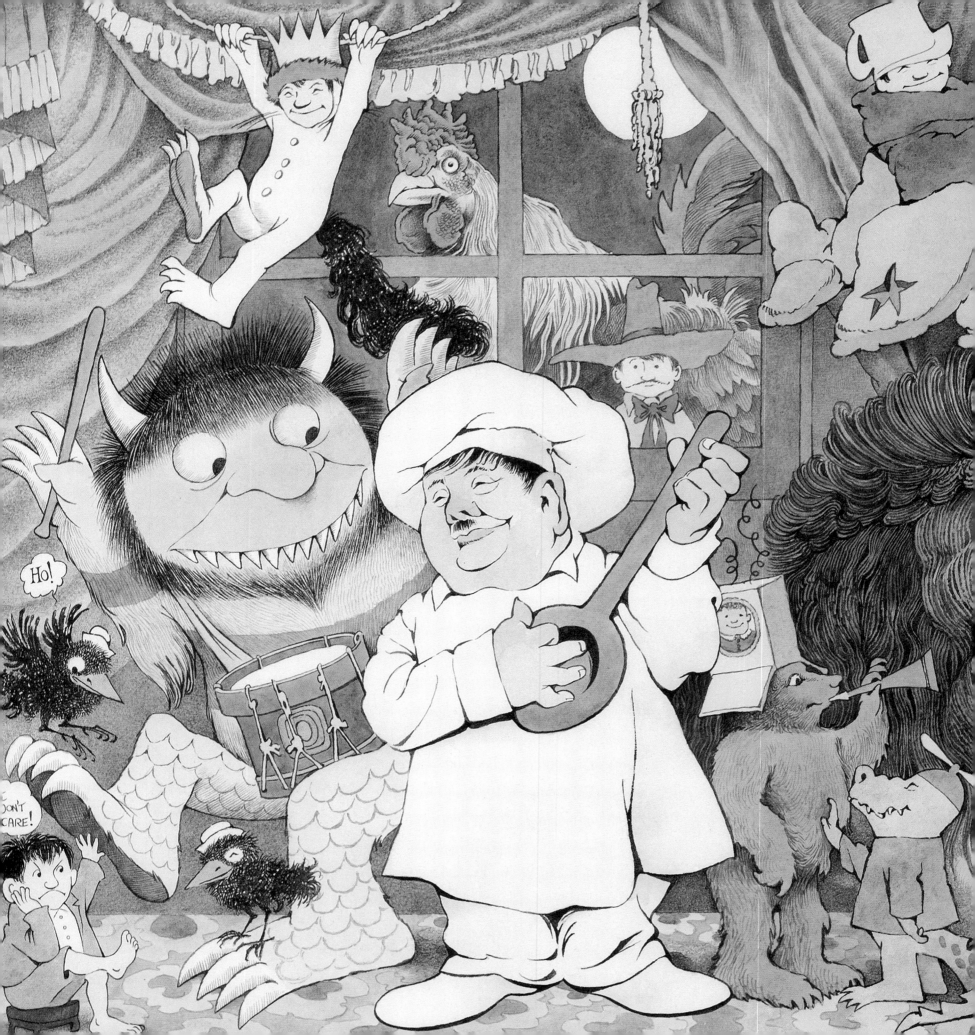

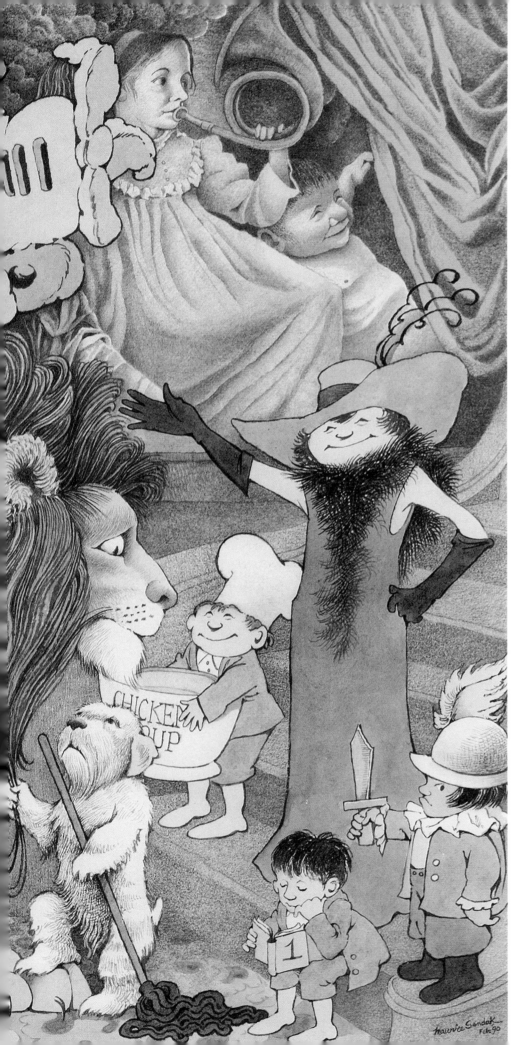

In Celebration of Maurice Sendak, 1990. Pencil, pen-and-ink line, and watercolor, 15 x 21 inches. Intended for use on a promotional poster for the reissue of Sendak's books, this illustration shows the artist's most iconic picture-book characters. The project was delayed for ten years, which prevented a wide distribution. The image eventually was revised—the characters from *We Are All in the Dumps with Jack and Guy* were added—and printed in 2001 to celebrate Sendak's fifty years as a children's book artist.

Really Rosie, 1980. Pencil, pen-and-ink line, and water-color, 11 x 7 inches. Original full-color study for the poster for the theater production, which opened in New York on October 14, 1980.

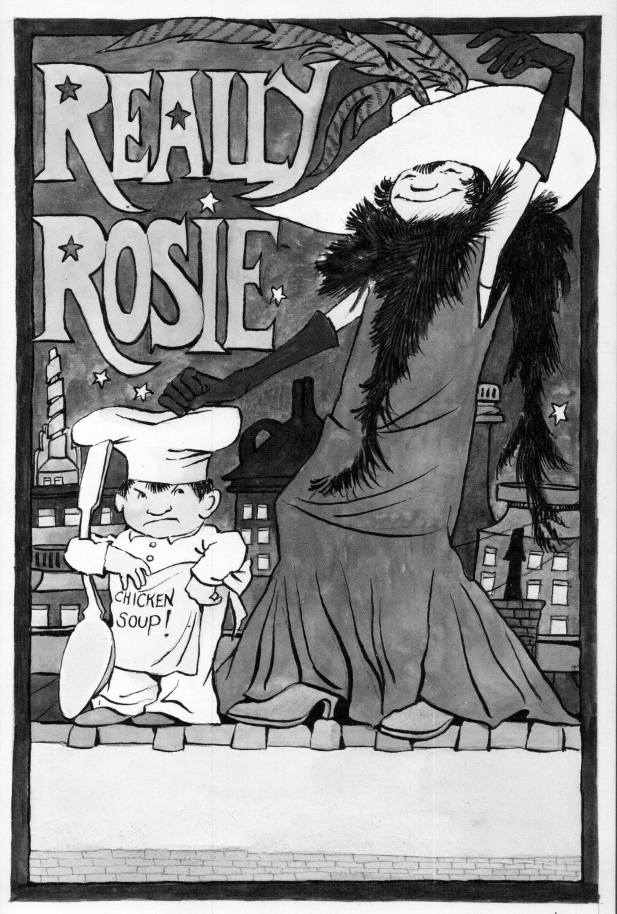

CHAPTER V: REALLY ROSIE

Rosie and the Nutshell Kids

eally Rosie is based on boyhood observations of a precocious young girl and her street friends. Maurice didn't know her personally but sketched them from his window as Rosie transformed herself in a fantasy romp with her brother Chicken Soup, as well as Pierre, Alligator, Johnny, and her best friend, Kathy. She recruits them to audition for an imaginary musical with singing and dancing, all leading to her being "discovered" as a future Hollywood starlet. Maurice initially introduced the character in *The Sign on Rosie's Door* (1960) and then created a series of diminutive stories and number- and alphabet-learning books as *The Nutshell Library* (1962): *Chicken Soup with Rice, Pierre, One Was Johnny*, and *Alligators All Around*, which he eventually linked together as an animated cartoon with music composed and performed by Carole King. Written and directed by Maurice Sendak and produced by Sheldon Riss, the film first appeared on CBS television as a half-hour special on February 19, 1975. To instruct the animators on the uniqueness of his characters, in 1974 Sendak created a series of pencil studies showing expressions and body language, often annotated with brief commentary. A small number of watercolor sketches were also done to provide background settings. Maurice had worked earlier with other animation projects for *Sesame Street*. These included a two-minute version of *Bumble-Ardy* (1971), which eventually evolved into Sendak's last picture book (2011), and a cartoon prologue for Christmas that was directed by R. O. Blechman and included in Public Broadcasting's *Simple Gifts* (1977).

The transformation of *Really Rosie* into a live-action musical directed and choreographed by Patricia Birch began at the Music Theater Lab in Washington, DC, in 1978, without sets or costumes, then expanded for off-Broadway at the Chelsea Theater Center (aka Westside Theatre, 407 West 43rd Street, New York), opening October 14, 1980, and running 274 performances. The play has stayed in the repertoire of children's musical theater ever since.

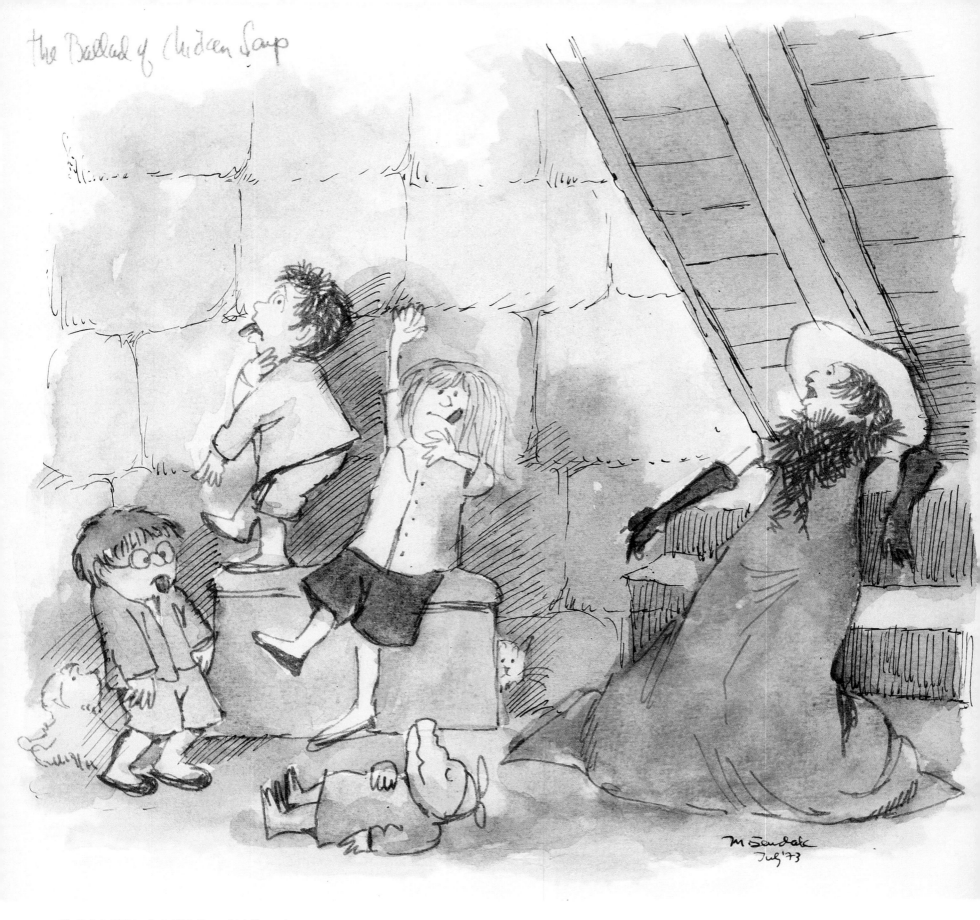

The Ballad of Chicken Soup, 1973. Pen-and-ink line and
watercolor, 8 x 9 inches.

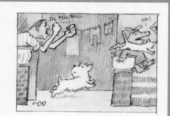

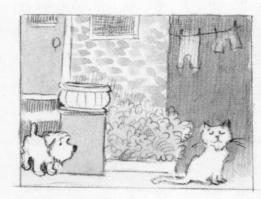

Storyboard for *Did You Hear What Happened to Chicken Soup?*, 1974. This sequence of illustrations shows Jennie chasing a cat through the neighborhood.

TOP: Pencil and watercolor, (top panel) 3⅛ x 5¹¹⁄₁₆ inches and (bottom panels) approximately 2½ x 1⅞ inches.

BOTTOM, LEFT: Pencil and watercolor, (top panels) 2³⁄₁₆ x 3⅜ inches and (bottom panels) 3⅛ x 3⅜ inches.

BOTTOM, RIGHT: Pencil and watercolor, (top panels) 2⁵⁄₁₆ x 3⅜ inches and (bottom panels) 2¾ x 4⅛ inches.

Storyboard for *Running Cats and Dogs*, 1974. Pen-and-ink line and watercolor, 7¾ x 18⅝ inches. Eight panels on one rectangular perforated sheet, these conceptual drawings were made for an animation sequence.

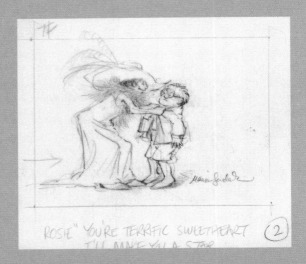

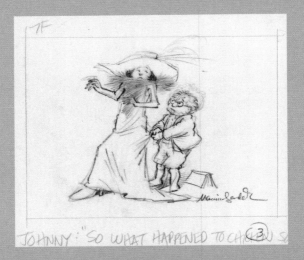

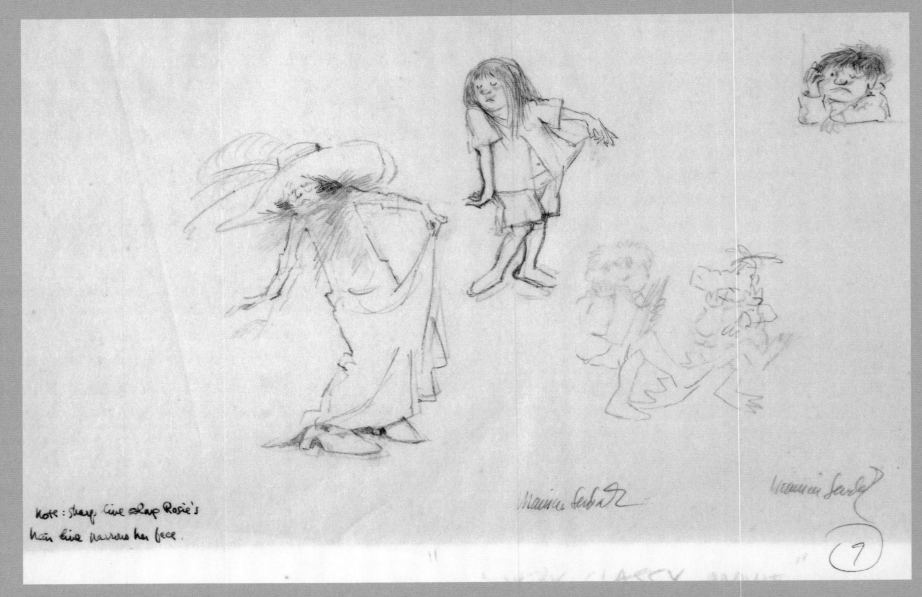

TOP, LEFT: Study for "*You're terrific, sweetheart,*" 1974. Pencil, 5 x 4½ inches.

TOP, MIDDLE AND TOP RIGHT: Studies for *Johnny:* "*So what happened to Chicken Soup?,*" 1974. Pencil, each 4¾ x 4⅛ inches.

BOTTOM: Study for *Rosie, Kathy, Pierre, and Alligator,* 1974. Pencil, 5 x 8⅝ inches.

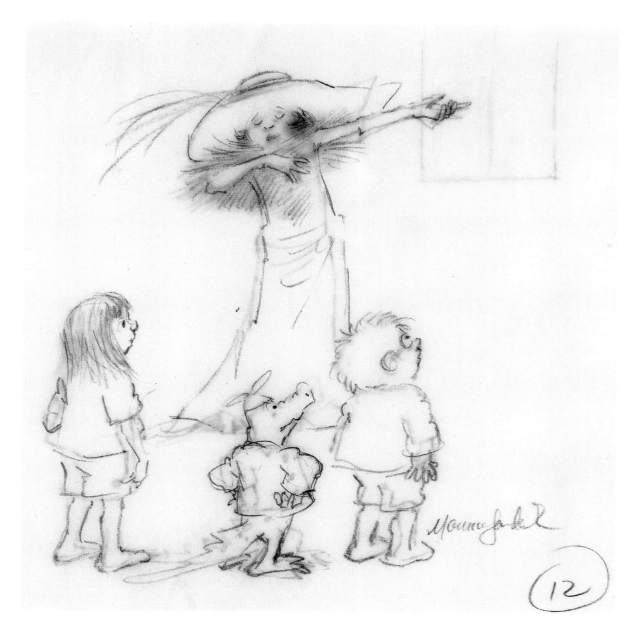

LEFT: Study for *Rosie, Kathy, Alligator, and Pierre,* 1974. Pencil, 6⅛ x 4⅝ inches.

BOTTOM, LEFT: Study for "*A typical Miss America pose,*" 1974. Pencil, 4¾ x 4¾ inches. This drawing includes extensive artist's annotations and instructions for the animator: "Rosie here is super-gushing–prepared to show us her favorite person–She is mugging at the camera–she strikes a typical Miss America type pose–" "Ron: is there any reason why Chicken Soup–or rather the Spirit of C. S.–shouldn't be sitting on the stoop à la my sketches? In this drawing where is he sitting??"

BOTTOM, RIGHT: Study for *Rosie and Kathy with Pierre from the Window,* 1974. Pencil, 4⅜ x 8½ inches. The annotation reads, "Rosie looks very bored-hopeless, as tho she didn't expect much–all exaggerated enacting. Kathy must wiggle + waggle–must be ridiculous–remember Ruby Keeler! Let her swing her ass sort of hoola-like."

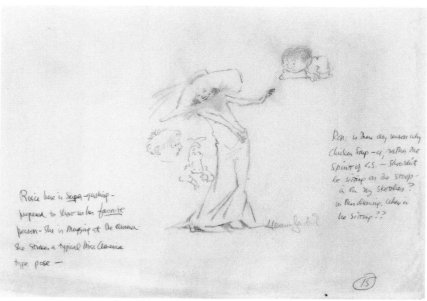

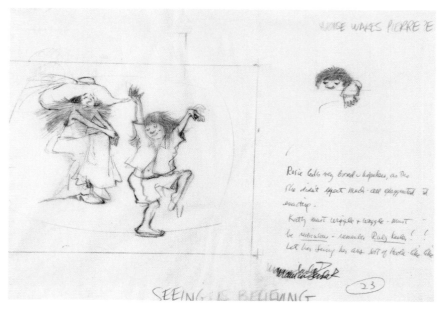

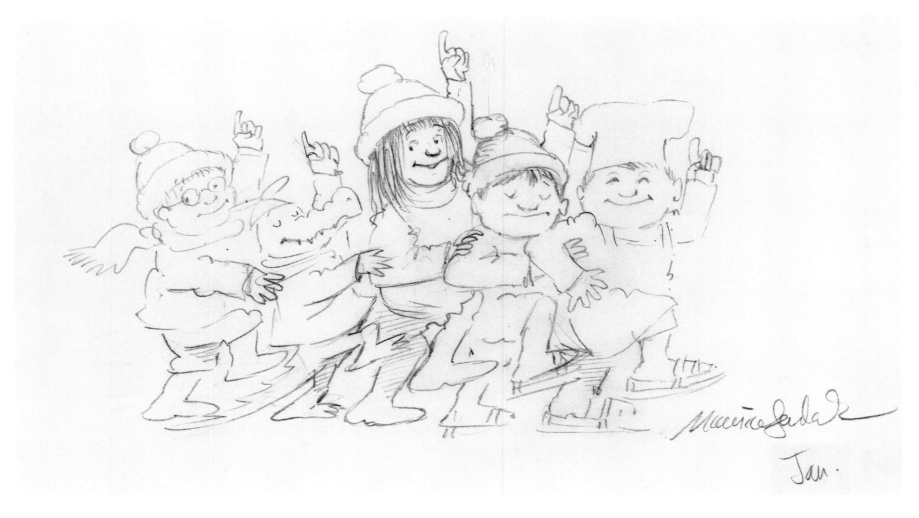

TOP AND BOTTOM: Studies for *Chicken Soup with Rice: January, June, and August*, 1974. Pencil, each 3¾ x 6 inches or smaller. These three sketches, made for the animators, depict the Nutshell Kids singing about different months of the year.

OPPOSITE, TOP: Six studies for *The End*, 1974. Pencil, 8 x 11¼ inches.

OPPOSITE, BOTTOM LEFT: Study for "*No star shines as bright as me*," 1974. Pencil, 4½ x 6 inches.

OPPOSITE, BOTTOM RIGHT: *Rosie and the Nutshell Kids: A CBS-TV Special*, 1975. Printed standup advertisement card, 12 x 18 inches. This card announced the date of the film's television premiere as February 19, 1975, but the film was not finished until February 14th and so not aired until the 23rd.

Wasn't that a *swell* Marie?

meow.

The end

You said it!

CREDITS

Maurice Sendak

②

sigh

burp

giggle

yawn

Maurice Sendak

No Star Shines so bright as me

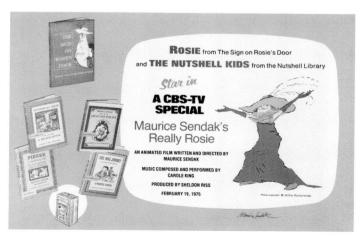

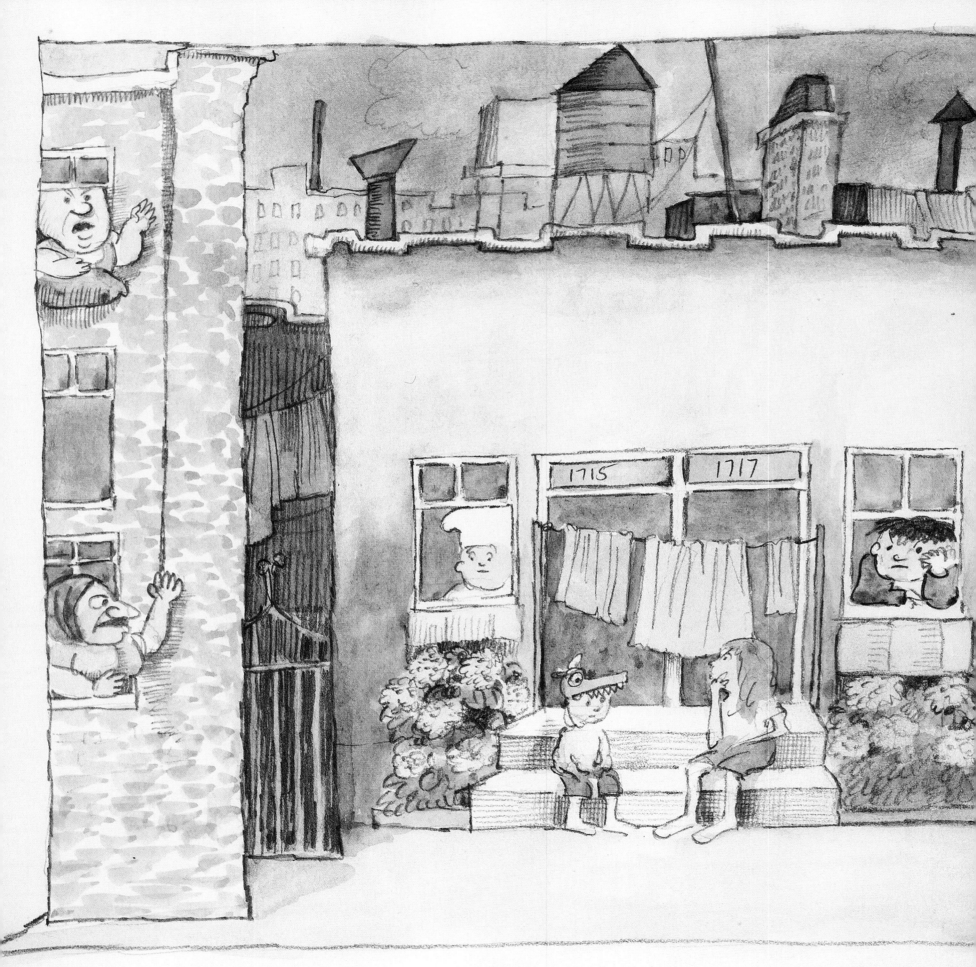

Really Rosie - Act

Study for *Really Rosie*, Act I, Scene 1, 1980. Pencil and watercolor, 7 x 11½ inches. Full watercolor stage-set design for the musical production.

Hansel and Gretel, 1996. Pencil and watercolor, 4 x 4 inches. This opera, based upon the original narrative by the Brothers Grimm and set to music by Engelbert Humperdinck with set and costume designs by Maurice Sendak, premiered on October 24, 1997.

CHAPTER VI: ON STAGE: THEATER, OPERA, AND BALLET

M & M (Maurice and Me)
by Frank Corsaro

The Goddess Serendipity made one of her most felicitous moves when her wand wafted Maurice into my orbit. I had just received an offer to direct a new production of *The Magic Flute* for Houston Grand Opera. Without a moment's hesitation, I decided Maurice Sendak should design the sets and costumes for Mozart's opera. Mind you, I'd never met the man, and to my knowledge, he had never designed for the theater. My inspiration was based on owning most of his children's books—collected for the gratification of my own inner child, and for the future child that would be born out of my recent marriage. Not only was he born, he was partly weaned on Sendak, and would, at eight years old, perform the role of the eagle in Janáček's opera *The Cunning Little Vixen*—a figure created by Sendak for New York City Opera. That would be my second collaboration with Maurice. How quickly, with pen in hand, one can travel—I had not as yet snared the elusive Mr. Sendak—and so with cell phone poised, telephone number punched in, I heard this voice:

Voice: [*gravely yet sweet*] Hello!

Me: Hello. May I please speak to Mr. Sendak?

Voice: Who is calling him?

Me: My name is Frank Corsaro. If this is Mr. Sendak, I certainly know who you are! The problem is whether my name is familiar to you in any way.

Voice: Are you the opera director?

Me: [*relieved*] That's me! I'm calling to pose a question. Have you ever given any thought to designing an opera?

Voice: I think you've got the wrong number then, Mr. Corsaro. Opera? Me? [*some gargling sound*]

Me: I'm perfectly serious!

Voice: But why me?!!

Me: Just because you're you! [*more gargling sounds*] I am speaking to Maurice Sendak?

Voice: Yes—sure—and you also know I write and illustrate children's books . . . !!!

Me: I know and—

He: [*interrupting with a tinge of desperation*] I'm mired! Mired in kiddy-book land. Of course I know who you are! I love the opera! Especially your *Traviata*! What more can I say?

Me: Mired or not—you've got to face the fact that opera is the biggest kiddy book in the world. [*I could feel that I'd thrown him an unexpected curve.*] Besides, there's a debut for everything in the arts, Mr. Sendak!

He: So—nu? Which one do you have in mind?

Me: *The Magic Flute!*

[*silence*]

Me: *Die Zauberflöte* [*I repeat*]

He: You don't mean—*the*—[*pause*]

Me: Why? Do you know another opera with the same title?

He: Mozart's!!!??

Me: Who else's?!

He: *Oy gevalt!* [*followed by more gurgling, and little squeaks*]

Me: So—nu?

He: Are you Jewish?

Me: I will be by the end of this conversation!

He: Listen, I've got to think about it. Give me your number!

Me: [*I gave it to him.*] Take your time, but not too much time. The head of the company in Houston is pressing the issue.

We soon met. I shook a sweaty palm—wet with hopeful anxiety. I shook the same palm a week later in my apartment—with the Houston capo in tow.

Capo: Listen, Mr. Sendak, designing an opera is not the same as writing a children's book . . .

I looked at Sendak and saw a flash of a Wild Thing in his eyes. I posited that under other circumstances, the capo's gaucherie would have been met with a fulcrum of curses on his head— but the lure of the flute beckoned.

M: I agree—only in part. But tell me, have you ever seen or read any one of my books?

The capo fumbled in his briefcase, removed a recently purchased *Wild Things*, and held it up in display.

M: Turn it around—and take a good look at the cover.
[*The capo did just that—and all the beasties nailed him with their fulsome beastliness.*]

M: Now—if that's not opera, what is it?!!

Maurice and I looked at one another, and so we were wed.

During our preliminary work on the production, Maurice disclosed his private ownership of one of Mozart's most remarkable letters—the one written after his mother's death—a masterwork. It was kept in a special folder with a plastic cover. Maurice translated the German text. Listening to him, I realized Mozart was the sine qua non inspiration in his life. This treasure was bequeathed to the Rosenbach Museum & Library in Philadelphia— along with other treasures.

The final designs for *The Flute* were staggeringly confident and original—a fantasia of Egyptiana and Restoration Masonry. The production was a huge success and traveled through countless opera houses in the US and Canada. Only photos of its glories are in existence, for the Goddess Serendipity had taken a vacation. Within days of her departure to sunnier climes, the production foundered in the storage space of Florida Grand Opera. An off-season hurricane occurred unexpectedly and destroyed all the paneled sets and fanciful costumes.

Maurice's response was to take the calamity as his doing—an omen against his ever having wandered from his bailiwick—and he conjured up the Lindbergh kidnapping, an obsession with death. He returned home to undue stress and incipient depression. He withdrew into himself and, for a while, hardly spoke to anyone— including me!

Wonder of wonders, the Goddess Serendipity returned to her throne, suntanned and feistier than ever. Maurice and I, with one further swish of her wand, were pulled out of our doldrums and rewarded with four glorious summers at the Glyndebourne Festival in England. We were the first Americans invited to work there.

The first opera was . . . finally! A comedy! Sergei Prokofiev's *The Love for Three Oranges*, with its outrageous pranks, pratfalls, Wizard Villainess Balloon, and Monster Puppet Cook. This production, we learned, went a long way toward dispelling the last vestige of gentility still lurking in the Glyndebourne ethos. The production became a sort of lovefest, where a permissible form of delirium seized us all—including its formally dressed audiences.

And then there were the gardens, the picnic grounds out back, with steep embankments scattered throughout the area, where expensive linens were spread to hold the picnic suppers during intermission. Beyond was the long pond holding a flotilla of large water lilies and Sendak frogs—the area was surrounded by masterfully designed topiary. For the souvenir program, Maurice, finally relaxed as never before, painted a study of Mozart wandering through the garden.

The next summer, the rapture was to continue with another delectable soufflé—the double bill of *L'heure espagnole* (the sexiest opera ever written) and its inseparable companion *L'enfant et les sortilèges*, both by the other Maurice [Ravel]. *L'enfant* is a masterpiece in its own right but oh so very difficult to produce. Our answer came from Ravel himself. After completing the work (it took him ten years to realize Colette's little pastiche), he offered it to Walt Disney—a rightful choice! Disney, however, thought it too "special" for his kiddy audience (Mickey Mouse was still the rage at the time) and turned it down. Mickey was also beloved by Maurice. One of Maurice's passions was to locate as many replicas and variations of the mouse as he could find. Ultimately, he managed to own the single most complete collection of his hero's exploits. The mouse was to lead us to solve the *L'enfant* dilemma: Disney represents topsy-turvy land—cartoon representations of human, animal, and mineral. In Ravel's opera, the fire sings, the numbers in the arithmetic lesson follow suit, an armchair and sofa converse. Rather than symbolizing them with dancers, simulating their presence by classic movement, we opted to create them via multimedia cartoons in Excelsis. Maurice's kiddy-book land rose and

triumphed—by actually moving. His artfulness was further demonstrated when he painted his cartoons in the spirit of the twenties— the era of the foxtrot—in which *L'enfant* takes place.

Then, the next summer, came the realization of *The Wild Things* and *Higglety Pigglety Pop!*, with the Wild Things in their idealized monstrousness—figures ten feet high, whose antics were re-created by nonsingers within their massive bodies operating machinery, all made more vivid by the brilliant and haunting music composed by Oliver Knussen, completely apposite for the book's characters.

After Glyndebourne came a tour of *Wild Things* and *Higglety*, commencing with a limited run in London (sold out and out)! It was followed by Zurich and a provincial stop in a suburban theater affiliated with Zurich Grand Opera. Then, it was overseas for a special two weeks at New York City Opera, with *Wild Things* going it alone, performing twice daily. *Higglety* was resumed as its companion piece in Los Angeles. Then, a much-needed break!

Meanwhile, under Glyndebourne auspices, a second company had been prepared, which toured the nearby provinces in England. In conjunction with the double bill, but shown on alternate days, was a loving new English version of *The Love for Three Oranges* made by the playwright Tom Stoppard. The original company of *Wild Things* was brought back the following summer to Glyndebourne for its last run in its original home. Following Glyndebourne came two hops away—first in Amsterdam and then in Kansas City, which concluded the international tour. In each of the above venues, we were forced to substitute other companion pieces for *Higglety*, which was deemed too subtle for the Dutch taste.

Amsterdam produced one of our most powerful endeavors ever: Igor Stravinsky's *Renard the Fox*—or, as it was billed, *Der Voss*. This medieval horror show was Maurice's homage to H. Bosch. As in *Wild Things*, the singers sang and gibbered from the pit while acrobats leapt, spinned, and otherwise contorted themselves to simulate the antics of their beast-y characters.

Lyric Opera of Kansas City preferred lighter fare to offset *Wild Things*. The animal focus was maintained, however, with Mozart's *The Goose of Cairo*, which featured a glimmering monster of a goose with shy, seductive eyes, who dominated the stage—as

our singers appeared out of, disappeared into, straddled, and otherwise cavorted all over its glistening hide.

Meanwhile, impatient fans of our work kept campaigning for a new *Hansel and Gretel*. The Goddess Serendipity, by now a devoted opera fan, once alerted to this demand, raised her wand, and before you could say "Engelbert Humperdinck," the die was cast.

We were commissioned by Juilliard Theatre Company and Houston Grand Opera to bring the beloved fairy tale to life. The plan was to open the production in Houston and then travel north to New York, where it would be nationally televised with a super cast of Juilliard students. The result was successfully controversial.

I shall never forget the opening night in Houston. As Maurice and I edged our way to the aisle to mingle during the first intermission, we were confronted by a distraught elder citizen of a lady who started berating us in a loud voice: "How dare you make people cry! This is a children's opera! Whatever possessed you to darken it up like this!?" And in a huff, while continuing to puff to those around her, she made her way out. Others nearby maintained a more composed demeanor, some even smiling and nodding in our direction. Once in the foyer, Maurice and I found a dark recess and hugged one another. We had done this otherwise sweet little opera a favor—by giving it an undercurrent of abandonment and menace!

The curtain to Act One had come down on the following scene: As the Sandman disappears, Hansel and Gretel sing their prayer, invoking the guardian Angels of the Night to watch over them. By ones and twos, other lost children come filtering in from the forest. Hungry, disheveled, still terrified by the dark powers in the witch's employ, and abandoned by their parents, they have reached a dead end. One little girl suddenly collapses, while the others seek comfort around the sleeping Hansel and Gretel. As the night settles oppressively down over them, a small group of angels appears. Preadolescent girls, wearing white, diaphanous sheathes billowing in the light breeze that has accompanied them, station themselves around the sleeping figures—as their protectors. The angel watching over the little girl who has collapsed realizes she is not breathing. Kneeling down, she picks up the child's arm, which quickly falls back to the ground. The child is dead! The angel rises, looks to the others of her kind, all of whom lower their heads. The sleeping children slowly awaken, as if from a nightmare, to realize that the nightmare has come true: One of them has not been able to endure their desolate ordeal and has succumbed to the powers of evil. The angel beside the dead girl slowly lifts her little body and, holding the child in her arms, bears her off to a preferred place—a safe place—her original home in the universe. As the angel bears her burden off, the dark clouds disperse to reveal a Sendak-yellow orb of a moon, its eyes glistening with tears.

The curtain slowly falls.

Maurice and I felt that the dark underpinnings from which the story springs needed to be dramatized, singularly expressed in place of the avalanche of such implications—as in most traditional productions. Not one complaint was made by any child in the audience thereafter. They understood.

The final witch's scene elicited combined images of Maurice's darkest yet most brilliant imaginings: The witch's house, made up of succulent goodies to draw in the unwary child, had big eyes that swiveled left and right, up and down, to survey all comings and goings. In a few productions over the years in European opera houses, the witch was played by a man—an intrepid custom we repeated in Zurich. The result was genuinely fearsome. A marvelous DVD, which is still available, was made in Zurich.

Maurice and I had baked a dozen operatic pies with *Hansel and Gretel*.

Back in the States, ideas for new productions came and went like autumn leaves scattered by the wind. And so we decided to leave it at a dozen, send the Goddess Serendipity a thank-you letter, and call it a day—and we each branched off into other venues.

Maurice became even more solitary, and the books he wrote were darker—until he found himself wresting with neo-Auschwitz settings.

Our past productions were being revived everywhere, but it wasn't the same. Once the revivals ceased, our old routine took over, with months passing before he'd return a call.

Maurice is gone now. He caught the last canoe out into a new brave world.

Sometimes at night, I awaken and sit up in bed, looking into the darkness. I've called out his name several times, hoping for a response. I'm prone to such occurrences, and they've happened! Okay, or so I've imagined. But since I believe such things are possible, I'll take any form of manifestation or connection feasible, thank you. As regards time? I'm used to waiting.

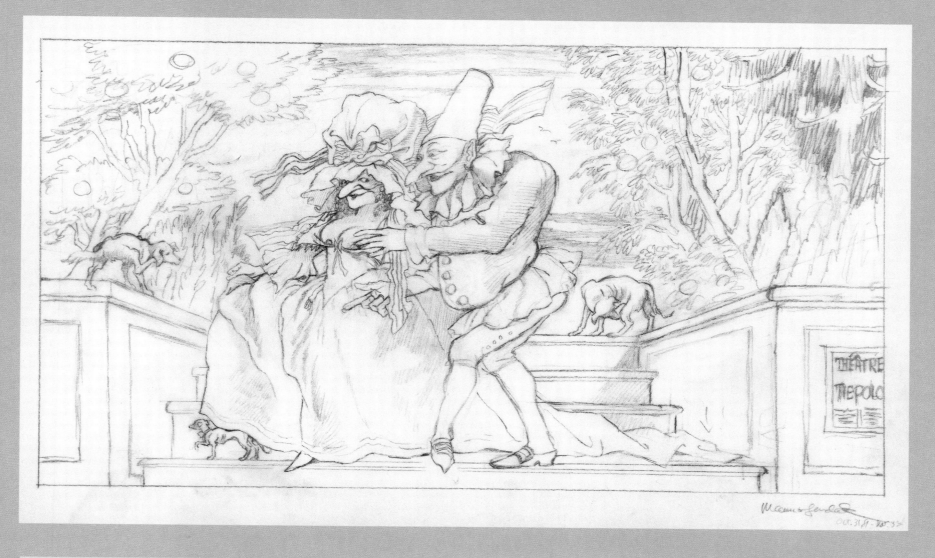

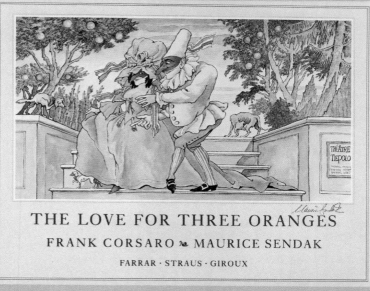

THE LOVE FOR THREE ORANGES

FRANK CORSARO ᴎᴇ MAURICE SENDAK

FARRAR · STRAUS · GIROUX

TOP: Preliminary drawing for *The Love for Three Oranges*, curtain for Act II, Scene 1, 1981. Pencil, 10¾ x 19⅜ inches. A watercolor version of this design was used for the printed poster promoting the book publisher Farrar, Straus & Giroux (1984).

BOTTOM, LEFT: Promotional poster for the book *The Love for Three Oranges*, 14½ x 18½ inches. In 1984 Sendak's set and costume designs were turned into a book (Farrar, Straus & Giroux) that contains a narrative of Sergei Prokofiev's opera as well as a dialogue between Frank Corsaro, who staged the original production, and Sendak.

BOTTOM, RIGHT: Studies of Jennie for *Higglety Pigglety Pop!*, 1983. Pencil, 7⅞ x 6¾ inches. These sketches were prepared for Glyndebourne, where the opera was performed in 1984 together with *Where the Wild Things Are*.

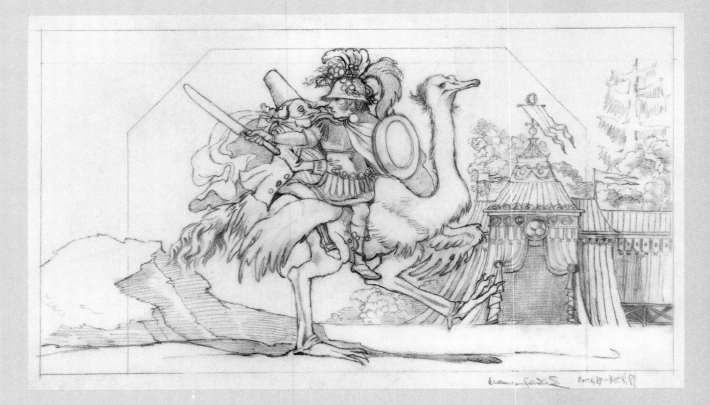

RIGHT: Preliminary drawing for *The Love for Three Oranges,* curtain for Act III, Scene 2. 1981. Pencil, 10¾ x 19¾ inches.

BELOW: Preliminary drawing for *The Love for Three Oranges,* finale drop curtain, 1981. Pencil, 11½ x 18¾ inches.

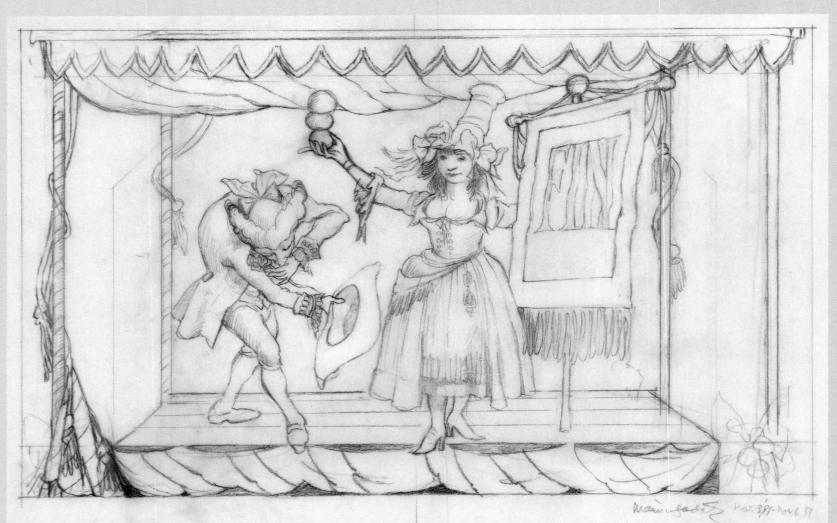

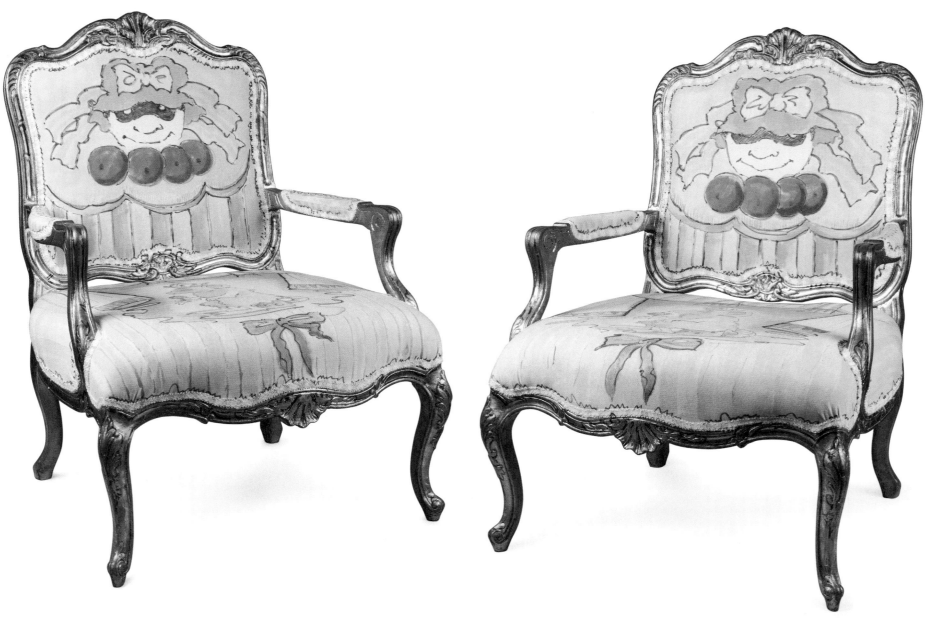

ABOVE: Armchairs for *The Love for Three Oranges*, 1995. Louis XV–style armchairs, decorated with ink and acrylic paint. These chairs were created for Julliard School of Music's 1995 production of Prokofiev's fairy-tale opera. The line drawings on the chairs were executed by Sendak and then painted in by production department staff.

LEFT: Maurice Sendak drawing on two Louis XV–style armchairs, 1995.

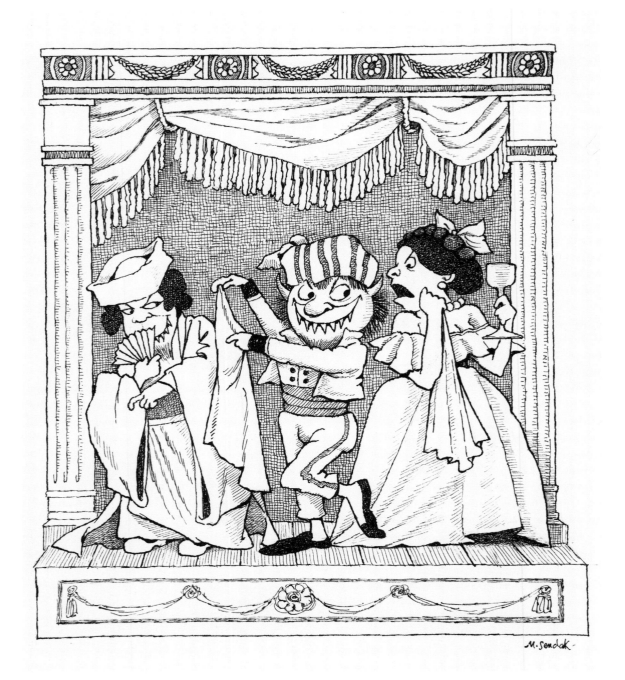

LEFT: Final drawing for *Everyone Deserves a Night at the Opera*, 1982. Pen-and-ink line, 5¼ x 4¾ inches. Created for New York City Opera's 1982 program cover and also used for the poster. In collaboration with Beverly Sills, then New York City Opera's general director, Maurice campaigned to bring opera to a larger audience. The program proved a successful venture, raising awareness of opera and garnering new converts—many of whom had never previously set foot in an opera house.

ABOVE: *Everyone Deserves a Night at the Opera*, 1982. Printed poster, 47½ x 79 inches. Created for New York City Opera and its ongoing campaign to bolster opera's stature and popularity among the general public. This successful advertising campaign was specifically created for bus-shelter billboards.

OPPOSITE: Six character drawings, 1982. Pen-and-ink line, each approximately 1⅞ x 2½ inches. Spot illustrations used for New York City Opera's campaign to recruit non–opera goers to enjoy "a Night at the Opera." The text beneath the figures reads, top to bottom, left to right: "Alceste," "Flute," "Merry Widow," "Mefistofele," "Hamlet," and "Candide." Beverly Sills is caricatured as the Merry Widow.

ALCESTE

FLUTE

MERRY WIDOW

MEFISTOFELE

HAMLET

CANDIDE

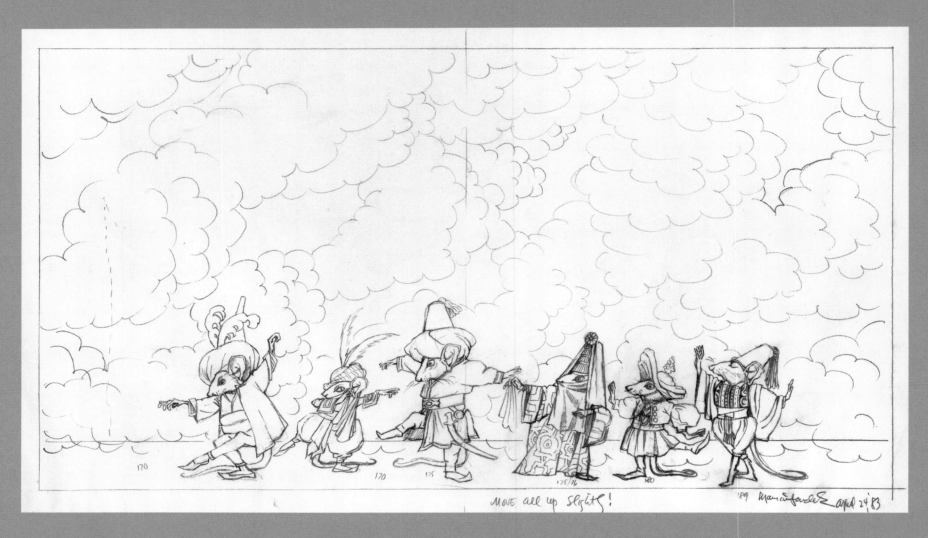

Move all up slight! '89 Marc Sendak april 24 '83

ABOVE: Study for *Six Dancing Mice*, 1983. Pencil, 11⅛ x 20⅞ inches. Production design for scrim for the Pacific Northwest Ballet staging of *The Nutcracker*.

OPPOSITE: *Let the Wild Rumpus Start!*, 1979–83. Pencil and watercolor, 8⅛ x 9¾ inches. Concept illustration (and part of a sequential staging tableau) for the stage set of Glyndebourne Touring Opera. *Where the Wild Things Are* premiered in 1984 at the National Theatre in London and was performed with *Higglety Pigglety Pop!*

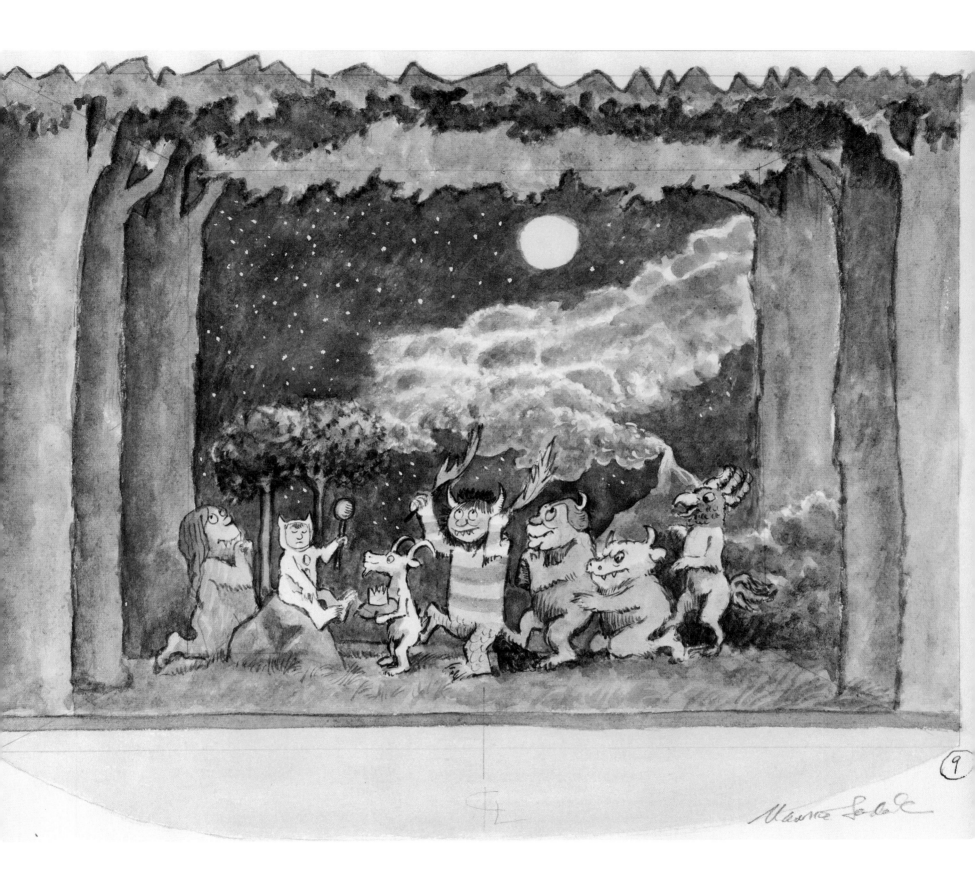

ABOVE: Printed poster, 17 x 11 inches. Poster for Ballet South of Savannah's production of *Where the Wild Things Are*. Created by the choreographer Septime Webre, this production premiered on October 19, 1996, at the State Theatre, New Jersey. It was produced in collaboration with American Repertory Ballet in Savannah, Georgia, where it had previewed a month earlier.

RIGHT: Study for *Sendak in Savannah!: Where the Wild Things Are*, 1996. Pencil, 5¼ x 6 inches. Poster design for *Where the Wild Things Are* world premiere presented by Ballet South of Savannah.

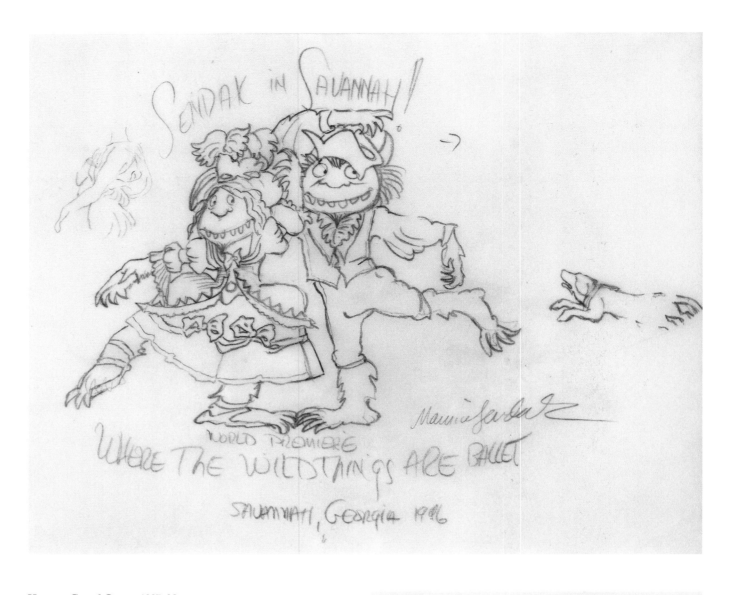

Houston Grand Opera, 1997–98

Sendak created illustrations for Houston Grand Opera's 1997–98 season, which included *Figaro, Arabella, Macbeth, Billy Budd* (together with *Madame Butterfly* as well as *Hansel & Gretel,* for which he also created the costume and set designs). These drawings were featured on programs and other promotional brochures. *Madame Butterfly* and *Hansel & Gretel* were also enlarged and used as poster images.

RIGHT: Preliminary drawing for *Figaro*, 1996. Pencil, 4 x 4 inches.

OPPOSITE: *Figaro*, 1996. Pencil and watercolor, 4 x 4 inches.

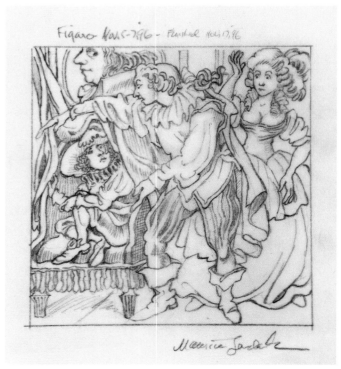

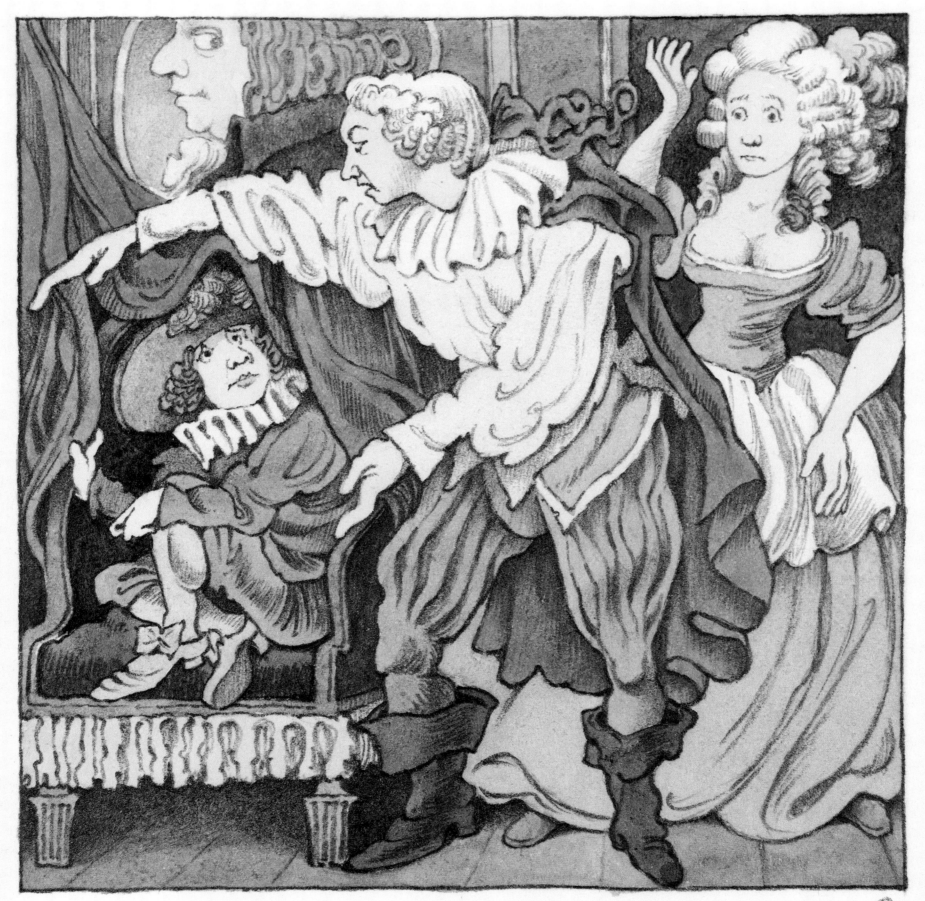

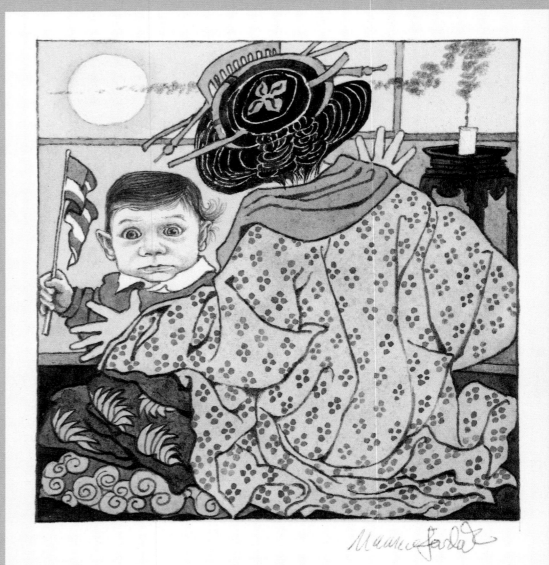

BUTTERFLY - NOV.'96

ABOVE: *Madame Butterfly*, 1996. Pencil
and watercolor, 4 x 4 inches.

RIGHT: Preliminary drawing for *Madame
Butterfly*, 1996. Pencil, 4 x 4 inches.

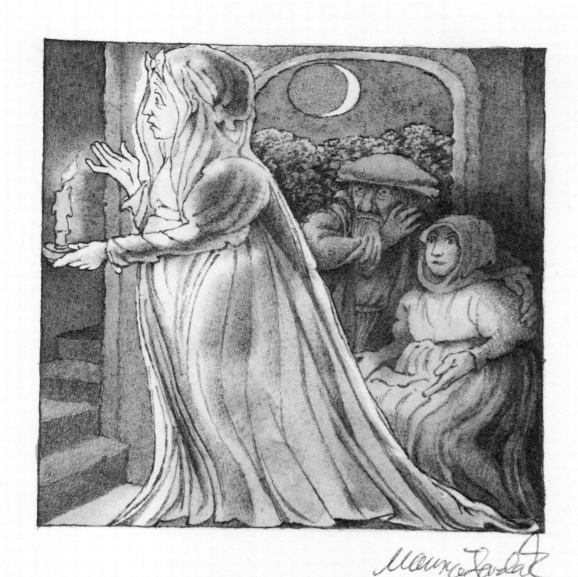

MACBETH - Nov 96

LEFT: *Macbeth*, 1996. Pencil and watercolor,
4 x 4 inches.

ABOVE: Preliminary drawing for *Macbeth*, 1996.
Pencil, 4 x 4 inches.

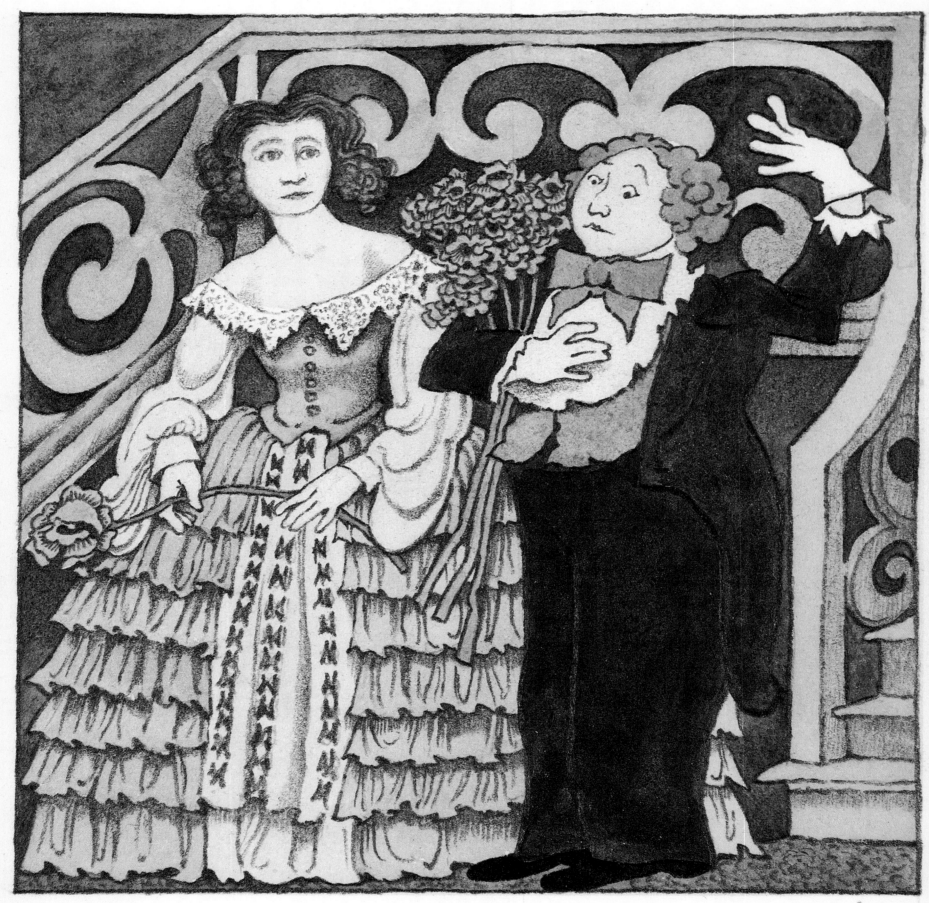

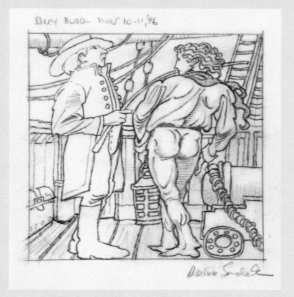

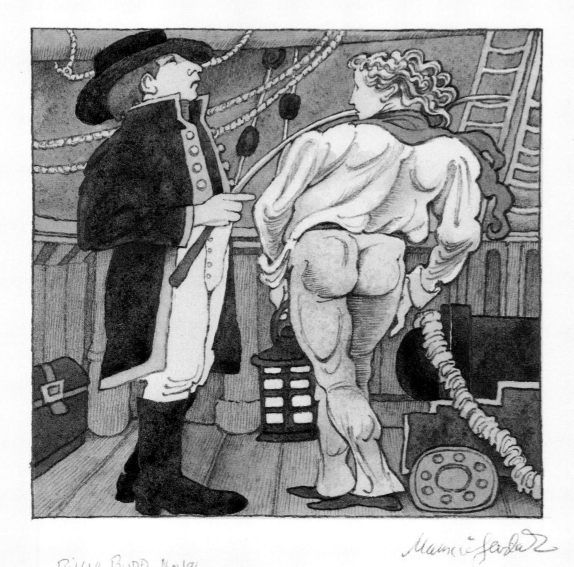

OPPOSITE: *Arabella,* 1996. Pencil and watercolor, 4 x 4 inches.

TOP, LEFT: Preliminary drawing for *Arabella,* 1996. Pencil, 4 x 4 inches.

TOP, RIGHT: Preliminary drawing for *Billy Budd,* 1996. Pencil, 4 x 4 inches.

LEFT: *Billy Budd,* 1996. Pencil and watercolor, 4 x 4 inches.

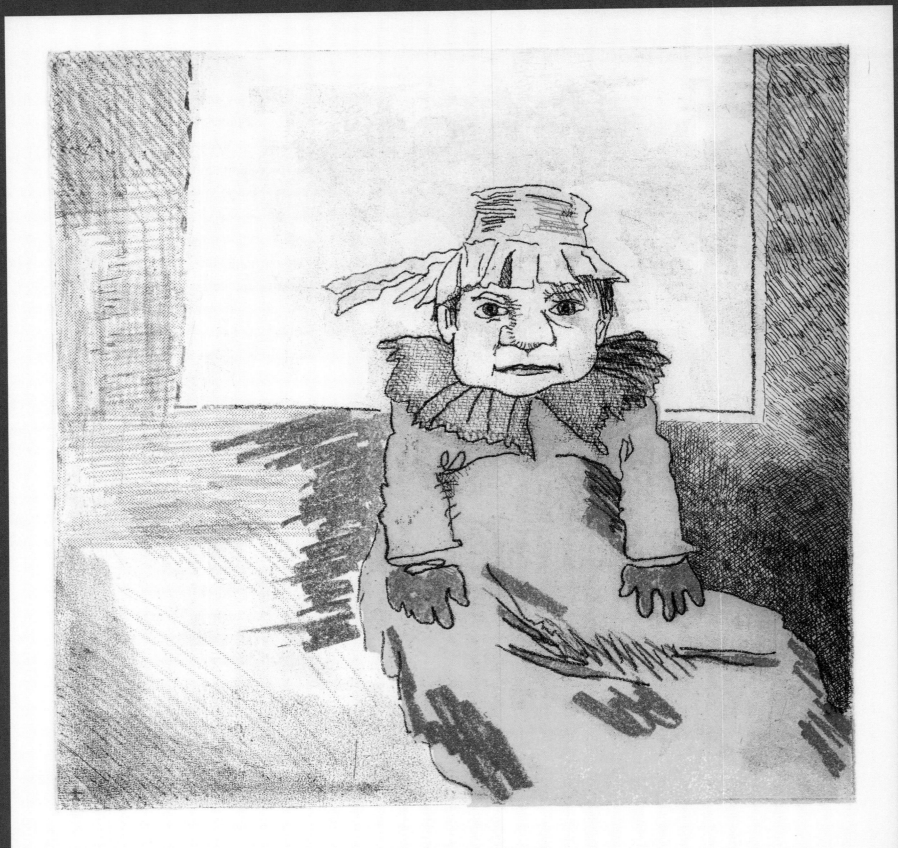

Ice Baby, 1982. Hand-colored etching on mould paper, 9¼ x 9⅜ inches.

CHAPTER VII: MAURICE SENDAK'S INTAGLIO PRINTS, ETCHINGS, AND LITHOGRAPHS

From early on in his career, Maurice Sendak appreciated original graphics, and he gradually began collecting the art of great masters: Dürer, Rembrandt, Blake, Stubbs, the German Romantics, Samuel Palmer, Edward Calvert, Randolph Caldecott, William Nicholson, Félix Valloton, Winsor McCay, Disney, Léger, Chagall, and Picasso, among others.

From 1977 until 1984 Sendak worked with master printmaker Kenneth Tyler of Tyler Graphics to learn the skills necessary to convert original drawings into multiples. His subjects included his current projects: Ida and her Wunderhorn; the Ice Baby; *The Magic Flute* designs for Houston Grand Opera; various images for *Nutcracker*; and the largest of all his prints, *"Moishe" Wild Thing walking toward a sunflower*. *Faithful Nutcracker* was issued as a signed print with the 1984 deluxe *Nutcracker* book (limited to 250 numbered copies), but all the rest were created in small quantities and never offered for sale. Tyler retired from printing and closed his studio in 2000. At this time he uncovered a quantity of original prints by Sendak from the late 1970s through early 1980s. These were returned to the artist, who signed them in 2002, often dating them "02" although they were printed earlier.

Anticipating the publication of *We Are All in the Dumps with Jack and Guy* in 1993, the publisher discussed making a special limited issue with an original stone lithograph by Maurice, which was created with the assistance of Tim Sheesley at the Corridor Press. The project was stalled for six years, however, and finally in 1999, *At Home with Jack*

and Guy was printed in an edition of two hundred copies (plus thirty-eight extras: "hors commerce," trial proofs, and bon à tirer). The original stone with Sendak's drawing is now preserved at the Rosenbach Museum & Library.

It should also be clarified that in 1971, Sendak selected a series of nineteen fine art prints from eight favorite books, each independent of its text and able to be enjoyed as a separate image: *A Kiss for Little Bear* (2), *Hector Protector* (1), *Higglety Pigglety Pop!* (2), *In the Night Kitchen* (4), *Lullabies and Night Songs* (2), *Mr. Rabbit and the Lovely Present* (2), *Where the Wild Things Are* (4), and *Zlateh the Goat* (2). These images were issued inside a portfolio box titled *Pictures*. None of the individual prints were signed. These sets were created for Harper & Row (US), The Bodley Head (UK), and Diogenes (Zurich). The American sets included a deluxe version of five hundred copies numbered on a label inside the cover and containing an extra reproduction of a pencil sketch of the Sealyham terrier Jennie, which Maurice autographed. All of the images were newly photographed from original artwork and their quality is exceptional (sometimes the pencil sketch of Jennie is mistaken for actual artwork). These are all photomechanical prints (sometimes called photolithographs) but occasionally they get described as "lithographs," which is incorrect. Over time, Maurice did sign individual prints for friends, family, and commercial sale either through Battledore bookshop or the Rosenbach.

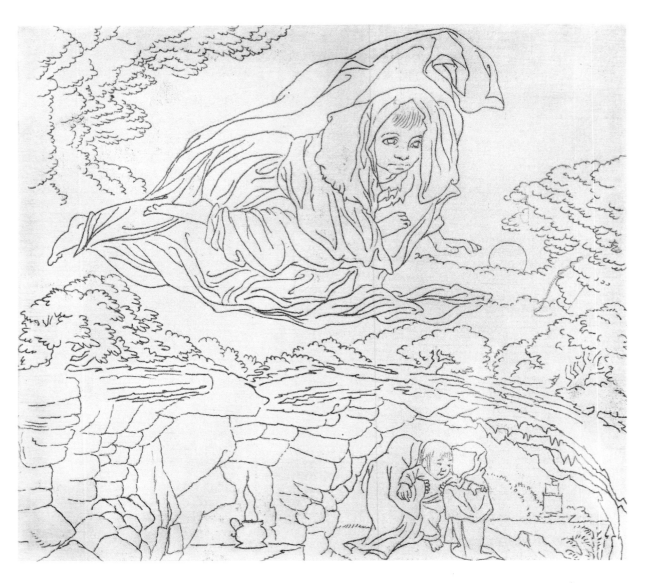

ABOVE: *Ida Floating in the Air* from *Outside Over There*, dated (in pencil) May 31, 1977. Etching on Arches paper, 8⅞ x 9¾ inches. "Foolish Ida never looking, whirling by the robber caves..."

OPPOSITE: *Ida with Her Wunderhorn* from *Outside Over There*, ca. 1977. Etching on mould paper, 8¾ x 9¾ inches.

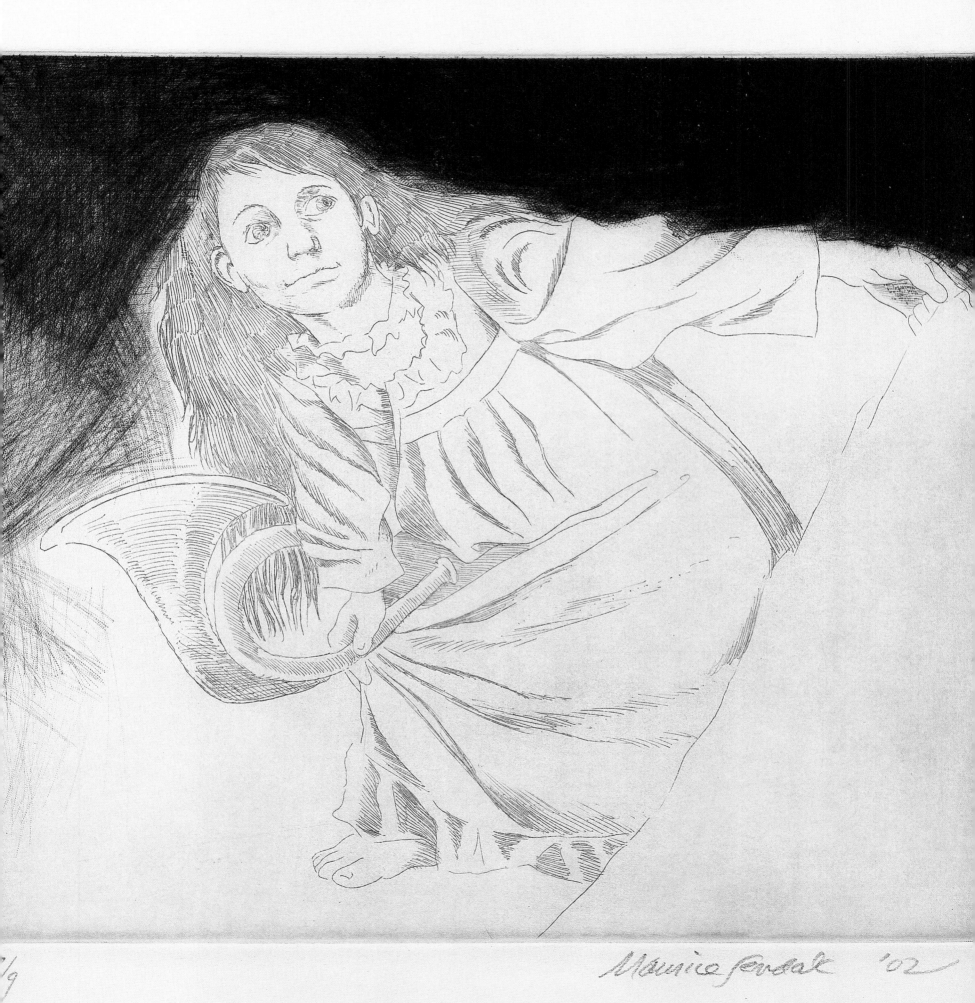

Maurice Sendak '02

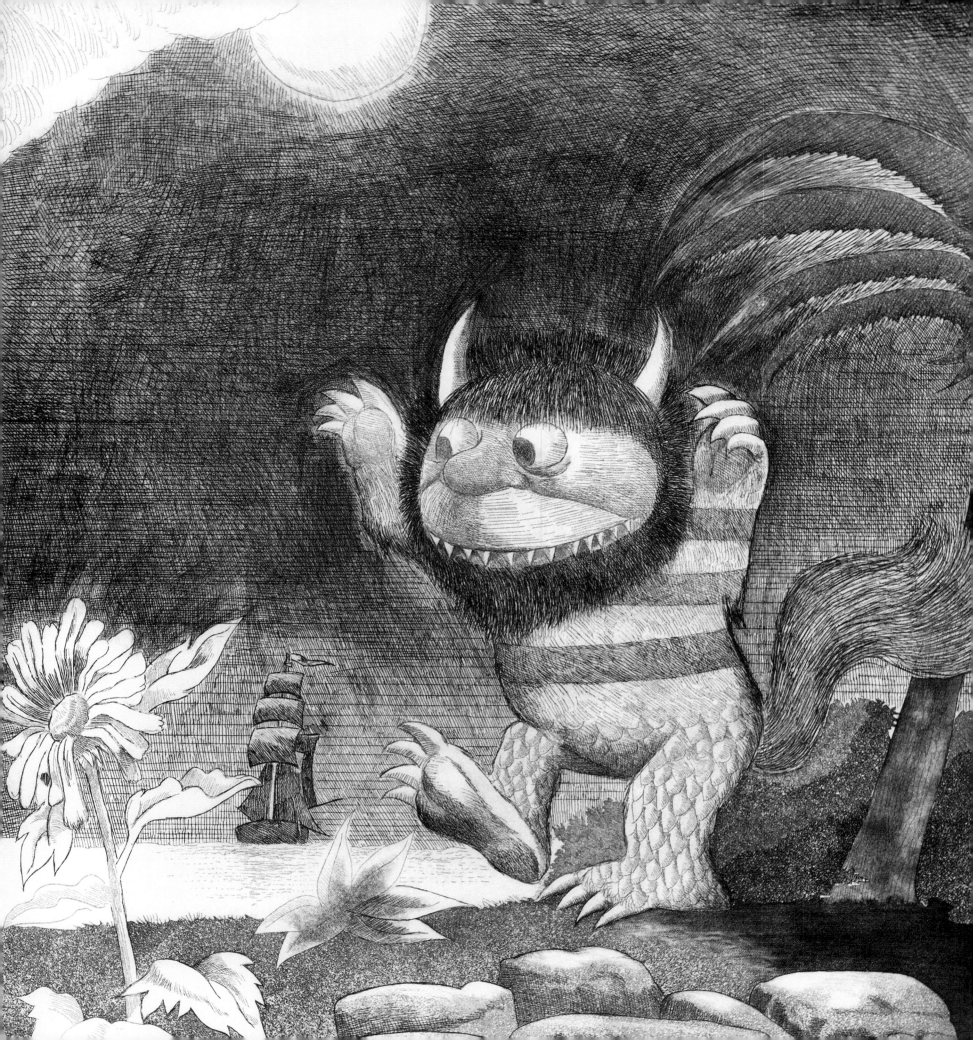

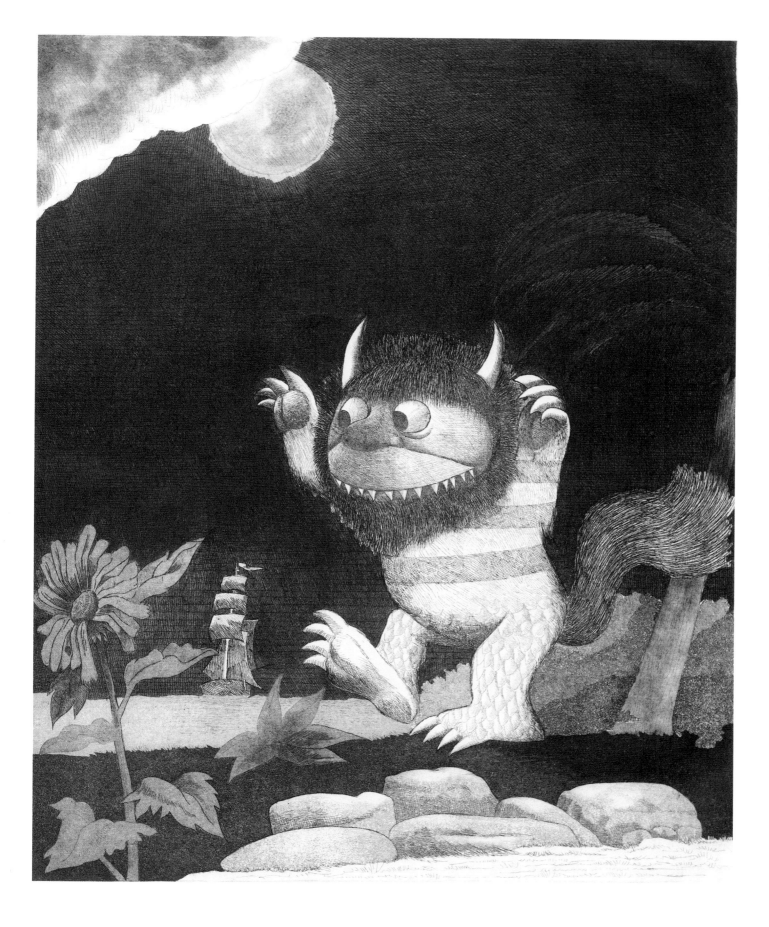

OPPOSITE: *Wild Thing*, ca. 1979. Etching, 16¾ x 20¾ inches on Arches paper. This print shows "Moishe" Wild Thing surrounded by elements that evoke *Outside Over There*: the beach and tall-masted ship in the background, a prominent sunflower in the foreground, and the full moon above.

LEFT: *Wild Thing*, ca. 1979–80. Etching, 16¾ x 20¾ inches on Arches paper. In this version, heightened contrast makes the moon an even more prominent feature and the water more luminescent.

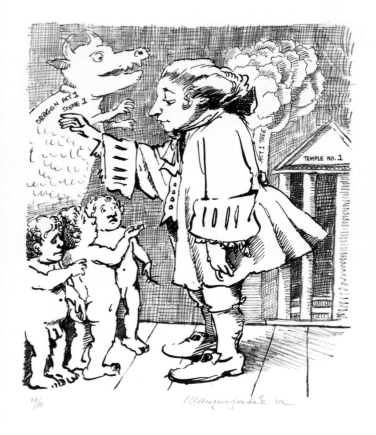

LEFT, TOP: *The Magic Flute: Queen of the Night,* ca. 1980. Lithograph, 12 x 10¼ inches. Mozart is shown kneeling in front of the Queen of the Night, while Papageno is seated at the top of the stairs.

LEFT, BOTTOM: *The Magic Flute: Three Boys (Child Spirits) with Mozart,* ca. 1980. Lithograph, 12½ x 10½ inches. The stage set of Act I, Scene 1.

ABOVE: Stage set for *The Magic Flute*, ca. 1980.
Lithograph, 13⅞ x 30 inches on Arches paper.
Landscape design for backdrop with temple ruins.

RIGHT: *Ballerina with Mozart and Dog*, ca. 1984. Etching on mould paper, 3¹⁵/₁₆ x 4¹⁵/₁₆ inches. This scene is described in a letter by Mozart, who was prone to using foul language and vulgar platitudes in his correspondence.

BELOW: *The Mouse King and Nutcracker*, 1984. Etching, 6³/₈ x 10¹⁵/₁₆ inches. The Nutcracker defending Clara from the Mouse King.

OPPOSITE: *Nutcracker Defending Clara from the Mouse King*, 1984. Lithograph, 5¹/₈ x 5¹/₄ inches. This print accompanied the deluxe limited edition of E. T. A. Hoffmann's *Nutcracker* (Crown, 1984), which was illustrated with designs by Sendak for the Pacific Northwest Ballet production.

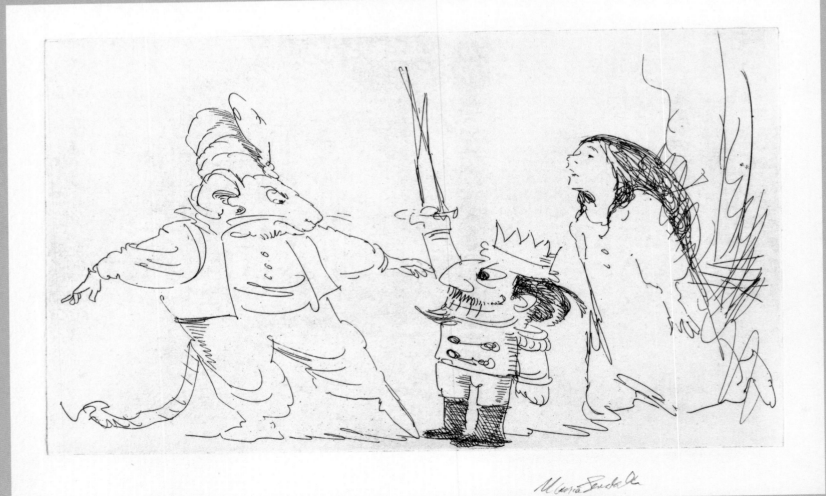

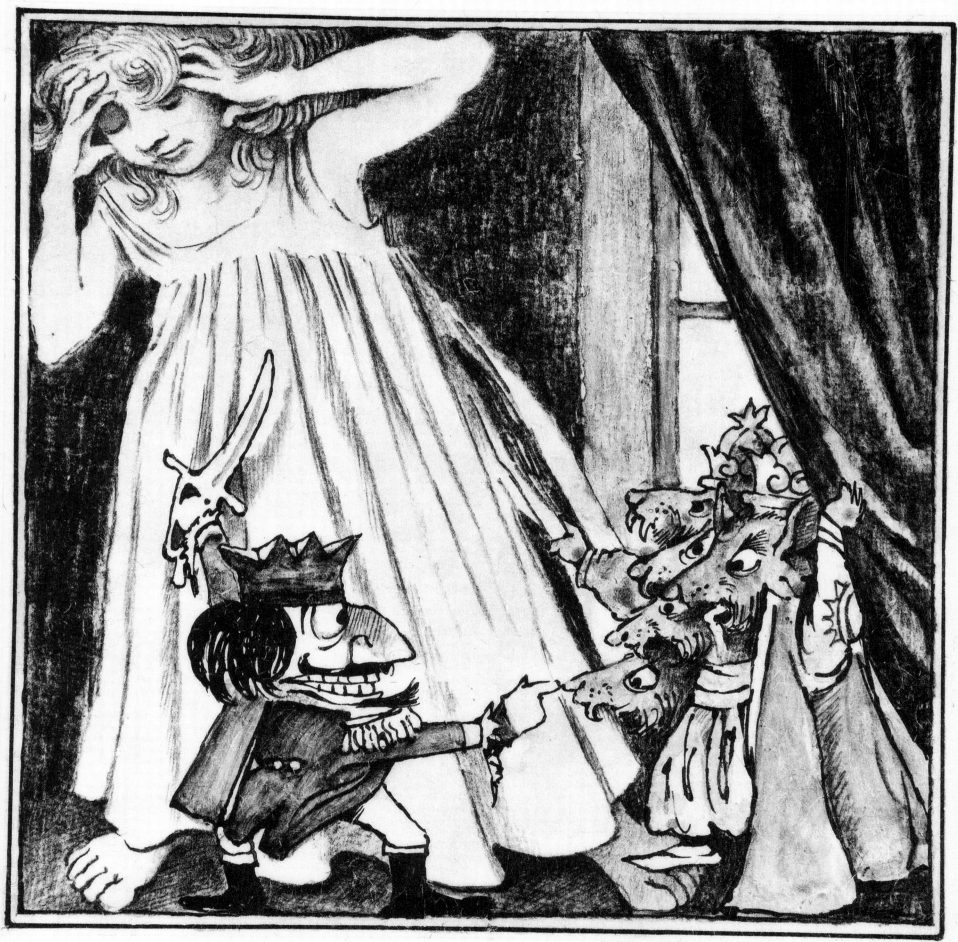

Maria Sedel '84

At Home with Jack and Guy
by Iona Opie

Study for *At Home with Jack and Guy*, 1993. Pencil, assembled from two sheets, overall size 13½ x 18¼ inches.

Maurice Sendak passionately believed in the resilience of childhood. In *We Are All in the Dumps with Jack and Guy* he set forth his credos: that the children of a cardboard city will build a life of their own, using their innate qualities of gumption and derring-do, and that no one can defeat the human spirit. This lithograph, an extension of the last picture in the book, is brilliantly rendered in the grand tradition of a nineteenth-century tableau. In it the moon, who has been so anxious and helpful all through the story, beams down on Jack and Guy, commending them for their rescue of the kittens and "the poor little kid," happy that the kid at last has a home and a place where he belongs.

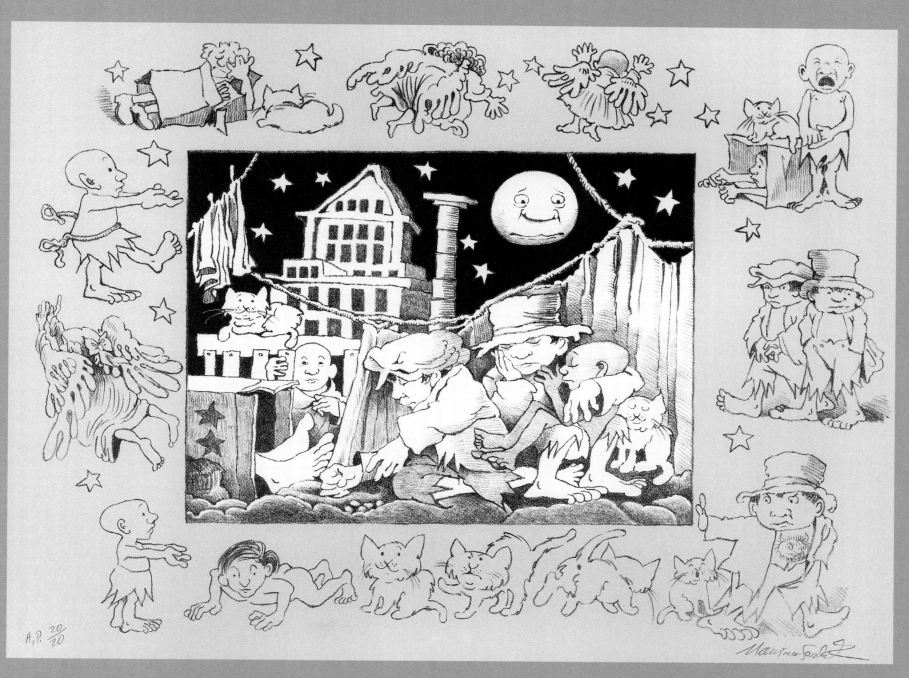

A.P. 20/20

Maurice Sendak

At Home with Jack and Guy, 1999. Lithograph, 14 x 19¾ inches. This design was drawn on stone in 1993 and intended to accompany a deluxe edition of *We Are All in the Dumps with Jack and Guy*, but the project was shelved. The image sat on stone until eventually a limited edition was printed in 1999 by Corridor Press Ltd.

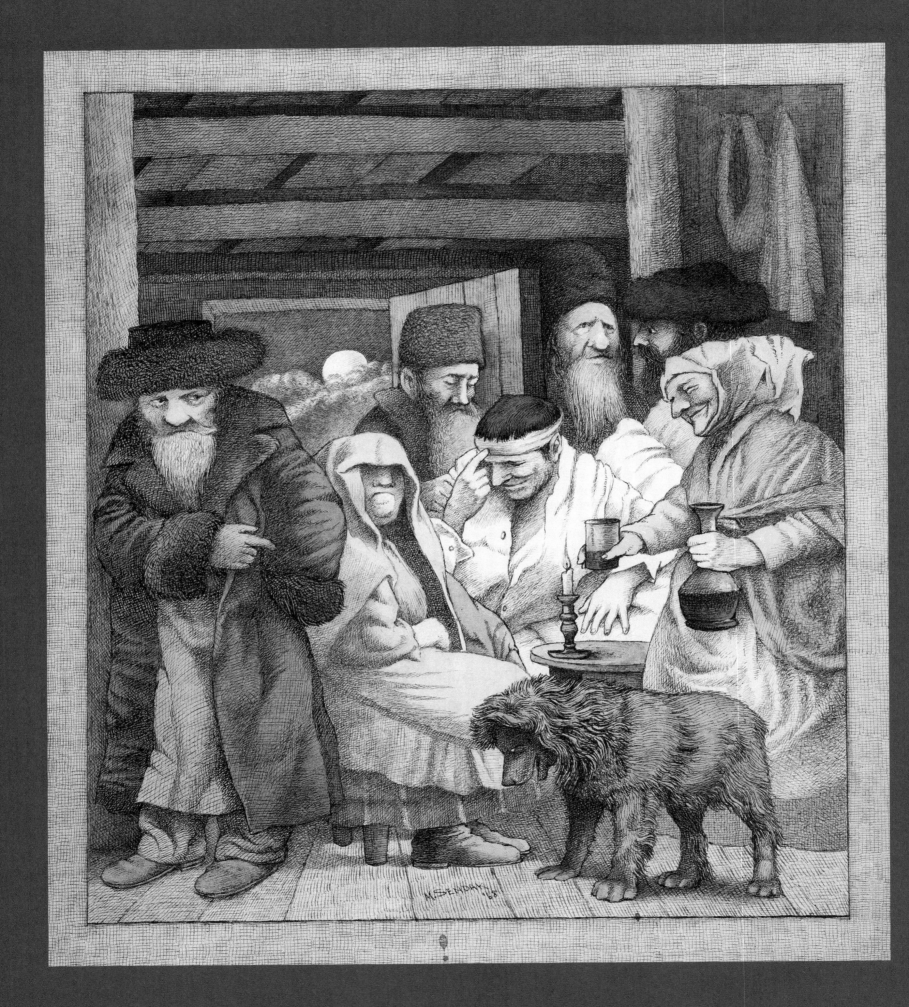

CHAPTER VIII: MAGAZINE CONTRIBUTIONS

OPPOSITE: *Yash the Chimney Sweep*, 1968. Pen-and-ink line and watercolor, 12⅞ x 11¹¹/₁₆ inches. Preliminary illustration for a story by Isaac Bashevis Singer for the May 4, 1968, issue of the *Saturday Evening Post*.

LEFT: *Lucas and Jake*, 1963. Pen-and-ink line and watercolor, 11⅛ x 8⅞ inches. Preliminary drawing for a story by Paul Darcy Boles titled "Lucas and Jake," which appeared in the March 1963 issue of *Ladies' Home Journal*.

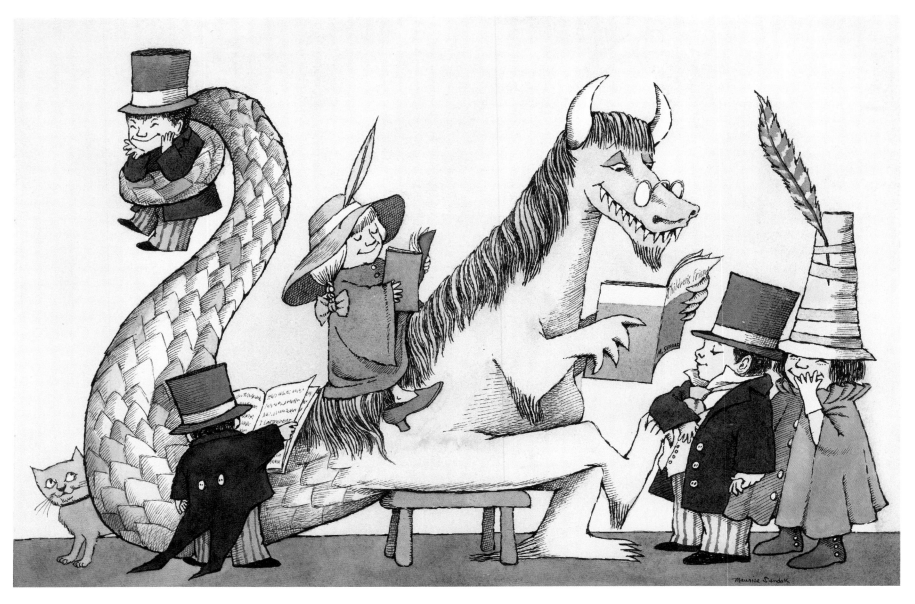

ABOVE: Drawing for *Children's Friend* magazine, 1969. Pen-and-ink line and watercolor, 13¾ x 17½ inches. Sendak was commissioned to create this cover design for *Children's Friend* (1902–70), a magazine published by the Church of Jesus Christ of Latter-Day Saints. Initially created for the Church's leaders and teachers to use as lesson guides for the children of the congregation, it was later adapted for parents and then expanded to provide the children themselves with a hands-on magazine. Eventually the magazine achieved greater circulation, and in 1971 it was replaced by *Friend* magazine, an ongoing publication and educational tool created expressly for the children of the Church.

RIGHT: *Children's Friend*, November, 1969. Printed magazine published by the Church of Jesus Christ of Latter-Day Saints.

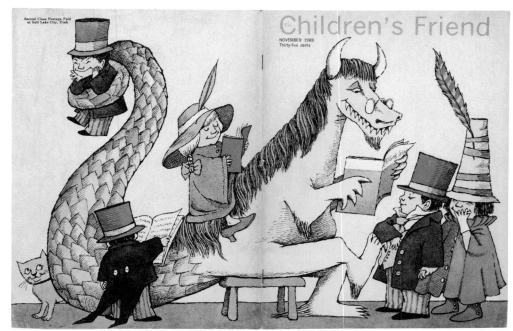

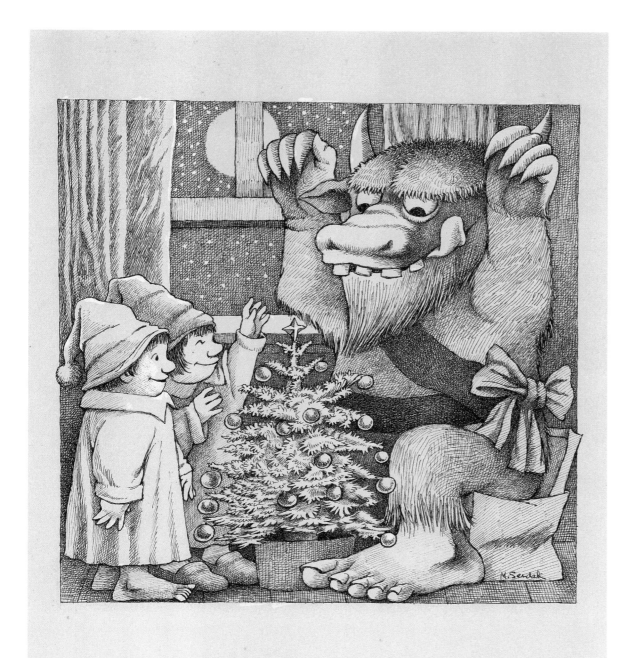

LEFT: *Wild Thing Christmas*, 1972. Pen-and-ink line with Chinese white, 6 x 6 inches. Illustration for Dallas Galvin's article titled "Maurice Sendak Observes Children's Literature," which appeared in the December 1972 issue of *Harper's Bazaar*.

ABOVE: Preliminary drawing for *Wild Thing Christmas*, 1972. Pencil, 6 x 6 inches.

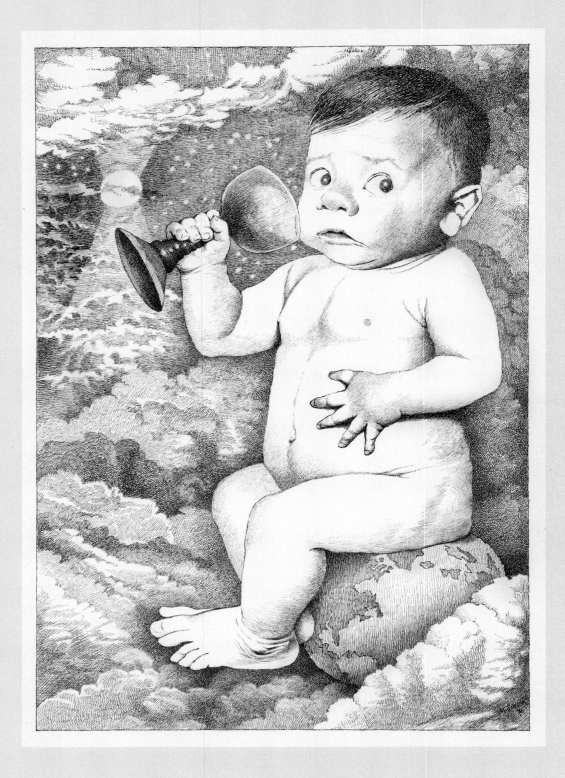

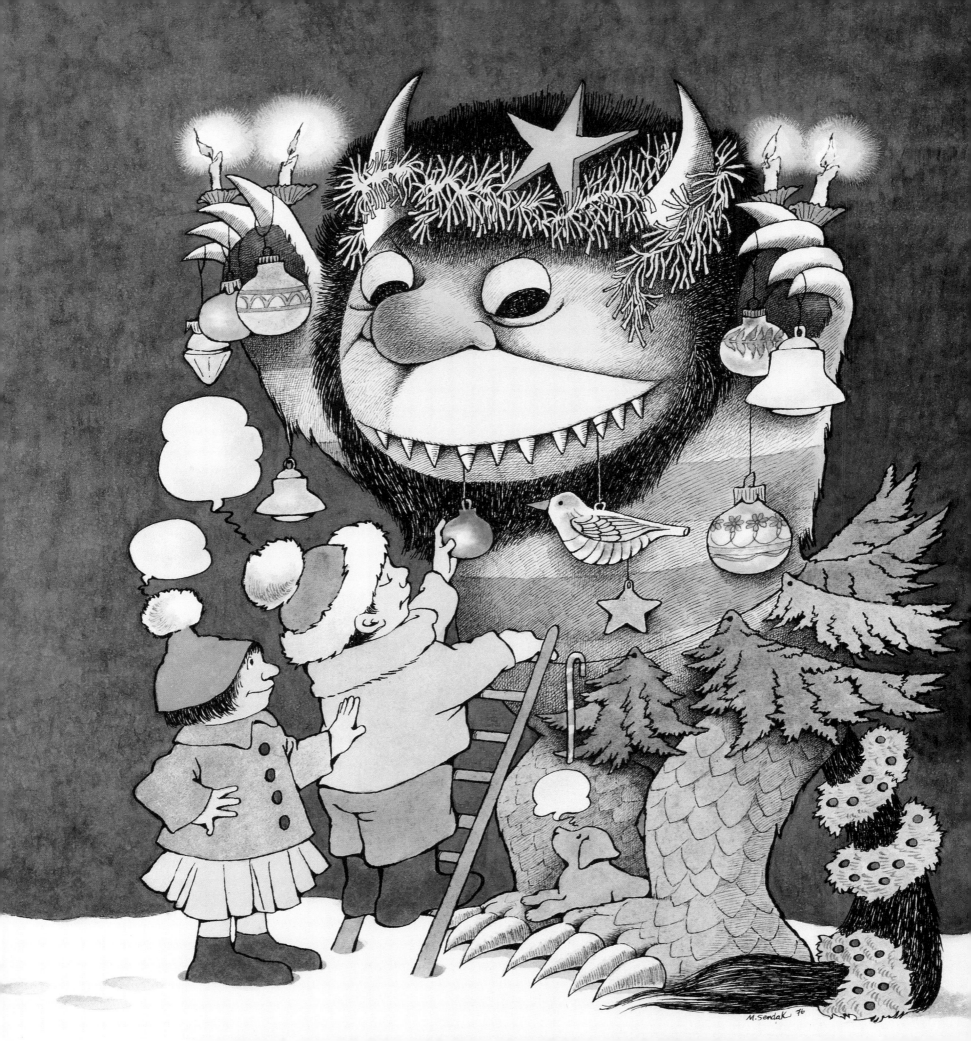

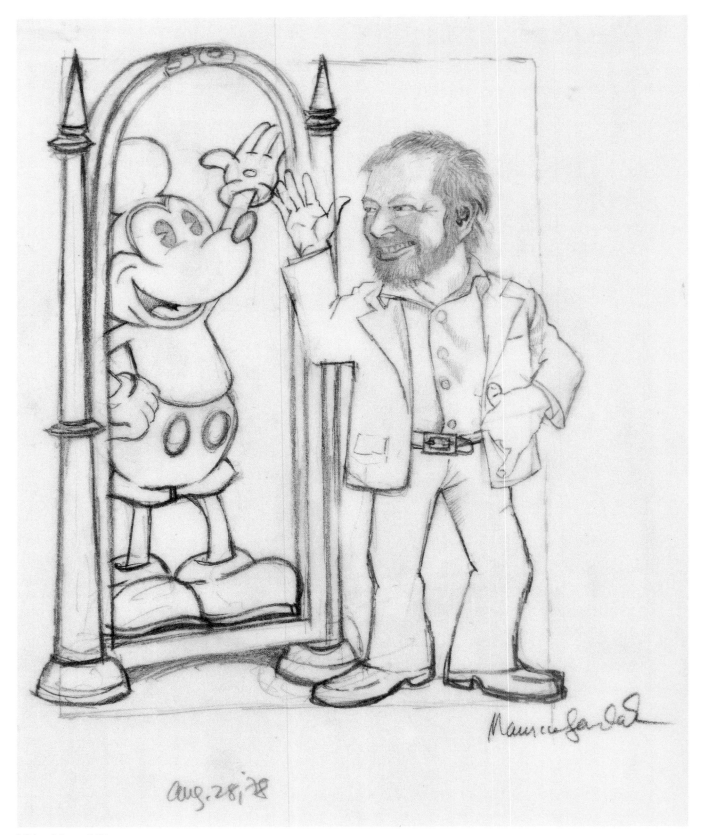

Aug. 28, 78

Mickey Mouse © Disney

Mickey Mouse © Disney

OPPOSITE: Preliminary drawing for *Growing Up with Mickey*, 1978. Pencil, 6 x 5⅛ inches. Sendak created this sketch for an illustration that appeared in *TV Guide* alongside an article he wrote about childhood memories and the serendipitous fact that both he and Mickey ("Steamboat Willie") were born in 1928. Over the course of his life, Sendak assembled one of the largest private collections of pre–World War II Mickey Mouse artifacts, including statues, toys, and rare books.

LEFT: *Me and Mickey*, 1981. Printed poster, 22½ x 17½ inches. Issued in a limited edition of five hundred copies by the Rosenbach Museum & Library, Philadelphia, this fine-art print promotes an exhibition of Sendak's childhood toys and books, including a selection from his personal collection of vintage Disney artifacts.

ABOVE: *Growing Up with Mickey*, 1978. In this article, written by Sendak for the November 11, 1978, issue of *TV Guide*, the artist remembers his childhood and the influence Mickey Mouse had on him while growing up.

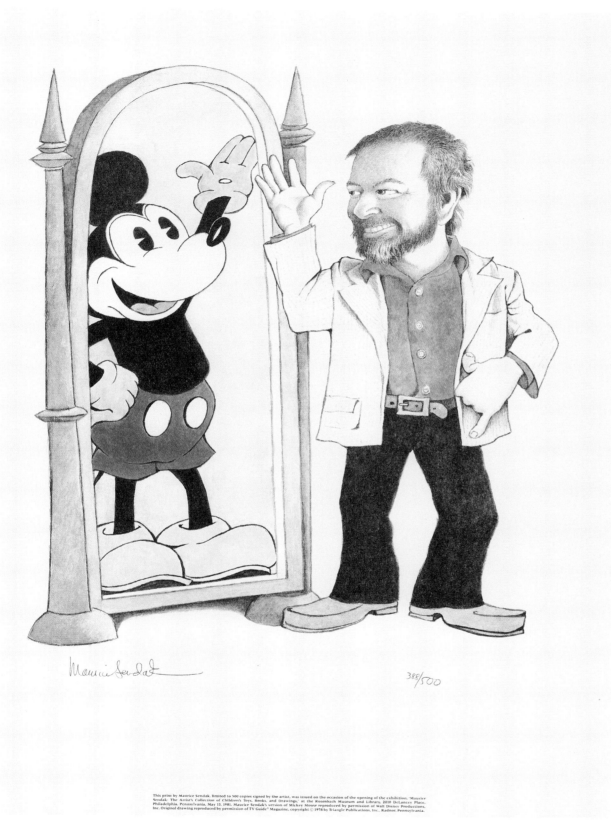

Maurice Sendak

388/500

Mickey Mouse © Disney

BELOW: Studies for *Baby by the Window*, 1983. Pencil, each 7⅞ x 7⅞ inches. Sendak created individual designs for the baby and for the background sunflowers and bird. This composite of two pencil studies provides a glimpse of how the artist worked.

OPPOSITE: *Baby by the Window (Sunflower Child)*, 1983. Pencil and watercolor, 10⅜ x 7½ inches.

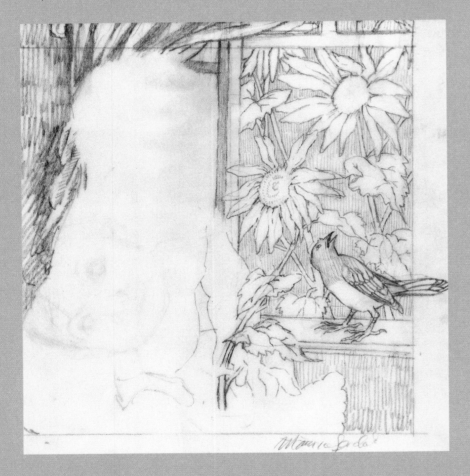

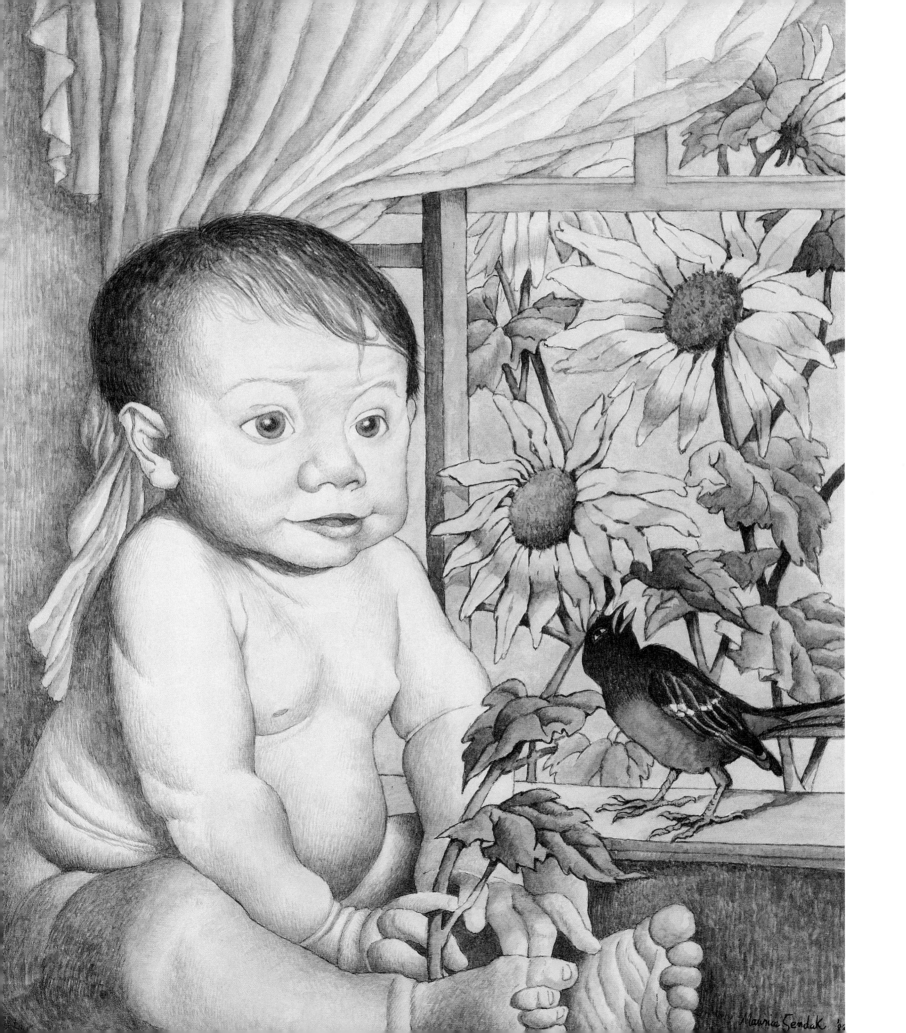

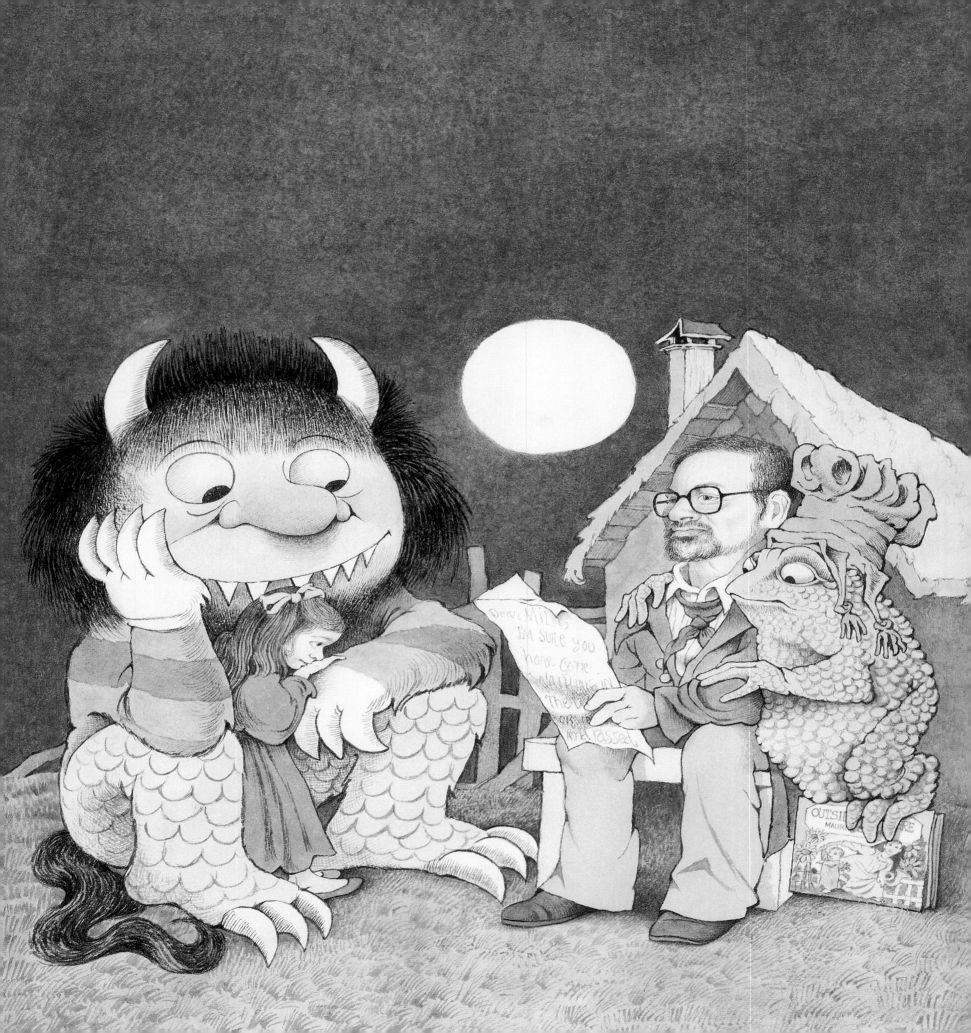

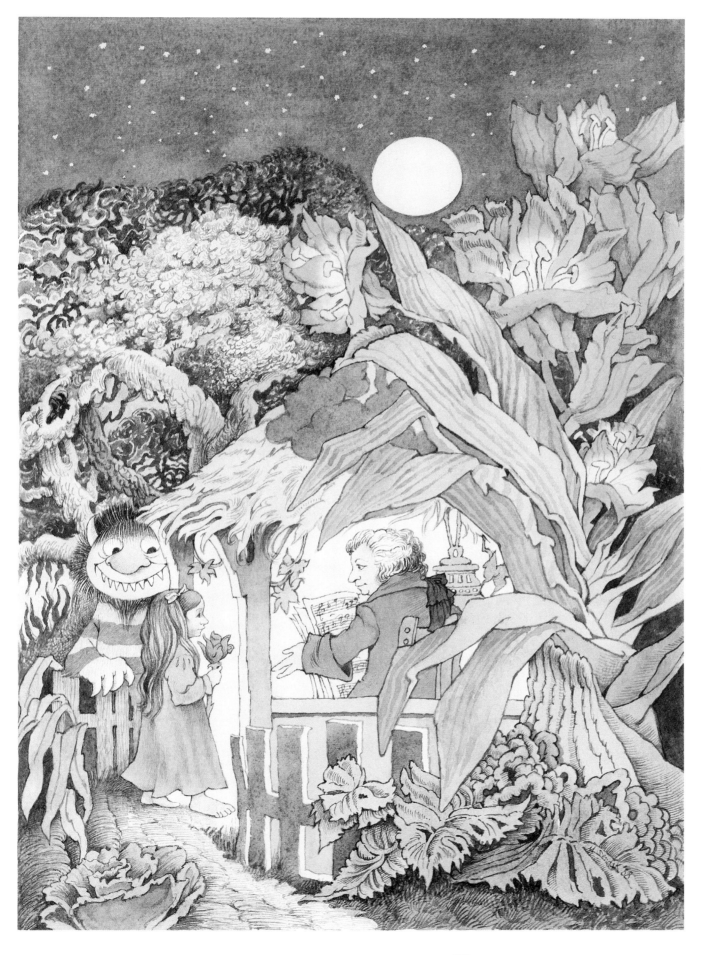

OPPOSITE: *Self-Portrait with Wild Thing and Mili*, 1988. Pencil and watercolor, 12 x 9¹/₈ inches. Wild Thing and Mili, with self-portrait of the artist reading Wilhelm Grimm's "Dear Mili" letter (see page 12).

LEFT: *Mili with Moishe Visiting Mozart in his Waldehütte (Composing Hut)*, 1988. Pencil, pen-and-ink line, and watercolor, 11½ x 8¹/₈ inches.

We Are All in the Dumps with Jack and Guy

Many articles about Maurice Sendak have appeared in the *New Yorker* magazine since the success of *Where the Wild Things Are* in 1963. In 1993, in anticipation of Sendak's new picture book *We Are All in the Dumps with Jack and Guy*, the magazine ran yet another story as well as commissioned a cover illustration.

ABOVE: *The New Yorker*, September 27, 1993. Printed magazine published by Condé Nast.

RIGHT: Preliminary drawing for the *New Yorker* magazine cover featuring *We Are All in the Dumps with Jack and Guy*, 1993. Pencil, 10⅝ x 8⅛ inches.

OPPOSITE: *We Are All in the Dumps with Jack and Guy* cover illustration for the *New Yorker* magazine, 1993. Pencil and watercolor, 11¼ x 8½ inches.

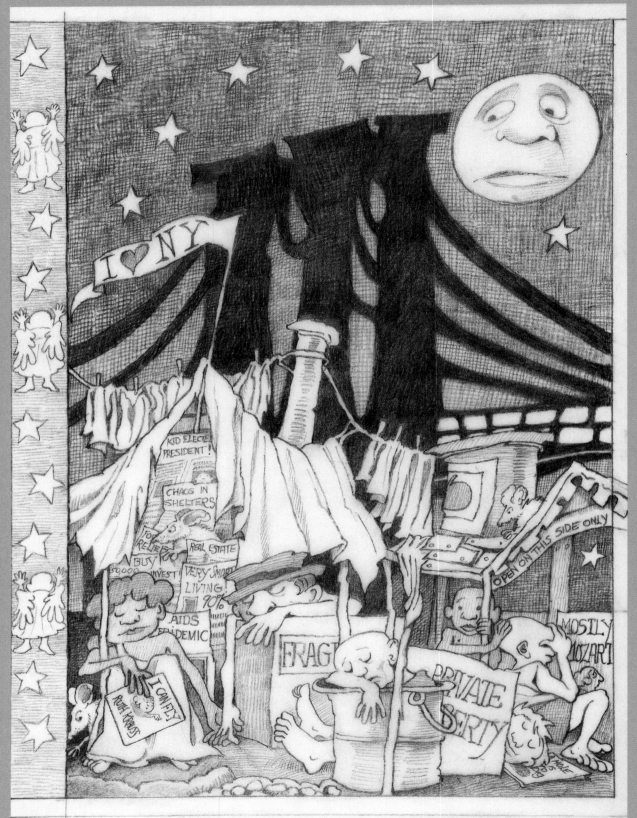

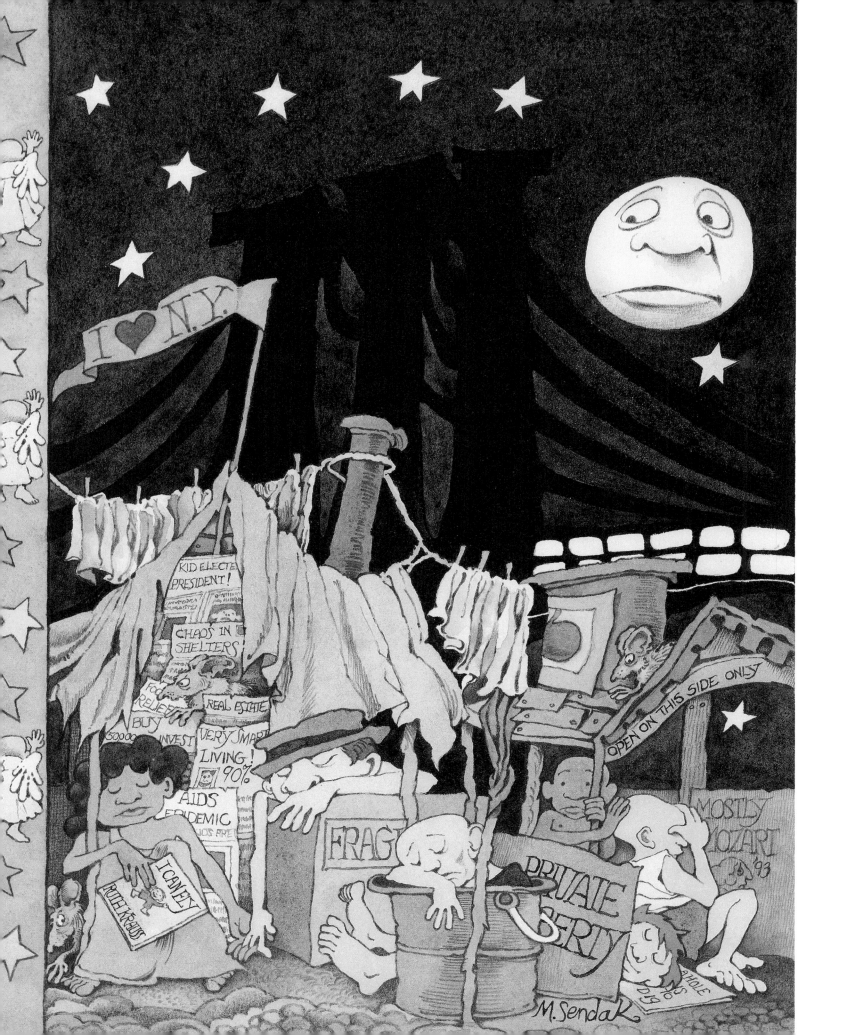

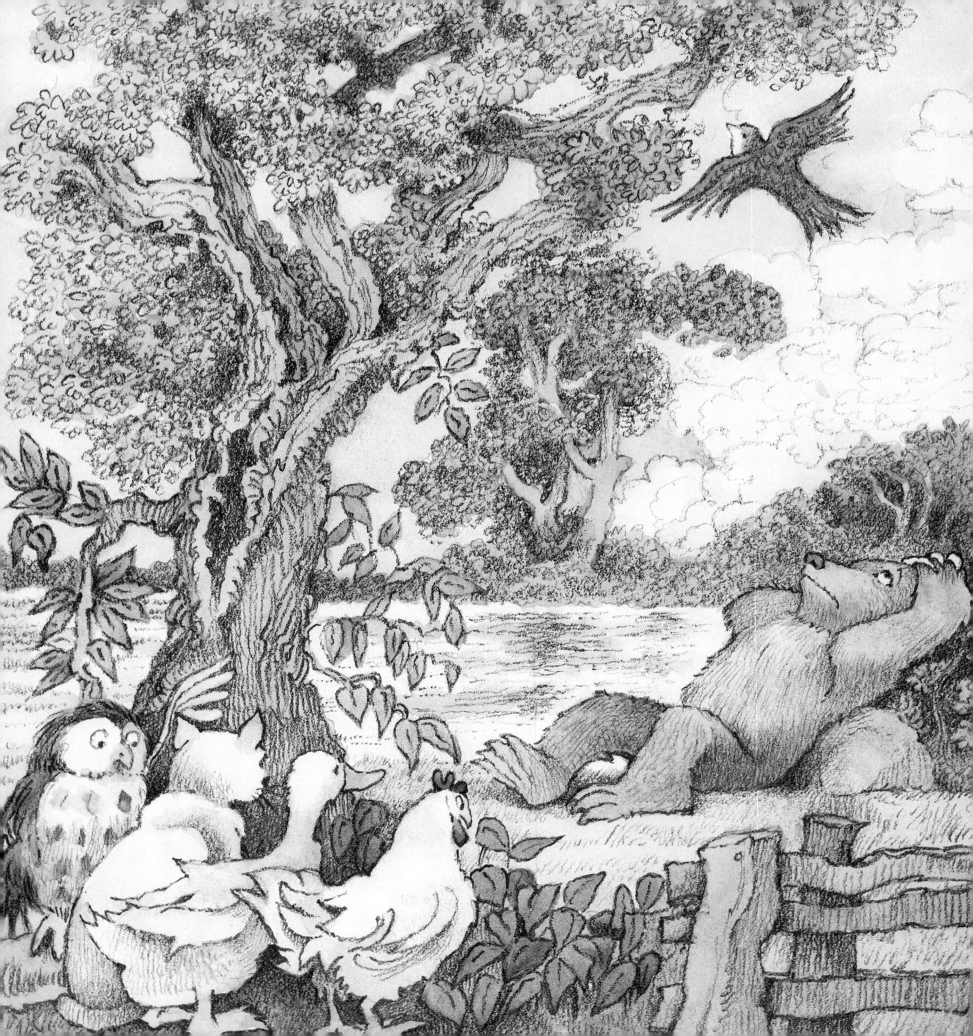

Little Bear's New Friend

These drawings were created for a new story by Else Holmelund Minarik, published in *Nick Jr.* magazine (2002) and the first "Little Bear" collaboration between Sendak and Minarik since 1968.

OPPOSITE: *Little Bear's New Friend*, 2001. Pencil and watercolor, 8⅛ x 6⅛ inches.

LEFT: "*A very young mouse scurried up. He thought Little Bear was a tree*," 2001. Pencil and watercolor, 4¼ x 6¼ inches.

BELOW, LEFT: "*My new friend?*," 2001. Pencil, 6¾ x 6¾ inches.

BELOW, RIGHT: "*My new friend?*," *said Little Bear.* "*It's ME!,*" 2001. Pencil and watercolor, 6¾ x 6³⁄₁₆ inches.

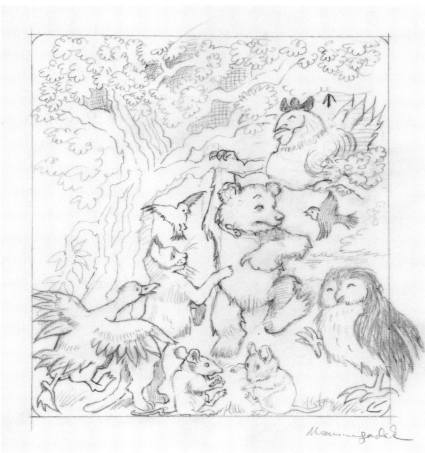

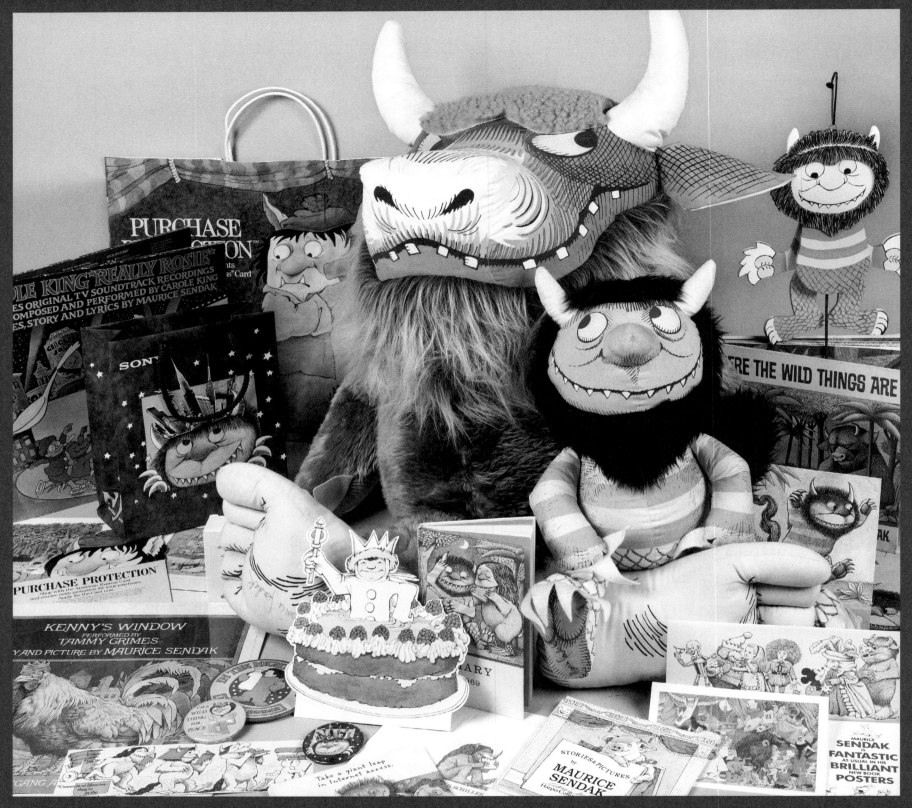

Many non-book items, offshoots of Maurice Sendak's work, have been created to supplement the appreciation and collectability of his output, most notably *Where the Wild Things Are*—including dolls (in various sizes and materials), tote bags, printed flyers and catalogs, notecards, buttons, and bookmarks. Maurice Sendak lent his imprimatur to numerous educational, artistic, and advertising campaigns, which further solidified his following and popularity, and established him as a household name and an American pop-culture icon.

CHAPTER IX: EPHEMERA

The Eclectic and the Esoteric of Maurice Sendak:
A Collector's Path from Printed Page to Way Yonder
by Joyce Malzberg

I was introduced to Maurice Sendak's work in 1969, when a box of his books arrived for my then-three-year-old daughter. My connection to these wonderful stories for children was immediate and visceral, and I have been collecting ephemera related to them ever since. My first foray outside of books was periodicals, which included articles by and about Sendak, some with original illustrations. My collection took off from there and now contains many categories, from silk scarves, dolls, and action figures to puzzles and pins, shopping bags, and video games.

Collectibles, most often those connected with the branding of *Where the Wild Things Are*, offer the greatest variety and appeal. The earliest examples are four Wild Things character dolls introduced by Colorforms (1980). These were followed by dolls issued by Crocodile Creek and Kelly Toys (2005). Since then, the market for Sendak dolls and figurines has continued to grow: In 2000 McFarlane Toys came out with a line of action figures, and in 2008, Madame Alexander, a doyenne of doll makers, introduced a Moishe and Max set. The 2009 movie directed by Spike Jonze spawned differently named monsters produced by Medicom/Kubrick, along with a seemingly endless array of licensed collectibles in many categories.

Beyond dolls, there have been *Where the Wild Things Are* games and puzzles, including a series of puzzles from Mudpuppy (introduced in 1999); The Wild Rumpus Card Game (1999; see page 192) and Where the Wild Things

Are Puzzle Maze Game from Briarpatch (1999; see page 193); and Where the Wild Things Are Game by Patch Products (2001). My First Uno Where the Wild Things Are Card Game was introduced by Mattel in 2006, and Xbox 360 and Nintendo Wii Where the Wild Things Are: The Videogame in 2009.

Many of Maurice's other books and characters have also been "packaged." The *Little Bear* books, written by Else Holmelund Minarik, have inspired many popular items, as has Nelvana's *Little Bear* TV series. Character dolls, clothing, games, and other products, including videos, have been widely marketed. On a smaller scale, the characters from *The Sign on Rosie's Door* and *The Nutshell Library* led to *Really Rosie*, a TV musical that, in a different incarnation, had an Off-Broadway run. A delightful Rosie doll wearing a red gown, black gloves, shoes, and boa, plus a feathered yellow hat with blue sash, was produced in celebration, as were posters, flyers, buttons, and audio and visual recordings.

Over the course of his career, Sendak created beautiful, evocative original art for many record albums and CDs of folk songs, symphonic music, opera, ballet, children's music and stories (including his own books), klezmer, and some works of Shakespeare. Among the loveliest are the cover illustrations that celebrate the trinity of music, literature, and art, including RCA's *Levine Conducts Mahler: Symphony No. 3* (1975). The album art, titled *What the Night Tells Me*, depicts a silhouetted Mahler at work in a *waldhütte*. In a moonlit, pastoral setting, the composer is visited by an angel/muse who bears a gift, as costumed animals play instruments nearby, and a lion and dog attend. Sendak created another lovely moonlit scene, though a more rustic one, for the cover of Leo Janáček's *The Diary of One Who Is Vanished* song cycle (1995), an album produced by Arabesque/Caedmon. And he captured a fairy in midflight as she spirits away a young man who is under her spell, taking him from his life and love, for Stravinsky's *The Fairy's Kiss* by Deutsche Grammophon (1997).

A wonderfully produced 2001 CD set, *Higglety Pigglety Pop! and Where the Wild Things Are*, double-bills Oliver Knussen and Sendak operas. This Deutsche Grammophon package contains full librettos, with images from both operas, all housed in a slipcase showing Wild Things looking through a cutout in the front panel at a scene from *Higglety Pigglety Pop!* When the cover is opened, a pop-up reveals Tzippy and Moishe.

Maurice Sendak wore many hats for the production of *Pincus and the Pig: A Klezmer Tale* by Tzadik (2004), a retelling of Prokofiev's *Peter and the Wolf*. He not only created the cover illustration of a large, costumed pig, but also wrote and narrated the story as well as illustrated the booklet and stickers that were part of the package. A limited-edition print with all the characters was issued that same year.

Pin-back buttons in a range of sizes—large, small, and miniature—have been produced for many Sendak books and events. The largest, which was created for *In the Night Kitchen* (1970), shows a triumphant Mickey holding a milk bottle. A yellow-backed Rosie (1975), made for *Really Rosie*, features the star of the show in her red gown, ready to perform. In 1993 HarperCollins published the shattering book *We Are All in the Dumps with Jack and Guy*—and a button that read, "Ask me about Jack and Guy."

Images of Sendak's most popular characters, and especially the Wild Things, may also be found on cloth bags, totes, and carryalls. Sendak designed a small ecru bag in 1982 for Justin G. Schiller Ltd. A large Tzippy reading a book, which is propped up on one of her feet, is featured on both sides, a fitting portrait for a children's book dealer who specializes in the rare and collectible.

An illustration of Bernard, cutlery in hands, licking his lips as he gazes longingly at a stack of books, is featured on a cloth tote designed for the Strand Bookstore in 1992. Inside was promotional literature for The Night Kitchen Theater, which was founded by Maurice Sendak and Arthur Yorinks. A T-shirt with the same image was also created (see page 191).

It is perhaps fitting to end with the ubiquitous shopping bags, which have been enlivened by the work of countless artists, including Maurice Sendak. In honor of the first "New York City Is Book Country" street fair (September 16, 1979), Sendak created what would be the first of his four posters for this occasion. The fair was held on Fifth Avenue, with book publishers and used booksellers occupying booths in support of the New York Public Library system. A full-color poster was issued—along with a plastic shopping bag, which re-created the image in shades of black and gray with red highlights. High atop the Empire State Building, where highlighted red toy planes are flying, a shaded lamp is lit, and Moishe, arm around the building, holds a partly eaten red apple as he reads.

What The Night Tells Me, 1976. Pen-and-ink line and watercolor, 8⅛ x 10⅝ inches. Unused drawing, intended for the cover of an insert booklet to RCA Victor *Levine Conducts Mahler: Symphony No. 3*.

American Express launched its "Purchase Protection Program" in 1988 with print ads, posters, and a large coated-paper shopping bag. Two wonderful new monsters amid ongoing catastrophes were introduced, one on each side of the bag. Their presence added lightness to a serious subject, while the context of the message was never lost.

How hard it is to wrap up when so much more can be written and described! And what a pleasure to have revisited the yonder world created by Maurice Sendak—and to remember what led me down that path so many years ago. As Maurice Sendak continues to be acknowledged as the foremost and most influential children's book artist of our time, the number of collectors has grown. Previously unknown works and ephemera continue to surface. The threshold awaits!

Little Red Riding Hood Mechanical

A special feature in the first printing of Selma Lanes's *The Art of Maurice Sendak* was a functioning mechanical pop-up replication of a wooden action toy created by Maurice Sendak and his brother Jack in 1948. The various components of the mechanical were meticulously drawn in pen-and-ink line and watercolor.

OPPOSITE, TOP: *Red Riding Hood and Platform Bed*, 1979. Pen-and-ink line and watercolor, 4½ x 6 inches and 4½ x 3 inches.

OPPOSITE, BOTTOM LEFT: *Wolf*, 1979. Pen-and-ink line and watercolor, 5⅜ x 4¾ inches.

OPPOSITE, BOTTOM RIGHT: *Feet*, 1979. Pen-and-ink line and watercolor, 3¾ x 1½ inches.

TOP: *Platform and Bed*, 1979. Pen-and-ink line and watercolor, 8 x 9 inches.

BOTTOM: Printed proof of a mechanical pop-up Red Riding Hood, based on a childhood toy Sendak created with his brother Jack, which was published in Selma Lanes's *The Art of Maurice Sendak* (Abrams, 1980).

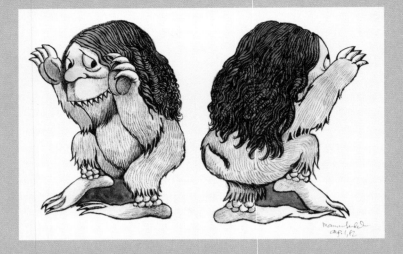

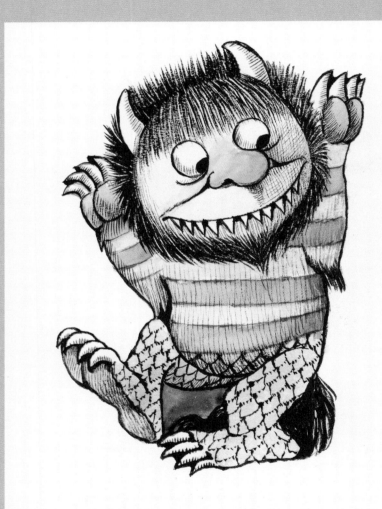

Wild Thing Character Dolls

Six pen-and-ink line and watercolor drawings, detailing each Wild Thing figure to be manufactured as patterns on fabric.

TOP, LEFT: *"Bernard,"* 1982. Pen-and-ink line and watercolor, 4 x 7⅜ inches.

TOP, RIGHT: *"Tzippy,"* 1982. Pen-and-ink line and watercolor, 4½ x 7⅜ inches.

BOTTOM: *"Moishe,"* 1982. Pen-and-ink line and watercolor, 4⅛ x 6⅜ inches.

OPPOSITE, TOP LEFT: *"Aaron,"* 1982. Pen-and-ink line and watercolor, 4½ x 6¾ inches.

OPPOSITE, TOP RIGHT: *"Emil,"* 1982. Pen-and-ink line and watercolor, 4⅝ x 6½ inches.

OPPOSITE, BOTTOM: *"Max,"* 1982. Pen-and-ink line and watercolor, 3½ x 6¼ inches.

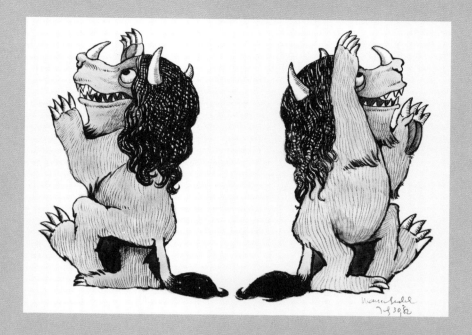

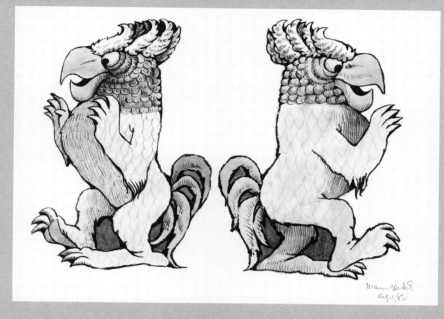

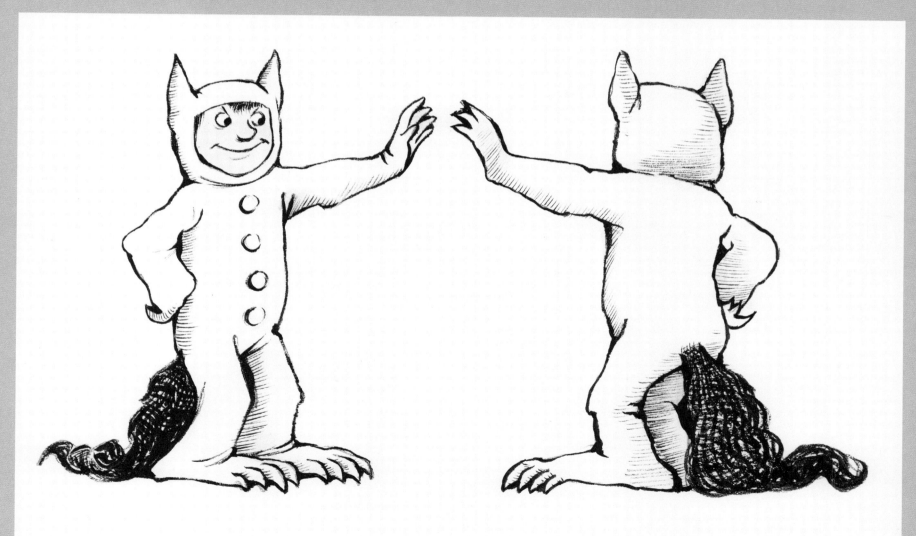

Nutcracker

TOP: Study for *Tchaikovsky Nutcracker* LP/CD album cover, 1986. Pencil, 12⅜ x 12½ inches.

ABOVE: Cover of *Tchaikovsky Nutcracker* CD, London Symphony Orchestra/Sir Charles Mackerras, featuring favorite excerpts from the original soundtrack recording, 1988.

RIGHT: *Tchaikovsky Nutcracker*, 1986. Pen-and-ink line and watercolor, 13⅜ x 13⅜ inches. This illustration was created for the recording of the 1986 production by Pacific Northwest Ballet, which featured Maurice Sendak's costumes and sets.

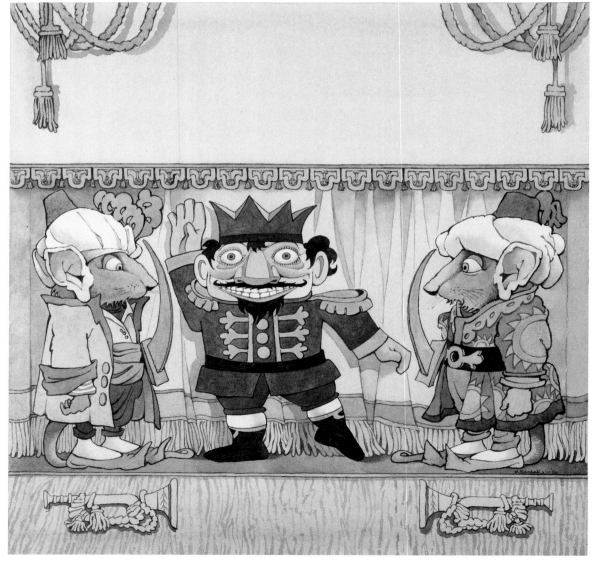

Where the Wild Things Are

Study for *"Moishe" with His Wunderhorn*, 1988. Pencil with watercolor, 26¼ x 30½ inches. Concept illustration for a silk scarf depicting "Moishe" Wild Thing holding a "Wunderhorn" (borrowed from *Outside Over There*).

In 1988 the fashion house and leather-goods firm Louis Vuitton commissioned leading artists, illustrators, graphic and scenic designers, and couturiers to create one-of-a-kind scarves with the understanding that they would be auctioned and the proceeds donated to help AIDS research. The scarves were then reproduced in a book by Andrew Baseman titled *The Scarf* (1989), which traces the history of designer scarves. In this book the finished scarf painted by Maurice Sendak is reproduced on pages 91 and 98.

May 12 95 - Goya? Bosch?

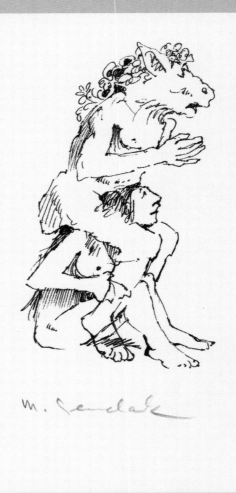

Midsummer Night's Dream: Five Character Scenes, 1995

Here, Sendak revisits his great love for Goya and adds a touch of Hieronymous Bosch.

OPPOSITE, TOP: Studies for cover design for Caedmon Shakespeare LPs/CDs, 1995. Pen-and-ink line, 4³/₄ x 11³/₈ inches.

OPPOSITE, BOTTOM: Preliminary studies for Caedmon Shakespeare LPs/CDs, 1995. Pen-and-ink line, 5 x 8¹/₂ inches.

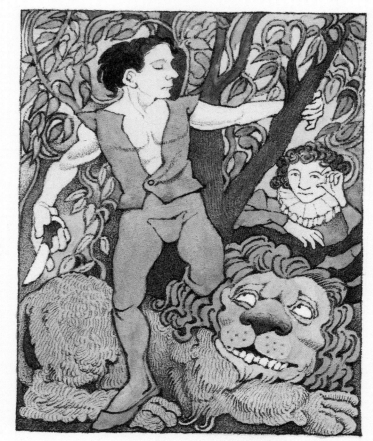

ABOVE, LEFT: *Much Ado About Nothing*, 1995. Pen-and-ink line and watercolor, 3³/₁₆ x 2¹/₂ inches. Created for a set of 1996 Caedmon Audio recordings of Shakespeare's plays.

ABOVE, RIGHT: *As You Like It*, 1995. Pen-and-ink line and watercolor, 3³/₁₆ x 2¹/₂ inches.

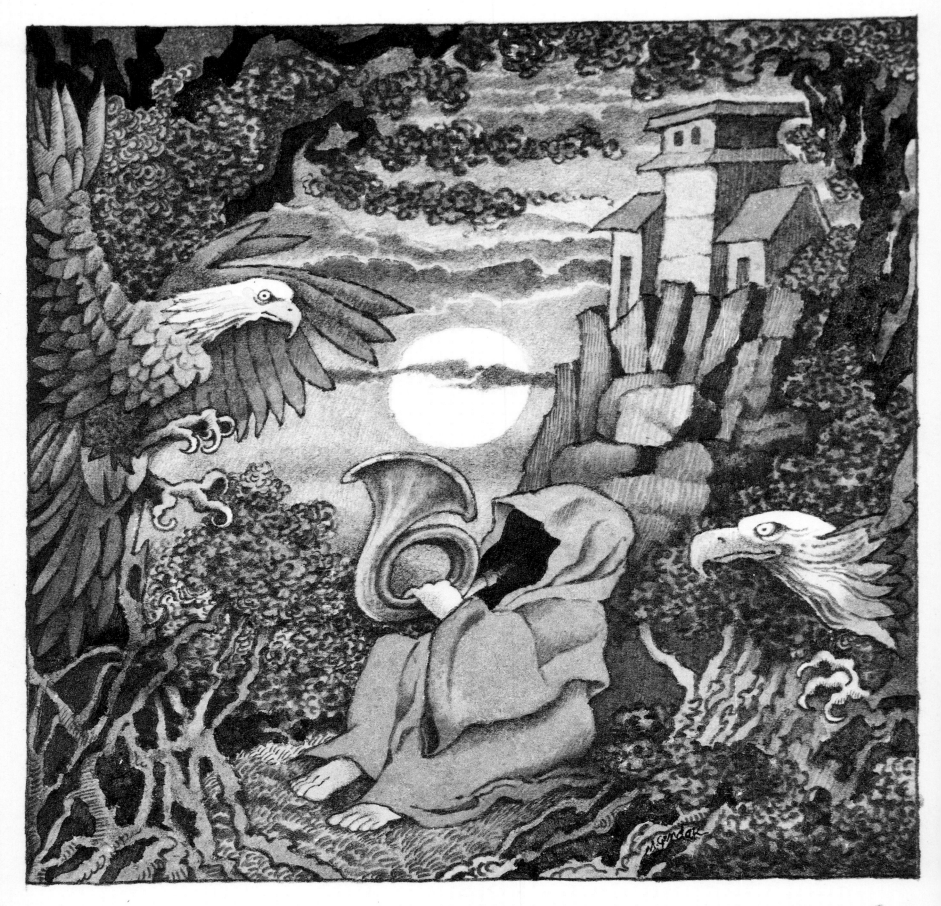

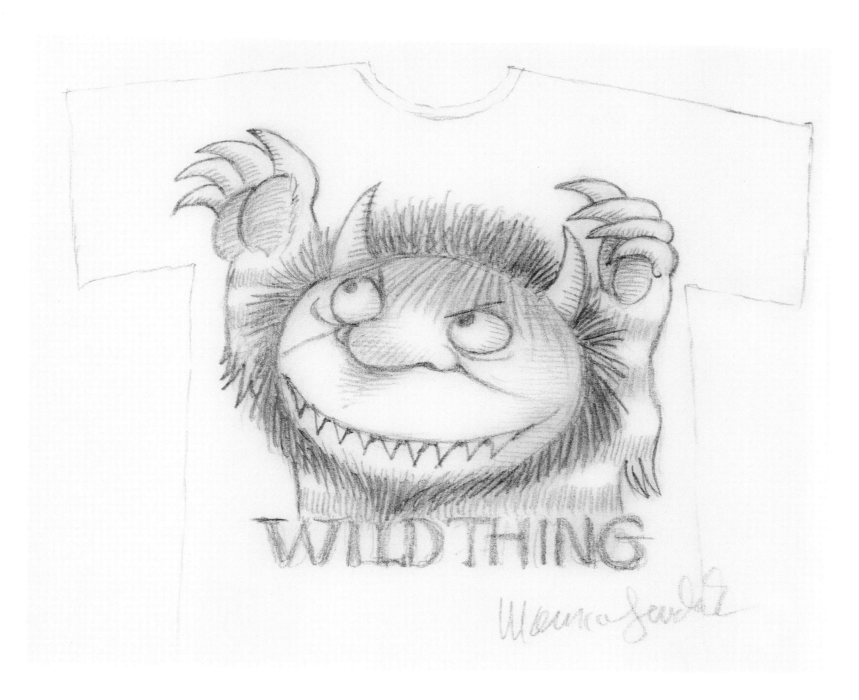

OPPOSITE: *Oliver Knussen: Horn Concerto,* 1996. Pencil and watercolor, 5 x 5 inches.

ABOVE: Study for Wild Thing T-shirt design, 1998. Pencil, 4 x 5½ inches. Created for Sony Metreon product merchandising and sold at the Metreon complex in San Francisco (and Tokyo), where it fed the demand for souvenirs of Maurice Sendak's *Where the Wild Things Are.*

FAR LEFT: Cover of *Oliver Knussen* CD, released by PolyGram Classics for Deutsche Grammophon, 1996.

LEFT: Wild Thing T-shirt (detail), 1998. Silk-screened Cronies T-shirt with a tag marked "© Maurice Sendak 1998."

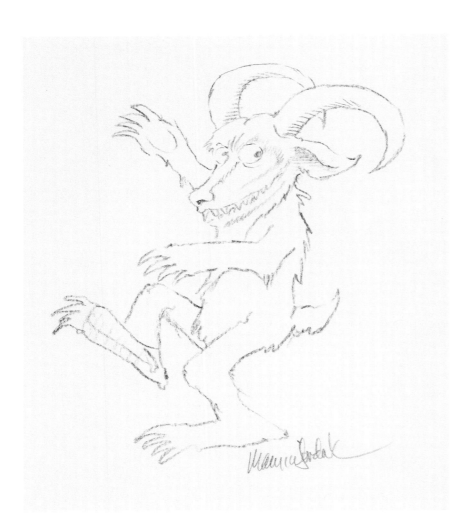

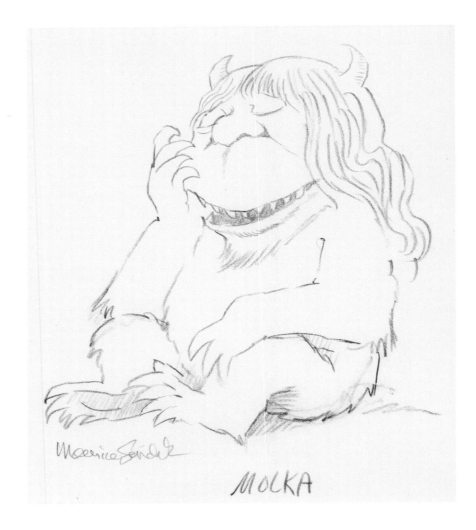

MOLKA

The Wild Rumpus Card Game, published by Briarpatch in 1999.

TOP, LEFT: Study for *Goat Boy,* 1999. Pencil, 5½ x 5 inches.

TOP, RIGHT: Study for *Mocka,* 1999. Pencil, 6¾ x 6½ inches.

RIGHT: Wild Thing playing cards, published by Briarpatch, 1999. Each printed card, 4½ x 3 inches. Among the products and souvenirs created for the public were games that employed Wild Thing characters, such as these playing cards.

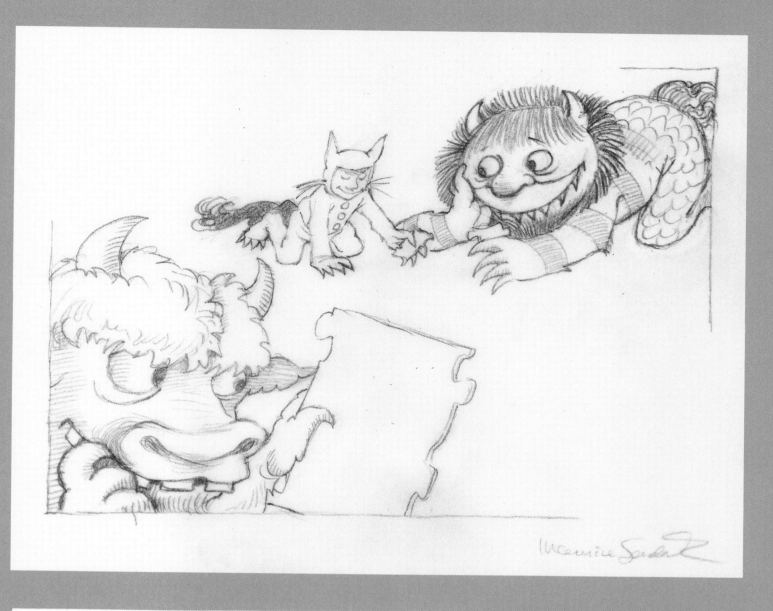

Wild Things: Puzzle Maze Game, published by Briarpatch in 2000.

The installation at the Metreon complex by the Sony Corporation in San Francisco (and Tokyo) created a demand for Maurice Sendak products, souvenirs, and collectibles. Along with postcards, buttons, articles of clothing, bags, and home furnishings, there were board games, jigsaw puzzles, and toys licensed for general merchandising.

TOP: Study for printed box for Briarpatch, New Jersey, 1999. Pencil, 5¾ x 8 inches.

LEFT: Printed box bottom, published by Briarpatch, New Jersey, 2000. 9¾ x 13¾ x 2 inches.

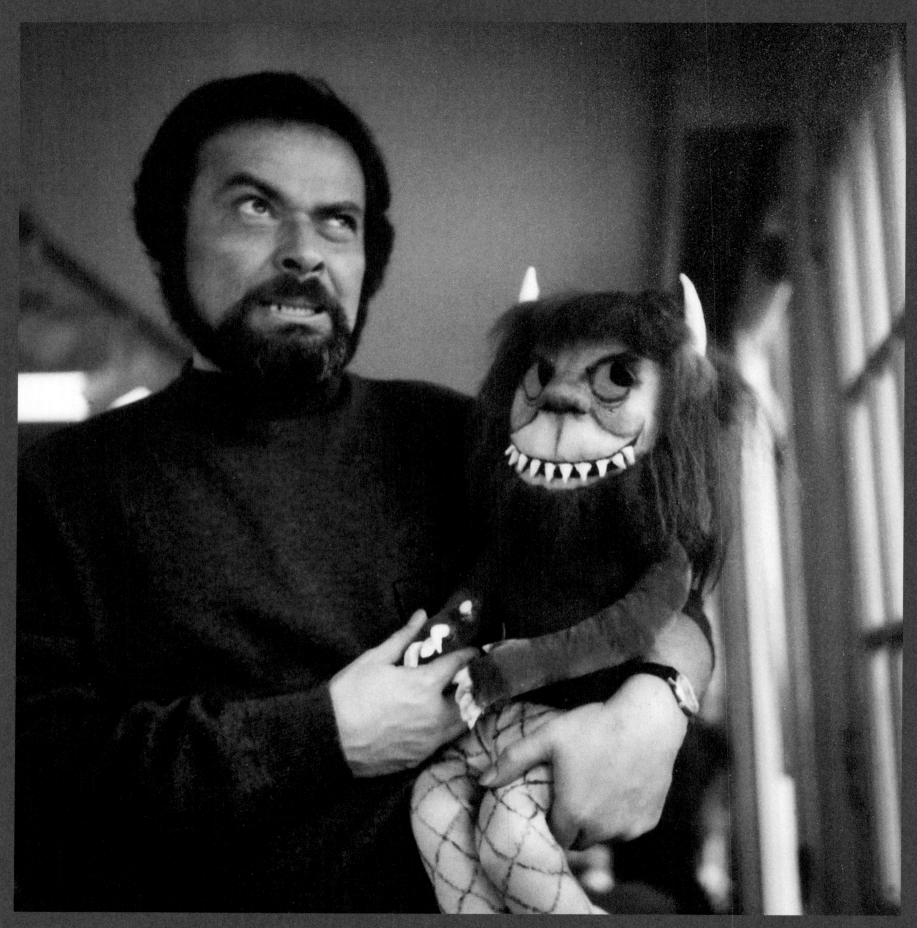

Maurice Sendak mimicking a Wild Thing doll, ca. 1970.

CHAPTER X: *WHERE THE WILD THINGS ARE*

Mad Max: On Three Preliminary Drawings
for *Where the Wild Things Are*
by Patrick Rodgers

Fifty years ago Maurice Sendak unleashed *Where the Wild Things Are*. Weathering several generations of readers and half a century of social change, it has only grown more popular, enjoying global distribution in a profusion of languages, big screen adaptations, and viral tributes of many forms online and offline. Commentators have often pondered what accounts for the book's longevity and exponential popularity. As is true of all stories that come to be regarded as "classics," it owes its success to a variety of factors. Readers love Max's rambunctiousness, the highly stylized Wild Things, the poetry in Sendak's writing, the way the illustrations expand to take over the pages, and the openness of the book to so many different readings and interpretations. But all these elements would seem scattered if Sendak hadn't wrapped them around a strong emotional core: the fury of Max, and his catharsis through fantasy. Sendak's editor at the time, Ursula Nordstrom, wrote to a journalist in 1964 that *Where the Wild Things Are* was "the first American picture book for children to recognize that children have *powerful* emotions—anger and fear, as well as the need Max had, after his anger was spent, to be 'where someone loved him best of all.' . . . A lot of good picture books have had fine stories and lovely pictures, and some have touched beautifully on basic elements of a child's life . . . but it seems to me that *Where the Wild Things Are* goes deeper."[1]

Max's depth as a character is communicated through surprisingly few words, expressed with subtle gestures, and condensed into just a few images. Like any great character in literature, Max has a history. The Max millions

of us know from *Where the Wild Things Are* evolved over many months, if not years.[2] He wasn't always clad in a wolf suit (in one manuscript Sendak dressed him in a panther suit), his name wasn't always Max (Sendak first considered Johnny, then Kenny), and the mischief he made was not initially limited to blanket forts and dog chasing. Much of Max's development can be gleaned from the two dummy books, forty-four manuscript pages, and more than fifty preliminary pencil drawings for *Where the Wild Things Are* at the Rosenbach Museum & Library in Philadelphia, where they are part of the larger ten thousand–piece collection the artist placed on deposit. Those materials tell us much about how Sendak nurtured his hero into the King of All Wild Things, but there are also preliminary materials in private hands that shed more light on Sendak's working process for the book, including the three watercolor drawings in the Schiller collection published here for the first time (see pages 197 and 198). These three drawings fill many gaps in our knowledge of how Sendak crafted his classic, and raise intriguing questions about Sendak's methods, technique, and characterization of Max and the Wild Things.

Sendak's exposition of his emotionally complex hero begins in the "mischief scenes": the story's first two illustrations and the opening words, "The night Max wore his wolf suit, and made mischief of one kind—and another—." We know from Sendak's dummy book and storyboard that he allowed for just two images for this sequence that would establish Max's bad behavior and suggest a deeper restlessness and frustration: the familiar madness of a cooped-up kid acting out. There are more preliminary versions[3] of Max's mischief in the Rosenbach's holdings than of any other scene in the book, even those depicting the Wild Things, suggesting that Max's misbehavior was one of the most arduous parts of the book for the artist to perfect. Two of the watercolors in the Schiller collection fit into this sequence, and were likely preliminary color versions of the "mischief scenes." Both were experiments in Max's misdeeds that Sendak had separately sketched in pencil and committed to watercolor.[4] In one drawing, Max stalks his dog (fans will recognize Sendak's own Sealyham terrier and sometime muse, Jennie, from *Higglety, Pigglety, Pop!* and dozens of other titles) in the corridors of his house. In another, he crouches on top of a table, attacking a plate of spaghetti with his paw, while his dog and cat peer at him from below.

The first of these two drawings appears unfinished: The plant at right is just barely outlined; while the wall behind Max is nicked with vertical ink strokes that appear sketchy next to the crosshatching Sendak employed in the left background and throughout the book's final drawings. A similar scene in Sendak's May 25, 1963, dummy book—showing Max in his wolf suit striking the same pose and scaring a black cat—leads off the "mischief sequence." Sendak elaborated on this domestic confrontation in several preliminary pencil drawings: One shows Jennie sitting on her haunches with her front paws wrapped around a cat that has just fallen backwards into her, presumably in terror at a frowning Max stalking up to them; another replaces the cat with a little girl about half Max's size with a mop of hair—perhaps Max's sister. In the more fully realized color version, however, Sendak distilled the mischief to a single confrontation between dog and wolf—civilized beast vs. wild thing—suggesting just how unruly Max had become to antagonize his own beloved pet. While Sendak significantly altered Max's pose from the exaggerated stance here to his more animated dash in his final artwork, he may also have recycled this pose elsewhere in his illustrations—most notably on the book's title page, in which Max strikes a similar pose while scaring two Wild Things, and perhaps even in the posture of the orange-and-brown-striped Wild Thing who greets Max when he first arrives at their land. The childish monster portrait tacked to the wall on the left—a device that prefigures the creatures Max will later meet—was a feature Sendak included in a number of other preliminary drawings and retained in his final artwork.

The second expands on Max's predatory performance and the appetites it arouses. Like its partner in the "mischief sequence," variants of this image exist in Sendak's dummy book (where Max actually has a corner of the tablecloth in his mouth) and preliminary sketches. In comparison with the first color "mischief" drawing, this image is packed with detail. We take in signs of Max's dull if cozy home life, from his family's glazed cupboard stocked with cups and dishes to a complacent Jennie, happy to scarf up the wolf's leavings but also warily keeping an eye on him; to a wily black housecat sharing a nefarious look with Max; to an assertively checkered tablecloth. Max himself barely fills out his wolf suit—witness the flaccid paw backhoeing his pasta, as though Max's hand were far back up the sleeve. Sendak scatters other signs of Max's

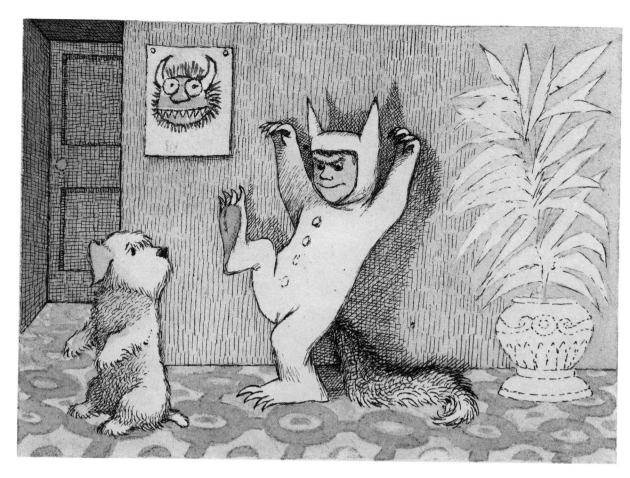

TOP: *Max Terrorizing Dog*, 1963. Pencil, pen-and-ink line, and watercolor on board, 4⅛ x 5½ inches. An unused drawing depicting Max's mischief. The final version, which shows Max chasing the dog down the stairs, appears in the book.

BOTTOM: *Max Eating Spaghetti*, 1963. Pencil, pen-and-ink line, and watercolor on board, 4⅞ x 6¼ inches. This unused drawing depicts more of Max's mischief.

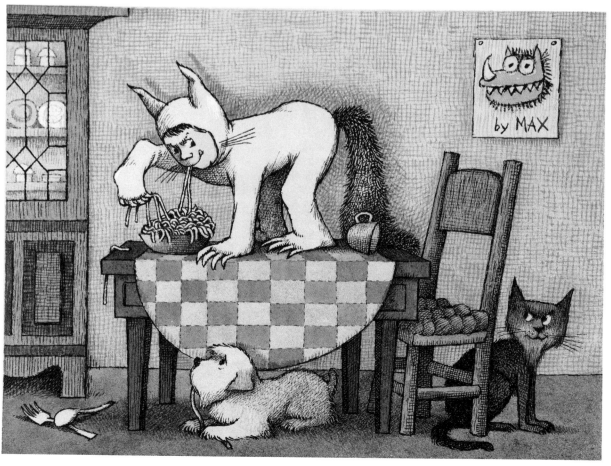

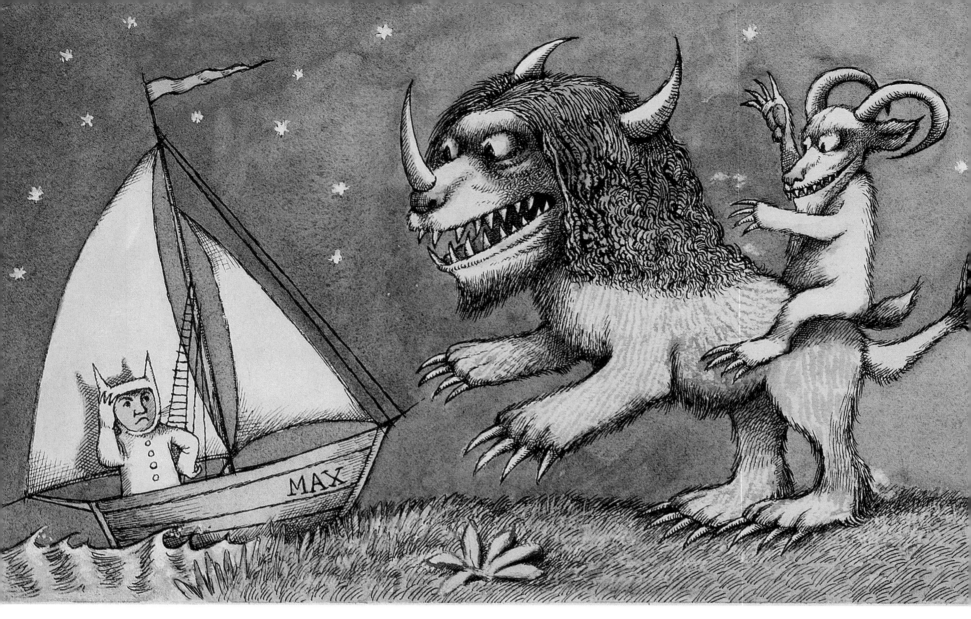

Max Arriving at the Island of Wild Things, 1963. Ink and watercolor on board, 6¼ x 20½ inches. Sendak identified this as his earliest completed drawing of Max and the Wild Things. This drawing and the two previous watercolors are a promised donation/bequest to the Rosenbach Museum & Library.

anarchy throughout the scene: the teacup knocked perilously close to the table's edge and the limp strand of spaghetti dangling from the table on the left like a Dalí-esque persistence of mischief.

A "deleted scene" like this—so engaging, detailed, and seemingly complete—easily lends itself to speculation about why Sendak chose not to include it among the "mischief scenes" in his book. One of the greatest contrasts between this scene and the final drawings for the book is its level of detail. Max's mischief comes across with a certain sly charm, but the composition seems weighed down by furniture, pets, patterns, and carbohydrates. Sendak had grappled with the problem of overly descriptive illustrating in another project from 1963: Leo Tolstoy's *Nikolenka's Childhood*. Sendak complained that Tolstoy's descriptive abilities

encouraged redundant illustrations, evoking a world that was already—as he put it—too "registered."[5] That is, more telling than showing. Who knows whether Sendak felt Max's dinner-table mayhem was a bit too "registered" for *Where the Wild Things Are*? He may have hinted as much in a 1966 profile for the *New Yorker*, in which he enigmatically explained that in *Wild Things* he tried to eschew the literal and the particular.[6] Rather than dwelling on the details of Max's domestic space, Sendak focused subsequent efforts on the emotional thrust of each picture, resulting in the confined, spare, almost forlorn "mischief scenes" in the book. The cat and dog that Sendak provided as reluctant companions for Max in the dining room preliminary are gone; so, too, is the family furniture that reminds readers of an adult presence.

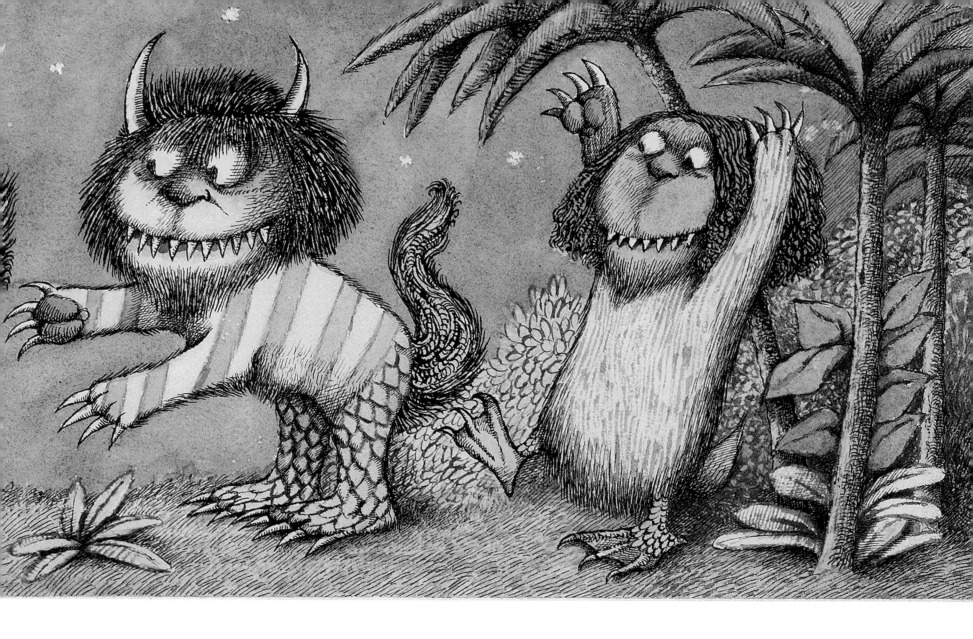

As Sendak pared down and reimagined this sequence, his illustrations—and Max's world—shrunk. Open the book today and you will see that his wolf now looks caged and even more restless, with fewer peripheral distractions.[7] Most importantly, the spaghetti had to go.[8] Throughout Sendak's drafting process, Max being sent to his room without dinner was the price he had to pay for his mischief, and the absence or presence of food (respectively) provided the motivation for both his escape to the land of the Wild Things and his return to his family. Showing Max gobbling up some spaghetti and going to his room with a full belly would have taken the sting out of his punishment.

There may be a synthesis of both color preliminaries into Sendak's final scene depicting Max's wild charge down the stairs toward Jennie. That final drawing maintains the wolf-versus-dog rivalry from the preliminary scene where Jennie acts as Max's foil, but the fork that he brandishes is a remnant of the dinner-table scene, a symbol that preserves the aggressive appetite Max formerly showed toward a plate of pasta.

The third preliminary color drawing in the Schiller collection provides perhaps the earliest glimpse of Max and the Wild Things together. On the left, Max's private boat arrives on the shores of "where the wild things are," and four Wild Things come to greet him. One of the first differences any fan of the published book will notice is the more bestial appearance of the Wild Things. Their pupils are slightly pointed, confronting Max with a more aggressive stare than the curious, eager eyes of the Wild Things in Sendak's

Maurice Sendak in his studio, ca. 1963.

the faces of the Wild Things more toward Max, modeling them in three-quarters profile rather than the frontal perspective here; he rotated the brown bands on the middle Wild Thing, bestowing him with his iconic, striped look; and he repositioned the yellow Wild Thing's tail, which would have plunged into the gutter of the book if this composition had been published as a spread (Sendak was always concerned about having a clean gutter).

But the appearance of the Wild Things was essentially a technical concern. What might be easily overlooked is the appearance of Max. The whole visual thrust of the scene is toward him, and since readers are invested in Max's point of view, his reaction to these outrageous monsters of his own invention is crucial. In Sendak's dummy book and pencil drawings, Max simply looks grumpy, with cross-looking eyebrows, set jaw, and both hands on his hips—he resembles the contrarian Pierre from Sendak's 1962 *Nutshell Library*. In this color preliminary, however, Max looks more bemused, frowning thoughtfully while he scratches his head. There is a hesitation there (which might be expected when encountering a strange group of monsters). What is missing, at least in relation to Sendak's final version, is an air of assertiveness. While Max's pose here could be considered a refinement of his raw anger in Sendak's dummy and is just as indicative of Max's grumpy mood (occasioned by hunger and resentment), it is not suggestive of his dawning control over the fantasy he has initiated. Sendak's final version shows Max with a fixed scowl and defiant expression, with one hand on his hip while he leans on the gunwale of his boat with the other. He looks both unimpressed and in control. His nonchalance lends him an air of mastery, as if even before he's landed on the island he has already started behaving like a king, someone who has already taken his measure of the misfit band of monsters he has just glimpsed. These are small changes in gesture, to be sure, but they say much about how Sendak conceived Max as the author of his own cathartic fantasy.

While the two preliminary "mischief" drawings in color document Sendak's process of paring down that opening sequence for the book, the preliminary version of Max meeting the Wild Things swings the pendulum in the opposite direction. If anything, Sendak went on to embellish them with greater detail and more vivid color. The Wild Things became catalogues of detail: walking, growling masses of fur, feathers, horns, greasy

finished work (but still nowhere near as nightmarish as the slit eyes of similarly beastly Wild Things in one preliminary pencil drawing).[9] The horned, yellow Wild Thing and the orange-and-brown-striped Wild Thing are also quadrupeds in this early conception. This beastly cast originated in Sendak's dummy book—which also featured a smaller four-legged white creature that looks like a cross between a dog and a polar bear and is probably a first try at the creature that would become the goatlike Wild Thing—and continued in a few preliminary pencil drawings until Sendak softened some of their features and accelerated their evolution into upright monsters. While Sendak maintained this composition as the template for his final drawing, he also refined some details: He turned

hair, duck legs, bird beaks, baggy eyelids . . . One of the chief delights of reading *Where the Wild Things Are* is in lingering over the details of the Wild Things's polymorphic bodies. They are so captivating that it's very easy to get hung up on them and to lose sight of the kid whose tantrum is being lived out through this fantasy. Even Sendak lost focus at times. In his manuscripts, he produced draft after draft of protestations on the part of the Wild Things when Max sends them to bed without their supper. After one redundant rewrite, a frustrated Sendak scrawled an angry note across the page urging himself to ignore the Wild Things and concentrate on Max once again.[10] In stripping his manuscripts of their speaking parts and refining their visual appearance in his artwork, Sendak reinforced the idea that the Wild Things are objects, not subjects. They are projections of Max's feral imagination, and that opens the door for readers to project on to them, as well. If you've ever read this book to a child, you know that a choice approaches when Max declares, "Let the Wild Rumpus start!" How do you "read" the next six wordless pages of wild mayhem? We participate in whatever ways come to us, projecting on those pages our idea of what's going on, whether we growl, improvise music, or march around as the Wild Things do. But it is Max—the book's true subject—who declares an end to the rumpus, and the fantasy. The three preliminary drawings reproduced here give us a better sense of just how Sendak constructed Max's subjecthood: refining expressions and gestures, merging and condensing imagery, and ensuring that Max's characterization propelled each part of the narrative forward. There are surely other details in these drawings that merit investigation and comparison. Questions linger about when exactly Sendak completed these drawings and how they fit into his sequence of drafting a manuscript and completing preliminary sketches. Even after fifty years, *Where the Wild Things Are* hasn't given up all its mysteries. But then, isn't that what makes a classic?

NOTES

1. Ursula Nordstrom to Nat Hentoff, December 1, 1964. In *Dear Genius: The Letters of Ursula Nordstrom*. Edited by Leonard S. Marcus. (New York: HarperCollins, 1998), 184–85. Emphasis original.

2. While Sendak drew a dummy book called *Where the Wild Horses Are* in 1955, the earliest known manuscripts for that story are dated April 1963. Sendak changed the title to *Where the Wild Things Are* in early May 1963 and completed a storyboard and dummy that reflected his new tack later in the month (a dummy book is a sort of mockup of text and images in book form that Sendak would often create when beginning many of his picture books). His preliminary and final artwork is undated, however. Whatever the exact dates are for his creation of the three color preliminaries under discussion, as well as other artwork for the book, it could be argued that a number of characters from previous books—including Kenny from *Kenny's Window* (1956), Rosie from *The Sign on Rosie's Door* (1960), and Pierre from *Pierre* (1962)—informed his development of Max in *Where the Wild Things Are*.

3. Pencil drawings on tracing paper were Sendak's favored media for his preliminary work on a book throughout his career.

4. There are very few color preliminary drawings for *Where the Wild Things Are* on deposit at the Rosenbach.

5. Interview with Sendak at his home in Ridgefield, Connecticut, August 10, 2007. Published on the DVD *There's a Mystery There: Sendak on Sendak, A Retrospective in Words and Pictures* (Rosenbach Museum & Library, 2008).

6. Nat Hentoff, "Profiles: Among the Wild Things," the *New Yorker*, January 21, 1966.

7. Another example of this is the "mischief scene," where Max nails a twisted bedsheet to his wall. There are four pencil drafts at the Rosenbach, each of which retains the basic composition but in which Sendak progressively eliminated layers of details, including paw prints on the walls and blanket and objects in Max's room.

8. In various manuscript drafts (one dated August 21, 1963, the others undated but probably written between August 16 and 23), Sendak singled out spaghetti as the food that Max can smell from far off, which causes him to leave the Wild Things and return home.

9. Also at the Rosenbach. Those Wild Things share the slit eyes of a wolf Sendak illustrated in Marcel Aymé's 1954 book *The Magic Pictures*.

10. Manuscript from August 21, 1963, at the Rosenbach.

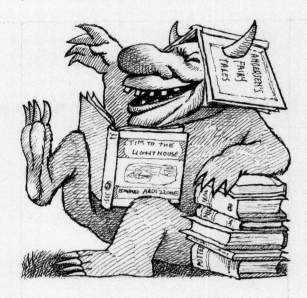

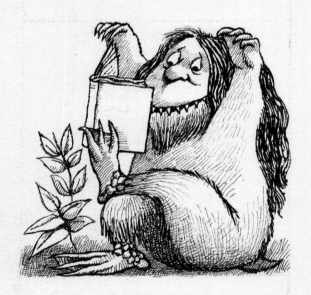

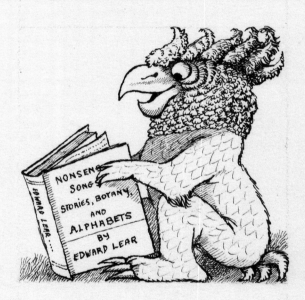

ABOVE: Four Wild Thing vignettes, 1968. Pen-and-ink line, each 2 x 2 inches. These illustrations were created for an article that ran in the November 16, 1968, issue of the *Times Saturday Review*, on the occasion of the British publication of *Where the Wild Things Are.*

OPPOSITE: *Wild Readers*, 1968. Pen and ink, 8 x 8 inches. This central drawing for the *Times Saturday Review* represents Sendak's first use of his "Literary Lunch" image.

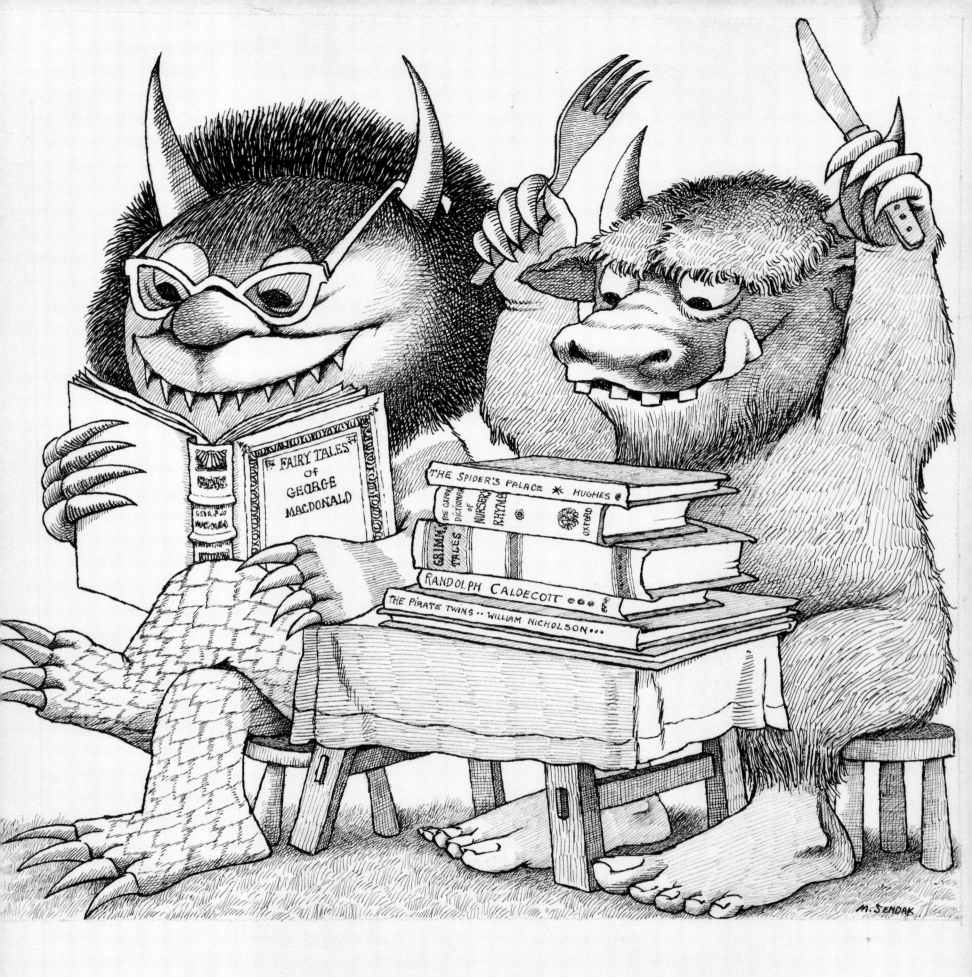

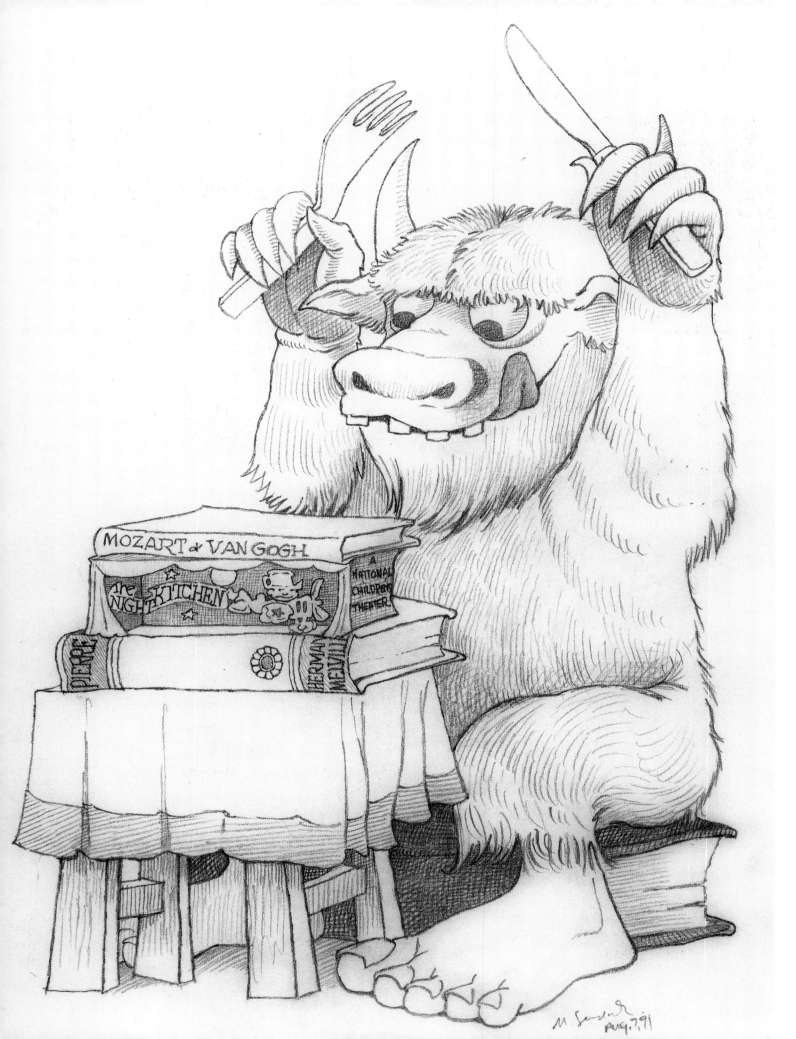

Study for *Literary Lunch*, 1991. Pencil on paper, 10⅜ x 7⅜ inches. Created for a promotion at the Strand Bookstore, New York.

LEFT: Autographed note to "Lisa, Heather, Patty . . . ," 1968. Pen-and-ink line, 8 x 5 inches.

ABOVE: Autographed note to Mrs. Yuill and her class, 1968. Pen-and-ink line, 5½ x 3¼ inches.

Sendak in South Carolina:
The Making of the Richland County Public Library Mural
by Ginger Shuler

Augusta Baker is the reason that all of this happened.

By the time I met her, Augusta had had a long and distinguished career in library service to children, first as children's librarian of the New York Public Library's 135th Street branch, in Harlem, and later as coordinator of youth services for the entire New York Public Library system. She was an extraordinary storyteller and librarian, and one of the things she had done was to travel the country giving workshops on storytelling and the importance of books in a child's life. She had retired in 1973, and so in 1980, I couldn't believe my luck when I read that she was coming to Columbia, and out of retirement, to be the first storyteller-in-residence at the University of South Carolina's library school. By that time, I was head of children's services for the Richland County Public Library, and so when Augusta arrived in town, I took her to lunch. We became very good friends.

In 1986 our library and the University of South Carolina's library school got together to start an annual storytelling festival in Augusta's honor. We decided to call it A(ugusta) Baker's Dozen: A Celebration of Stories and to contact Maurice Sendak for permission to use an image from *In the Night Kitchen* on the poster advertising the event.

Maurice had known Augusta for a long time by then, having given one of his very first talks to children at her branch library in Harlem in the early 1950s. Maurice, she later told me, had been a nervous wreck in anticipation, and before he went out to talk to the children, told her, "I don't know what I am going to talk about." Augusta, who

could be quite direct with people, looked him in the eye and said, "Young man, you had better figure it out!"

Maurice's response to our request was also direct—and extraordinarily generous. He simply sent us a postcard that said, "Of course." It was the first of many acts of generosity on his part. In 1989 when he came down to Columbia to give the annual A. Baker's Dozen lecture, we feared he would not approve of the way we had printed his art. But when we showed him the poster, he just looked at it and said, "It works." And that is when I fell in love with that man.

After Maurice's first visit to Columbia, I wrote to him regularly, and I spoke with him occasionally by phone. I also sent him fun gifts from time to time—a badminton set, a pair of binoculars with a book about bird-watching and a CD of bird calls, a needlepoint Christmas stocking that featured the angels from *We Are All in the Dumps with Jack and Guy*, and special "boxes" I made for him, including one that played a recording of Perry Como singing when you lifted the lid!

We started talking about a Wild Things mural for the new Richland County Public Library building in 1991, two years before the building was due to open. At the first planning meeting, I said I wanted a Sendak mural for the children's room. The interior designer Don Palmer, who was from Houston, responded enthusiastically that he, too, was a Maurice Sendak fan, and so why didn't I call him. Maurice, as it happened, was going to be in Houston for a production of *The Magic Flute* (1991), and so Don, our library director David Warren, and I arranged to meet him at his hotel to show him the plans. These included Don's detailed sketches of the mural and side panels. Don had drawn a somewhat elongated but otherwise exact rendering of the rumpus scene in which the Wild Things are swinging from the trees. In the two side panels, Max contemplated what to do next and the Wild Things looked drowsy. When Maurice saw the sketches, his first comment was "It will define the space." And then he said, "It will be the first time my art has been used as public art." This made all of us happy because we knew then that our plan was going to work.

When it was time to have the mural made, Maurice told us, "You will need to get Michael Hagen, who paints all the set designs for my operas. Just ask him. He'll do it. He loves me!" Michael painted the mural on linen in his studio in South Glens

Falls, New York, and then put it, all rolled up, on an eighteen-wheeler to Columbia. When he arrived to oversee the installation, he came with a small bucket of screws and things for hanging the piece on the wooden frame he had built for it. The linen scroll came in the front door, and we took it first into the auditorium and then to the children's room. Then at last it was up, just as we had imagined. To thank Maurice, I felt I had to give him something of great personal value, and so without telling my family, I sent him one of my grandmother's quilts.

When the new library opened three days later, everyone had a reaction to the mural. One patron said the Wild Things were too frightening for children. But another commented, "I never realized they were smiling." One evening a toddler who was playing in the children's room with his father got up from the puzzle table, toddled up to the mural, and said, "Play!" His dad went over to him and said, "They can't play," and led him back. Whereupon this little boy stood up again, went right back over to the mural, and commanded, "Play! Play!" Then—before his father could retrieve him a second time—he plopped down on the floor in front of the mural and burst into tears. He so wanted those Wild Things to come down and play with him!

Augusta Baker once told me a story from back when *Where the Wild Things Are* was first published, when it was considered by many to be a controversial book. She had stopped in at one of the New York Public Library's many branch libraries to look in on the children's room, and she noticed a young boy sitting by himself reading Maurice's book. She walked over to him and said, "Young man, does this book frighten you?" The child looked up from his book. Then pointing to a picture of the Wild Things, he said, "No. Look at their feet. They've got such soft feet. Just look at them."

OPPOSITE: *Hillbilly Wild Thing*, 1997. Pencil and watercolor, 7¾ x 7¼ inches. Drawing of "Moishe" Wild Thing, to which a hat and lasso were later added, to produce a limited edition photolithograph to commemorate Maurice Sendak's visit to West Virginia.

OVERLEAF: Preliminary drawing for *Max with Four Wild Things Hanging from Tree Branches*, 1993. Pencil, 10½ x 21¾ inches. This is the only preparatory drawing created by Sendak for a 46-foot mural in the children's room in the Richland County Public Library in Columbia, South Carolina. The installation was completed by scenic artist Michael Hagen, who had previously painted Sendak theater sets.

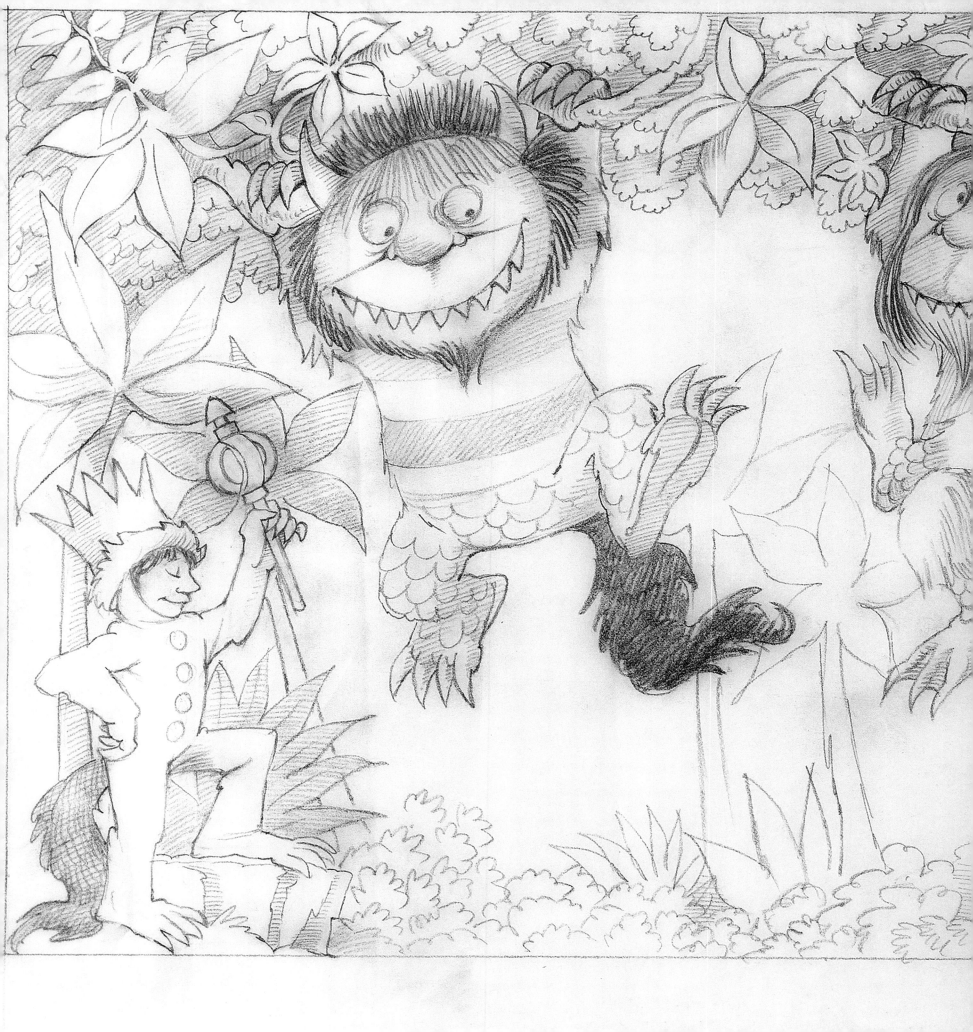

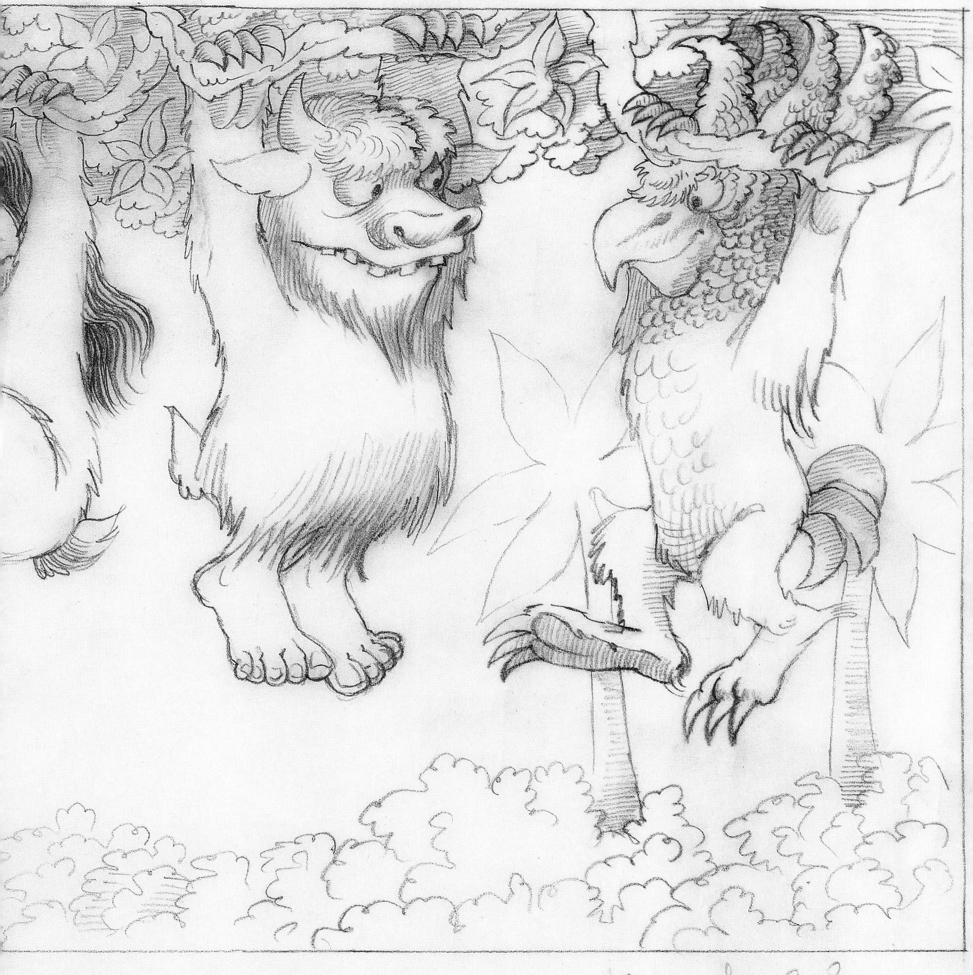

Maurice Sendak
July, 2000

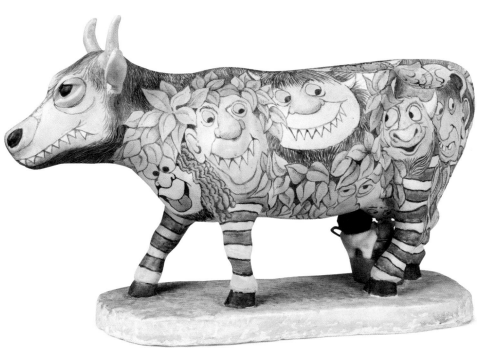

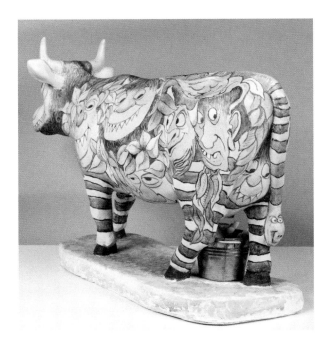

A Tabletop Cow

Maurice Sendak's hand-painted cow was sold at a 2003 fund-raiser to help Chicago Opera Theater stage their inaugural production of the artist's *Brundibar*. It was designed and decorated by the artist with Wild Thing characters interspersed with foliage. Sendak's associate Lynn Caponera filled in the background, base, and banded legs and tail under his supervision, after which he provided finishing details and placed Max, dressed in his wolf suit, inside a metal pail under the udder. This was the year of the giant Cow Parade that could be seen all over New York (also staged in Chicago and Zurich), part of a public arts project to bring artists together, garner corporate support to raise money for charity, and delight everyone. Though Sendak was invited to decorate a full-size cow, he felt, as a children's book artist, that a tabletop version would be more appropriate. Sendak's cow was displayed at the premiere of *Brundibar* in Chicago and returned to New York for auctioning over the Internet by Sotheby's.

OPPOSITE: *Tabletop Cow ("Moo-Reese")*, 2000. Pencil and watercolor on a molded plaster cow with metal pail and "Max" plush doll, 27 x 17¼ x 7½ inches.

LEFT AND ABOVE: *Tabletop Cow* (side and rear views), 2000.

Maurice Sendak at a lectern,
ca. 1968.

CHAPTER XI: MAURICE SENDAK AS TEACHER, EDUCATOR, AND MENTOR

Sendak at Yale
by Paul O. Zelinsky

In the fall of 1971, when I signed up for a picture-book course I saw in the Yale College catalogue, its teacher, Maurice Sendak, was already famous—at least to people who read children's books. I surely knew who he was. I was a sophomore who spent my spare time in bookstores, where I'd wander to the children's section and browse through the picture books. Before that course, although I'd always loved to draw and was considering some form of art as a possible life's work, it had never dawned on me that children's books might represent a career.

To apply for the course, you had to submit a sample of work or a written justification for admittance. I probably dropped off some drawings—I don't remember, but I do recall being thrilled to see my name on the accepted list.

The dozen or so would-be writers and illustrators who piled into a small ground-floor classroom in Yale's Ezra Stiles College didn't know each other, but we were all excited about what was to come. The most significant of us was a writer, Helen Kivnick. I say this because the whole course was her idea. The previous year, as a junior in a writing tutorial with A. Bartlett Giamatti (the master of Stiles College, who later became the commissioner of base-ball), her increasingly long poems were coming to resemble children's stories. Wouldn't it be lovely, she mused, if Yale offered a course in children's books, with Maurice Sendak as its teacher? Giamatti told Helen that if she contacted Sendak and got him to agree, Yale's Residential College Seminar Program would allow it to happen. Helen

found Maurice's number in the New York City phone book and gave him a call. About that conversation, she now remembers little more than the state of her nerves, from the moment Maurice answered his phone to the moment he hung up. During the call, Maurice decided to accept the invitation as long as another teacher could be brought in to help him. Helen recruited English professor Elizabeth Francis, with whom she'd studied previously, and the course was scheduled. One thing Maurice had not mentioned to Helen was that when he walked into our class and started to lecture, it would be the first time he had ever taught anything, anywhere.

On the first day of class, Elizabeth Francis sat at the head of a long table. She was a young assistant professor with a specialty in Victorian novels, and she wore her curly hair in a Victorian-style knot, swept up and pinned in the back. Maurice sat next to her. He was short and dark-haired, with big glasses and a trimmed beard. From then on, every other Tuesday of the term, he would travel to New Haven from his house in the woods of western Connecticut. The alternate classes would be led by Dr. Francis. The curriculum had Maurice introducing us to the history of the picture book and guiding us through projects of our own; with Dr. Francis, we studied texts about childhood—how it was treated in literature and viewed sociologically.

Maurice came overflowing with historical information and critical commentary that, in its concentrated delivery, defied note-taking. He spoke seriously, with energy and conviction, displaying an Anglophilia that his Brooklyn accent threw into interesting relief. Maurice's pleasures were his obsessions, and every one of them was contagious. He drew us into his admiration for Randolph Caldecott and for Samuel Palmer and William Blake, whose *Songs of Innocence and of Experience* he saw as proto–picture books. At the time, he was considering illustrating a book of nursery rhymes, and he passed out photocopies of the massive collection he'd gathered. His notes were scattered throughout, and I wish I'd kept the handout. He made us feel we were sharing in his life, as he talked openly about friends and colleagues like James Marshall and Edward Gorey, and his dealings with Justin Schiller and his first editor, Ursula Nordstrom. Only later did the limits of this openness become clear: We thought that Maurice lived and worked by himself in his big house in the country; he never once mentioned his partner, Eugene Glynn.

Maurice stressed the loneliness of an illustrator's job. At the time, he was spending his days crosshatching his exquisite illustrations for *The Juniper Tree*, the collection of Grimm tales on which he collaborated with translator Lore Segal. Later he would tell me that during this period, he had been so fiercely wrapped up in his work that our class had been his only human contact, that it had been a lifeline in his isolation.

My classmates were more writers than artists, and a few wanted to try their hand at both. When we started working on projects of our own, Maurice was generally protective and kind, but he could not praise what he didn't like. That said, a lot of what we had to show him he liked well enough. Andea DaRif drew elegant, Beardsley-like drawings for another writer's texts. Eve Rice, from the start, was composing wonderful stories that were poetic and young, which she illustrated in a simple 1940s style. Her first effort, she confessed to Maurice, borrowed more than a little from Marie Hall Ets, one of her favorite author–illustrators. Maurice shared her appreciation of Ets and was encouraging. He told her, "If you're going to steal, steal good." Barnaby Conrad III had already illustrated a published children's book, which his writer father had written about the family's pet fox, and he worked on a fox story for the course. I loved what Helen Kivnick was writing. She had no inclination to illustrate, so the two of us decided to collaborate. I wish I recalled Maurice's specific responses to our efforts, but I remember that he reacted well. Sandra Boynton showed him drawings she'd made of funny monsters in the roles of "Minor Maladies," such as Cough and Little Tickle, but he couldn't muster enthusiasm. He dismissed her drawings as "greeting-card art." That was blunt, but he wouldn't have said it if he weren't taking our contributions seriously. With us, as with his own writing, he did not condescend.

Sandra Boynton went on after graduating to found a greeting-card empire, and to illustrate a great number of beloved (and un-Sendakian-ly silly) picture books and songbooks. Before Eve Rice graduated from Yale at the end of that year, she had a picture book under contract with Young Scott publishers. She went on to notable success as an author-illustrator until she entered medical school (and ultimately became a psychiatrist). Months after Eve's story was accepted, the same editor said yes to a dummy I'd submitted with Helen (who went on to become a professor of social

work at the University of Minnesota). Before our book could go to contract, however, Young Scott was bought by Addison-Wesley, which kept the smaller publisher's backlist but fired its staff. What would have been my first published book never saw print. (I only learned later that Young Scott had been Margaret Wise Brown's publisher, and the one responsible for Gertrude Stein's children's book, which contains "Rose is a rose is a rose is a rose.") Barnaby went on to write nonfiction books and has done a lot of travel writing; more recently, he's added painting to the list.

When Maurice came to our class, he brought books he loved and passed them around. One day he showed us a book with moving parts by the German paper-engineering genius Lothar Meggendorfer. (I know now, from working on my own paper-engineering projects, what a precious collector's item that was.) Another day he brought in some of the art he'd made for *In the Night Kitchen*, which had come out the year before. It was in two parts: the black line drawings and the colored art, the latter of which he had painted in gouache on paper prepared for him by the book's printer, with pale-blue printouts of his line art. Maurice told us always to ask for Strathmore Illustration Board for our non-photo blues. I don't think he was being patronizing or coy; he was treating us as colleagues.

By that time, I had made my way through a couple of Yale's art courses and encountered a great deal of talk that befuddled me. In the art department, formalism ruled: Art was abstract, and its tools, its terms, and its raison d'être were visual. All subject matter was irrelevant. Whether a painting showed bottles on a table or just blobs of paint, you were required to see it as interrelationships among formal components—and what's more, to judge whether these interrelationships "worked" or didn't. Heaven help you if you had anything to say about the bottles or the table—that was out of bounds. If you cared about that, you were verging on "illustration." I did my best to figure all of this out, but I was having trouble making paintings about edge or value relationships that inspired my full interest.

Formalism wasn't remotely Maurice's approach. But as I learned more, I started to see that on a formal plane, Maurice's pictures have great strength. He looked at the old masters and grasped the abstract essence of their images. You can tell it from his pictures. His illustrations for chapter books by Meindert

DeJong weren't ersatz Rembrandts; they conjured, without copying, the way Rembrandt's drawings function, the vivacity of his line, and the judiciously placed accents. In his pictures for *The Juniper Tree*, the large and small shapes—classically rounded, strong shapes—complement each other and interlock, both flat on the paper and in their virtual third dimension, in a Dürer-like way that's utterly satisfying. Maurice's form is commanding, but what his pictures depict is obviously essential as well. And there is no conflict. My other teachers used the word "illustration" to mean an image that falls flat as form, whose only interest is on the level of subject matter. Sendak was quite the counterexample.

If Maurice didn't talk about the abstract choices he made as a draftsman, he did speak about the formal structure of his books, and this was an eye-opener for me. He talked about a book having rhythm, much the way a piece of music is rhythm from beginning to end. The word "rhythm" alone opened a world of understanding to me. Looking at Randolph Caldecott's idiosyncratic layouts, where words of a nursery rhyme aren't regularly placed through the book, stanza by stanza, but are interrupted by a wordless vignette here, or a free-standing line—Maurice showed us how it *became* music: the pauses and repetitions, loudnesses and softnesses, all with a big overall shape that carries you from the first page to the last. I began to think that I could access these mysterious issues of form and structure that I'd found so elusive in painting class, if I tried to put them to use in illustrations for a book.

It was with the greatest passion that Maurice approached his art. He reserved his greatest contempt for those who, in his view, didn't share that seriousness. (Our class, happily, was in a kind of protected zone, greeting-card art notwithstanding.) Not many publishers earned his good graces. Eve Rice remembers his comments when students proposed sending their work to one publisher or another, hoping for a first book. "Moribund" was his pronouncement about the first. And also the second and the third. (*Not* moribund were, of course, the publishers with whom he himself was working.)

Maurice may have approved of our stealing artistically, but he wasn't so keen on being the one stolen from. We were all aware of one particular author-illustrator of some note, whose books featured a cruder version of Maurice's cross-hatch technique and covers that looked a great deal like the *Nutshell Library*'s. Maurice told

us a story in which this artist introduced himself while standing at a neighboring urinal. What Maurice stopped himself from doing next was something he kindly left to our imaginations! His stories were not gentle, but they were extremely funny, and he clearly liked to shock his listeners.

He also liked to bemoan. How hard it was to do the work, how little respect the world had for it. (This was long before celebrities had any interest in the field.) But the bemoaning never grew burdensome because he kept his sense of humor and wouldn't let himself get too carried away. Over the years, our conversations on the phone may have tended to drift into grand statements about the sad, downhill state of things, but then Maurice would stop himself. I remember once, in the middle of such a pronouncement, he said, "Why am I saying this? I'm just being fatuous."

One day during the term, Maurice invited us to his house. A few of us had cars, and the rest of us piled into them, driving the hour or so from New Haven to Ridgefield. He had moved into this house only about a year earlier, and had two large dogs to go with the big property. It was a lovely, traditional New England clapboard house, set among old, large trees, and filled with a dazzling display of memorabilia and collected items—his obsessions made tangible. I don't remember which treasures he showed us then and which I saw later, but I will never forget my amazement at the quantity and variety of old Mickey Mouses. There were also antique toys, old photographs, and drawings and comics from friends, which were more than occasionally R-rated if not X. His anecdotes would have earned similar ratings, though he was concerned about how he came across. Before telling a story about someone famous, he would apologize in case he should sound like a name-dropper. I remember parts of a yarn he told us on the day of our visit—it involved a talk show. He was a guest, along with a news anchor and someone with an orangutan. The anchor overestimated his own charm with primates, crossed some line, and suddenly the angry animal was reaching under the anchor's crotch and ripping his pants wide open. I occasionally thought in later years of asking Maurice how much of this story was actually true, but I never remembered to, which is probably for the best. His stories were so dramatic, they often made you wonder.

Near the end of the course, we signed up for time slots to meet with Maurice one-on-one to go over our work. The meeting took place in the guest suite of the master's house at Stiles College, and it lasted about forty minutes. I had seized up during the second half of the term and failed to do very much worthwhile with Helen's manuscripts. In part, I'd been so worried about my other courses that I'd shortchanged the one in which I'd felt most at home. Then shame set in, which made things worse (after the course ended, I worked productively on Helen's stories, well into the summer). For this meeting, I labored feverishly for a couple of weeks, and then presented Maurice with an illustrated series of poems by an intensely bad nineteenth-century Scottish poet I'd come across, an amateur whose ode to a bridge that had collapsed and a paean to its replacement struck me as funny. Maurice appreciated some aspects of my drawings but was basically disappointed in what I'd done—it was deeply trivial—and sad because he believed I could do much more. And he was right. It felt like a good talk with a good father, and I walked away feeling more encouraged than not.

I also felt extremely strange because of the room in which we'd met. It happened that my real father, a mathematics professor, had been invited to speak at Yale that same weekend, which was quite exciting. I had arranged to have him housed near me, in Morse College, where the master Vincent Scully offered him the Morse master's suite. Stiles College and Morse College were designed by Eero Saarinen (creator of the St. Louis Arch) as mirrored complexes, and so the Stiles and Morse master's suites were identical but reversed. I walked to my meeting with Maurice directly from my father's room—and the two rooms were exact mirror images, furnishings and all. It was the kind of coincidence that would be too unrealistic and corny and symbolic to put in a book.

The course seemed over almost as soon as it started, but Maurice made it easy to stay in touch. He gave us his phone number in Connecticut. I continued to call him now and then, or to drop in on a class when he was teaching at Parsons. Others have spoken about what a good listener he was. In conversation with him, you felt how seriously he took what you were saying and that there was nothing you couldn't say to him. To me, he was always kind and accommodating.

I knew he was not always kind to everybody. But he counted me on his side of an issue that was so important to him: He believed that art can be for children, that it mustn't be treacly or pandering, and that it should be as rich and good as the art that

Preliminary drawing of *The Junior Museum, The Art Institute of Chicago*, 1984. Pencil, 22¼ x 18⅞ inches. (See finished watercolor on page 110.)

adults want for themselves. He had no patience for people whose hearts, as he saw it, weren't in the right place. But for the others, his attention and patience and concern were manifest. For years his answering machine had an outgoing message that said something like "This is Maurice Sendak. You've reached my answering machine. Please don't let it throw you," before asking you to leave a message after the tone.

My contact with Maurice varied over time, with some long gaps, but it grew more regular in recent years. I visited him a couple of months before his death. Sitting in his living room, we started to talk about the class at Yale. Maurice's recollections were fond, but dwindling (though in general his memory seemed outstanding—better than mine ever was). He remembered the students I've mentioned here, but not some of the others I named for him. To write this piece I contacted a number of classmates, and it was distressing to all of us to realize how much of the past disappears with memory. Somewhere there are copies of the *Yale Literary Magazine* from 1971: The *Lit* put out a special issue based on the stories and pictures our class had done. Maybe the whole class is represented there; I don't know.

Toward the end of his life, Maurice's recording requested callers not to speak too fast. "We move slow here," it said. That moving has slowed to a stop. Now and then, I still find myself thinking of calling Maurice, and then I catch myself. As memories fade, one of the last to go must certainly be that of a favorite teacher. Maurice was that to me, for which I could not be more grateful.

A PERSONAL REFLECTION
by Dennis M. V. David

aurice was my special friend. It seems many people felt that way about him, because he was sincere and genuine. He was accommodating, interested, and had acute powers of observation; he was charismatic, with a sensitive heart. These characteristics may be common to artists, but for Maurice, they were more evident to a fault. He internalized the world's angst, though clearly he also shared in its joys.

We first met in early 1981 as my life was in transition. I had been a graduate student in biology and was entering the rarified world of antique books. Maurice was one of Justin's friends and I didn't know much about him, though by way of introduction, I had been given an inscribed copy of his haunting and magical *Higglety Pigglety Pop!* To learn the story behind the story always makes something more meaningful, and so I studied the pictures and carefully read and reread the words.

Maurice enjoyed coming into Manhattan, and we would go out for dinner, visit art galleries, walk around town. Once we strolled past the corner windows of FAO Schwarz (its significance was totally unknown to me at the time) and peeked in. Gradually I was being educated in American culture and art, though I was never made to feel uncomfortable or inadequate. I didn't realize such things at the time, but I believe Maurice knew how much his advice and good counsel meant to me.

Maurice in Kingston, New York, 2001.

Dennis, Maurice, and Justin, Ridgefield, Connecticut, 1999.

Among my most vivid memories was the time we saw *Ran*, Akira Kurosawa's beautifully aesthetic production of Shakespeare's *King Lear*, translated into a blood-dripping Japanese-French epic. "*Ran*" has many translations, from "rebellion," "uprising," and "revolt" to "disoriented" and "confused." Hailed for its powerful images and use of color, it was playing at an art film house in New York and had a running time of 160 minutes. Beforehand, Justin convinced Maurice it would be okay to pick up sandwiches at Kaplan's delicatessen one block away and eat them during the film, since there wouldn't be time to have a normal lunch, watch the movie, and then go on with our days. Without thinking, we all ordered roast beef on rye. And so there we were, watching a gory, blood-soaked film while gorging ourselves on dripping roast beef sandwiches to the disgust of the people around us. It was more than a 3-D experience. Perhaps it was karma that this specific movie theater has since been converted into a trendy Asian-fusion restaurant with a giant gilt Buddha resting on a lotus tank inside.

To help delineate my new life in New York, I began studying paper restoration and bookbinding; here Maurice was especially supportive. The first assignment he gave me was to make a protective case for an original manuscript letter written by Vincent van Gogh, which he had just acquired. To be entrusted with such a treasure partly overwhelmed me, but he knew I would not let him down. Additional manuscripts and books followed as needed.

We had our share of good visits to Ridgefield, where Justin and Maurice would spend the afternoon talking about the dire condition of the world, reminisce about the good old days of collecting, and gossip about people and the eccentric collectors they knew. We would always eat meals together, food being such a predominant theme in Maurice's life and books. Usually we would take a stroll through the adjoining woods, where Maurice liked to go walking with his dog, crossing over to the wooded property he would eventually own, which is lined with horse paths and neatly piled fieldstones. We were there in all seasons, but it was particularly beautiful in the late autumn, when we would watch the

auburn sunset behind defoliated trees. As the hint of winter chill crept into the air, we waited for the first snow to lay a blanket on the leaf-covered ground. Maurice dreaded the fall, but he adored the beginning of winter. He found the beauty of the snowfall gratifying and loved to be indoors with his "happy labor." Although he found it exhausting, he was happiest when he was working. The walk through the woods was a treat he later abandoned in favor of flatter terrain. The paved roads around his home were just as pretty, and he would take us as far as the second bend, where there was a clearing and view of the open fields on the faraway hill. This was the cue we were to head back. These are wonderful memories.

Maurice came to visit us in Kingston several times, and we walked our little street (West Chestnut) on the hill—all the way to the end with its view of Rondout Landing below and the Hudson River farther to the left. Our setting is a more nineteenth-century urban one compared to the tranquility of Maurice's Chestnut Hill and Spring Valley Roads. Our Battledore Gallery had several one-man shows of his art, but during the rest of the year he shared the premises with Chairman Mao Zedong and vintage Chinese propaganda art. Maurice called it the "Mao and Mo Show."

On one of his visits to Kingston, Maurice expressed a desire to visit Olana, Frederic Church's historic home overlooking the Hudson River in Columbia County. It had already been closed for the season, but upon hearing Maurice's name, the staff welcomed us. We were greeted by the chief curator, who gave us a tour that included the family's private quarters, which were usually not open to the public. We were able to see where the children played, and Maurice was invited to look through the personal sketchbooks of Frederic Church. A further treat awaited us at the tower, which has panoramic views of the river and the adjoining property. We enjoyed lunch afterward in nearby Hudson, New York, and the following day, went into New York City to view the Chagall show at the Jewish Museum . . . it was always a pleasure to travel with Maurice.

Maurice was always generous, and on occasion he was my sounding board and confidant—usually in late-night calls, as his days were occupied. He shared his emotions and did not mince words or shy away from expletives when imparting his opinions. I would try never to initiate contact because I realized how busy he was, but he knew he could reach me anytime. His unique character and genius are something that I will never forget, and he will always be in my heart as a treasured friend.

MAURICE SENDAK

June 10, 1928 – May 8, 2012

June 12, 2012
The Grace Rainey Rogers Auditorium at
The Metropolitan Museum of Art

OPPOSITE: Maurice Sendak at Olana, Hudson, New York, 2001.

LEFT: Maurice Sendak memorial program, June 2012, featuring an illustration from *Higglety Pigglety Pop!* (Harper & Row, 1967). Following Maurice's death on May 8, 2012, there was a great outpouring of sentiment in all media: in print, on the radio and television, and over the Internet. Friends and fans clamored for a formal farewell, and guided by Maurice's friend Tony Kushner, a memorial program was organized at the Metropolitan Museum of Art, which filled the auditorium of seven hundred seats to capacity, and featured various tributes and musical interludes to honor the memory of a unique individual: an artist, colleague, humanitarian, and friend.

CONTRIBUTORS

FRANK CORSARO is one of America's foremost stage directors of opera and theater. He made his operatic directing debuts at New York City Opera in 1958 and at Metropolitan Opera in 1984. His Broadway productions include *The Night of the Iguana* with Bette Davis (1961). From 1980 onward his innovative approach in redefining traditional operas and ballets proved the perfect bonding with Maurice Sendak's sets and costumes, leading to a close friendship.

DENNIS M. V. DAVID came to the United States from his native Philippines in 1980 for graduate studies toward a master's degree in biology. Soon after, he was introduced to the world of rare children's books and Maurice Sendak. He studied paper conservation and restoration, learned how to research and catalogue old books, and ultimately began doing rare book appraisal. Following the death of Arnold Lobel and evaluating the artwork in Lobel's estate, he collaborated with Justin Schiller to create Battledore Ltd. (1988) as a business promoting illustration art. The 2013 Maurice Sendak exhibition at the Society of Illustrators also celebrates the twenty-fifth anniversary of Battledore.

STEVEN HELLER, the author or editor of more than 150 books on graphic design and illustration, is the co-chair of the School of Visual Arts MFA Design: Designer as Author and Entrepreneur program. He also writes the Visuals column for the *New York Times Book Review*, where he was art director for almost thirty years.

JOYCE MALZBERG, a self-confessed Maurice Sendak groupie, is a transplanted New Yorker who lives in New Jersey in a house overflowing with books. For twenty years she worked in a used and antiquarian bookstore, and her collection of Sendak books and ephemera is considered the best in private hands. She is married to science fiction and fantasy author Barry Malzberg.

LEONARD S. MARCUS is among the leading authorities on children's books and the people who create them. His own award-winning books include *Margaret Wise Brown: Awakened by the Moon*; *Dear Genius: The Letters of Ursula Nordstrom*; *Minders of Make-Believe*; *The Annotated Phantom Tollbooth*; and *Show Me a Story!* A frequent contributor to the *New York Times Book Review* and the *Horn Book Magazine*, he is a founding trustee of the Eric Carle Museum of Picture Book Art and teaches a popular course on children's books and child development at New York University.

IONA OPIE and her late husband Peter are recognized worldwide for their many studies of children's literature, the lore and language of childhood, and the child in folklore, as well as for compiling their *Oxford Dictionary of Nursery Rhymes* (1951, many times reprinted and amended). Their collection of historical children's books is now at the Bodleian Library, Oxford. A longtime friend of Maurice Sendak, Opie collaborated with him in 1992 by reissuing *I Saw Esau* (traditional nursery rhymes first published 1947, now brilliantly illustrated in full color). After nearly seven decades of work, Iona enjoys her retirement in the Hampshire countryside.

PATRICK RODGERS is curator of the Maurice Sendak Collection at the Rosenbach Museum & Library in Philadelphia. Since 2007 he has worked with this collection, curated exhibitions, lectured, led guided tours, and recorded many interviews with the artist that were edited in 2008 as *There's a Mystery There: Sendak on Sendak, A Retrospective in Words and Pictures.*

JUSTIN G. SCHILLER began collecting old books at the age of eight. His collection of the L. Frank Baum Wizard of Oz series went on exhibit at Columbia University's centenary of the author's birth (1956) when Schiller was twelve, and he helped finance his college years by issuing rare book catalogues from his dormitory. He was one of two American undergraduates selected for the 1964 eight-week Shakespeare symposium at Stratford-on-Avon, graduating the following year with honors in English Renaissance literature. He issued his first catalogue of collectible children's books in 1967, and his company, Justin G. Schiller Ltd., is the oldest antiquarian rare books firm continuously devoted to the buying and selling of rare juveniles. His friendship with Maurice Sendak during the past forty-five years was one of the two greatest events in his life.

GINGER SHULER was chief of youth services at the Richland County Public Library in Columbia, South Carolina, for thirty-five years. She graduated from Louisiana State University and received her master's degree from the School of Library and Information Science at the University of South Carolina.

JUDY TAYLOR met Maurice Sendak in 1962 and, as his editor at The Bodley Head, was responsible for introducing *Where the Wild Things Are* (1967), followed by his many other titles, to British audiences. They shared a passionate admiration for Beatrix Potter, William Nicholson, and Edward Ardizzone, and had a close friendship for half a century. Aside from being Maurice's British editor, Judy has a distinguished list of works that she has either written or edited.

AHRON D. WEINER first met Maurice Sendak in an advertising agency conference room in the summer of 1997 to discuss production of a Wild Things advertising campaign for the newly merged Bell Atlantic. A friendship developed out of many things the two shared, including an obsession with the Holocaust. At the time Weiner was transferred to the Prague office of Young & Rubicam in 2001, Sendak was grappling with his *Brundibar* pictures. The artist asked his friend to shoot photos of Prague, the Czech countryside, and the Terezin concentration camp, which he then used as reference for his book and stage sets. When Weiner took a sabbatical in 2004 to photo-document former Jewish sites across Eastern Europe, Sendak asked him to visit Zembrov, a small town in northeast Poland that was home to the Sendak family until the Nazis annihilated them. All that remained was a desecrated cemetery with broken gravestones. Weiner selected a Hebrew-inscribed chunk of stone to represent this lost community as a souvenir, and throughout the remainder of his life, Sendak kept this memento on the desk in his studio. It now rests over his ashes in a memorial grove along with those of his partner, Eugene Glynn.

PAUL O. ZELINSKY's illustrations have won wide acclaim and many awards, including the Caldecott Medal for his retelling of *Rapunzel* and three Caldecott Honors, for *Hansel and Gretel*, *Rumpelstiltskin*, and *Swamp Angel*. His movable *Wheels on the Bus* is a perennial favorite among toddlers. In 2012, every one of the six major children's book review journals that award stars starred *Z is for Moose* (written by Kelly Bingham). Known for the variability of style and genre in his books, Zelinsky says, "I think I am recognized for being unrecognizable."

Freedom to Read, 1991. Printed poster, 22 x 17 inches. Published by the American Booksellers Association (ABA), this fine art print is limited to 407 signed copies in various forms. Issued to raise awareness of the ABA's legal battle against censorship, the imagery pays homage to *In The Night Kitchen*, one of the banned books depicted in the poster. Throughout his career Sendak was plagued by censorship and confronted with problems of approval or disapproval, and even rejection by publishers, editors, and critics. This poster, created as a protest, provides a glimpse of his heartfelt defiance and fortitude.

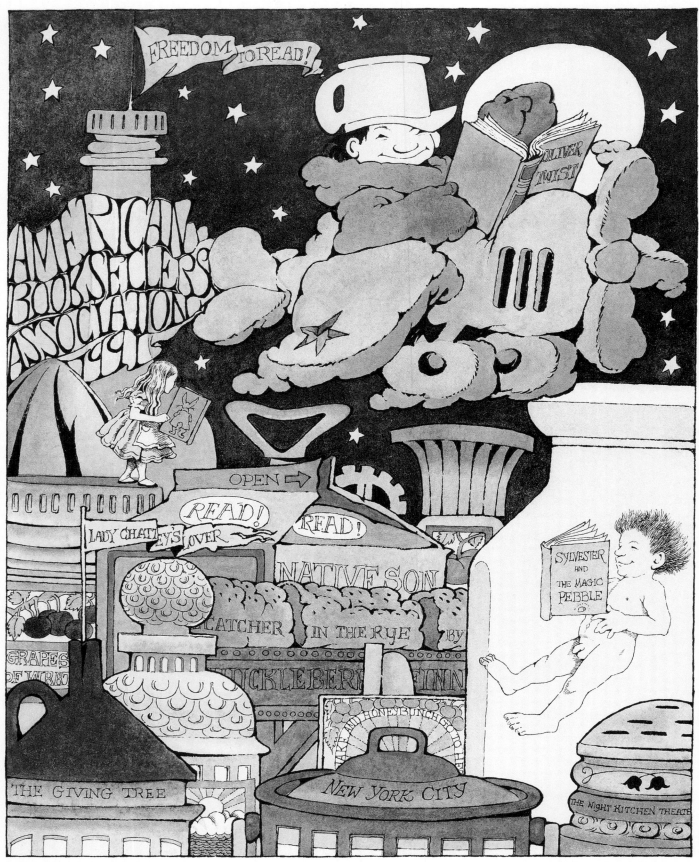

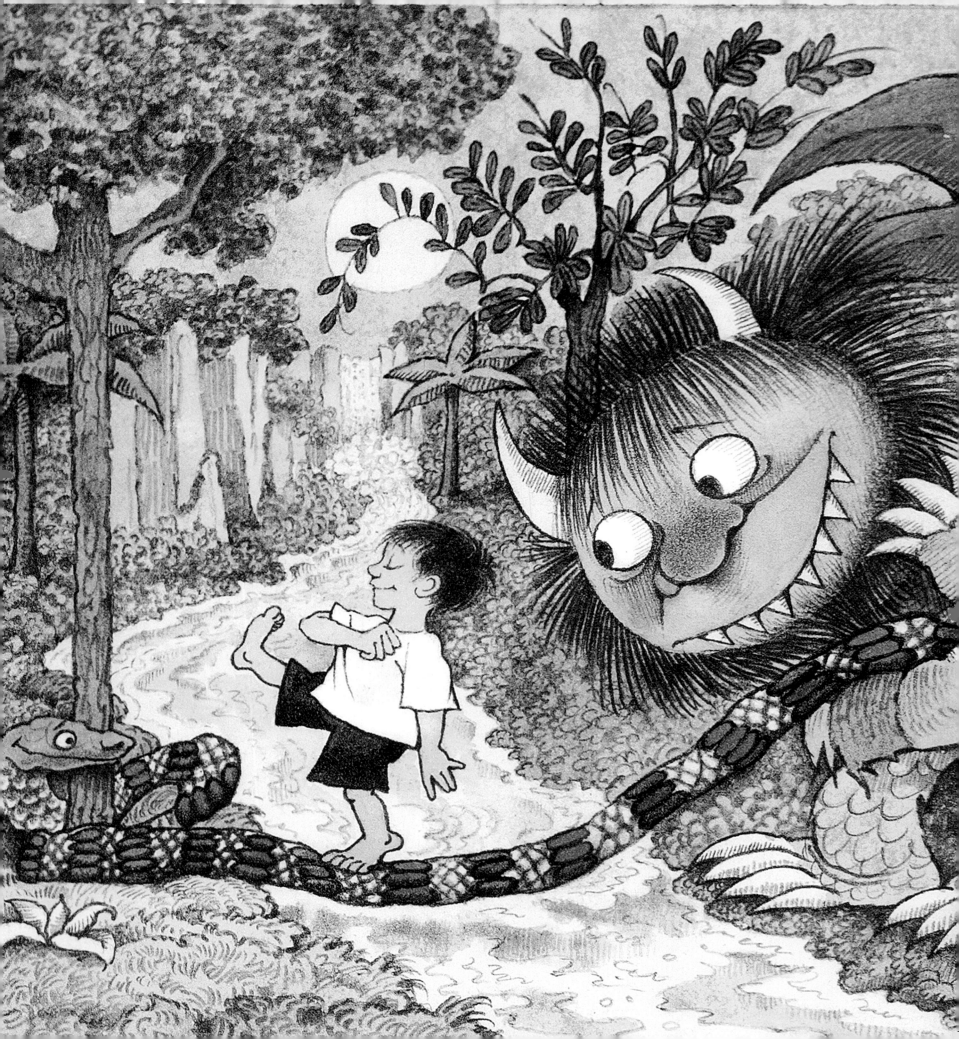